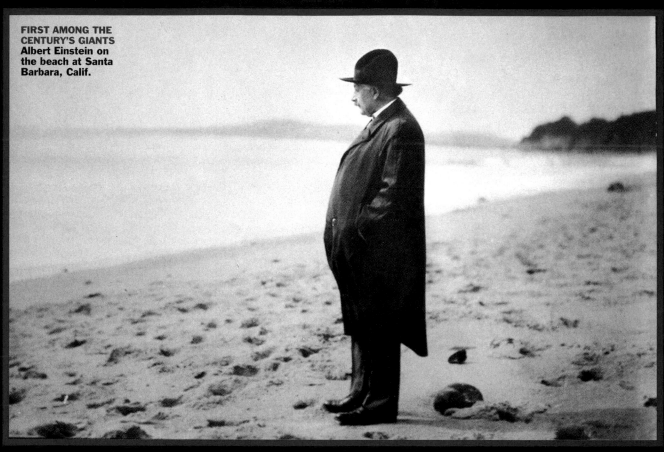

FIRST AMONG THE CENTURY'S GIANTS Albert Einstein on the beach at Santa Barbara, Calif.

SANTA BARBARA HISTORICAL SOCIETY

Person of the Century

Find out more about the Person of the Century at **www.time.com/poc**

POC COVER: *Photograph © Philippe Halsman* MILLENNIUM COVER: *Photograph by Brad Rickerby—Reuters*

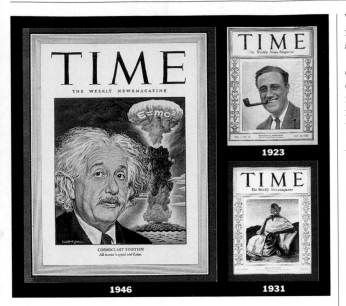

1923

1946

1931

Writers for the Century

YEARS AGO, WHEN SOME OF US BEGAN THINKING ABOUT WHO might be Person of the Century, Albert Einstein was one person who made each of our short lists. It was, above all, a century that would be remembered for advances in science and technology. Einstein stood out as its greatest scientific genius, and his work touched the most important fields of technology: nuclear weapons, television, space travel, lasers and semiconductors.

Since then, we've assembled panels of experts to help us choose our top nominees, who were profiled in the five issues of our TIME 100 series and on CBS News specials (and are now available as a book, *People of the Century,* from Simon & Schuster).

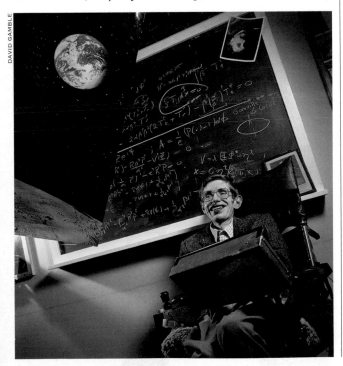

We've done TV panels with Charlie Rose for his PBS show, had meetings with an array of historians and gotten millions (yes, really) of e-mails and votes online.

We came up with three finalists, all profiled in this issue, based on the major themes of the century. There was the triumph of freedom over fascism and communism, for which Franklin Roosevelt is the embodiment. To represent the crusades for civil rights and individual liberties, we chose Mohandas Gandhi. And, of course, there was Einstein to represent science and technology.

We had dream candidates to write about each finalist, and we were thrilled when they all agreed.

For Einstein, the obvious choice was **Stephen Hawking,** one of the greatest living theoretical physicists. His classic work, *A Brief History of Time,* has sold close to 9 million copies and was made into a PBS series that he narrated through his voice synthesizer (he has ALS, known as Lou Gehrig's disease). He's best known for devising theories of the Big Bang and black holes based on Einstein's work. We e-mailed Hawking at his Cambridge lab earlier this year to convince him of the importance of explaining Einstein at the end of his century.

One of **President Bill Clinton's** accomplishments has been to restore the strength of Franklin Roosevelt's legacy by reforming welfare and conquering runaway deficits while still showing how government could help average citizens. He's written a fascinating piece about what Roosevelt means today. **Doris Kearns Goodwin,** author of a best-selling book on Eleanor and Franklin Roosevelt, is a great historian and a wonderful writer. Her biographical essay on Roosevelt captures, in a moving way, his personality and historic significance.

I once had the opportunity to accompany **Nelson Mandela** on a tour of the cellblock on South Africa's Robben Island where he spent many of his 27 years of imprisonment. He recalled how he and his colleagues used to argue about the tactics of Gandhi, who developed his theory of nonviolence as a young lawyer in that country. In his essay, Mandela describes how he strayed from Gandhi's philosophy at times, and why.

By the end of our process, we felt even more strongly that Einstein best met our criteria: the person who, for better or worse, personified our times and will be recorded by history as having the most lasting significance. I explain how we arrived at that conclusion in a story on page 48. Let us know if you agree. Either way, I'm confident that you'll appreciate the work of the great writers who make personal the legacies of all three of our finalists.

Walter Isaacson, Managing Editor

POPULATION Americans moved from industrial cities of the Northeast to the Sun Belt of the South and West

▶ **10 most populous cities**

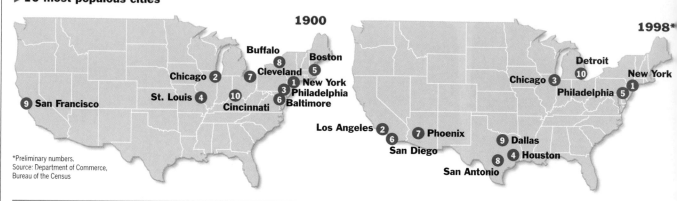

1900

- Buffalo ⑦
- Boston ⑤
- Cleveland
- Chicago ②
- New York ①
- Philadelphia ③
- Baltimore ⑥
- St. Louis ④
- Cincinnati ⑩
- San Francisco ⑨

1998*

- Detroit ⑩
- Chicago ③
- New York ①
- Philadelphia ⑤
- Los Angeles ②
- San Diego ⑥
- Phoenix ⑦
- Dallas ⑨
- Houston ④
- San Antonio ⑧

*Preliminary numbers.
Source: Department of Commerce, Bureau of the Census

AGE Since people are living longer, the population profile has evened out

▶ **Population by age**

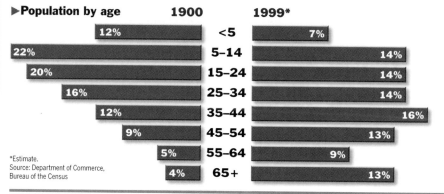

	1900		1999*
<5	12%		7%
5–14	22%		14%
15–24	20%		14%
25–34	16%		14%
35–44	12%		16%
45–54	9%		13%
55–64	5%		9%
65+	4%		13%

*Estimate.
Source: Department of Commerce, Bureau of the Census

IMMIGRATION Latinos now surpass Europeans as immigrants

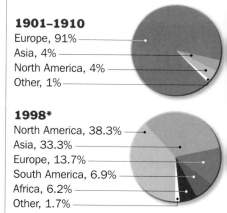

1901–1910
- Europe, 91%
- Asia, 4%
- North America, 4%
- Other, 1%

1998*
- North America, 38.3%
- Asia, 33.3%
- Europe, 13.7%
- South America, 6.9%
- Africa, 6.2%
- Other, 1.7%

*Preliminary numbers. Note: 'North America' includes Mexico, the Caribbean, Central America and Canada. 'Other' includes Oceania.
Source: Department of Justice, Immigration and Naturalization Service

DEATH Some diseases that once were top killers have been brought under control

▶ **10 leading causes of death, rate per 100,000**

	1900
1. Pneumonia, influenza	202.2
2. Tuberculosis	194.4
3. Diarrhea, enteritis, ulcers	142.7
4. Heart disease	137.4
5. Stroke	106.9
6. Acute kidney infection	88.6
7. Accidents	72.3
8. Cancer, malignant tumors	64.0
9. Senility	50.2
10. Diphtheria	40.3

	1998*
1. Heart disease	268.0
2. Cancer	199.4
3. Stroke	58.5
4. Pulmonary diseases	42.3
5. Pneumonia, influenza	35.1
6. Accidents	34.5
7. Diabetes	23.9
8. Suicide	10.8
9. Acute kidney infection	9.7
10. Chronic liver disease, cirrhosis	9.2

*Preliminary numbers. Source: National Center for Health Statistics

COST OF LIVING It costs more today to make a hamburger, less to make an omelet

	1900	Inflation adjusted	1999
Sugar (1 lb.)	$.04	$.78	$1.49
Eggs (1 dozen)	$.14	$2.75	$1.79
Butter (1 lb.)	$.24	$4.70	$4.49
Beef (1 lb.)	$.07	$1.37	$2.99
Coffee (1 lb.) on the commodity exchange	$.07	$1.37	$1.35
Kodak camera*	$5	$98	$120
Lionel electric train	$6	$117	$150
Train ticket**	$13	$254	$43
First class stamp	$.02	$.39	$.33

* Pocket Model D in 1900, APS (Advanced Photo System) in 1999
** From St. Paul, Minn., to Minot, N.D., on the Great Northern Railway
Sources: The People's Chronology, Uncommon Grounds, Lionel LLC, Eastman Kodak Co., Amtrak, The Great Northern Railway–A History, The Traveller's Official Railway Guide, U.S. Postal Service

Compiled by Deborah Wells and Lina Lofaro. Graphics by Eliot Bergman

FARMS Texas leads the nation, with 132 million acres in farms and ranches

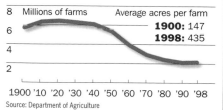

Millions of farms

Average acres per farm
1900: 147
1998: 435

1900 '10 '20 '30 '40 '50 '60 '70 '80 '90 '98

Source: Department of Agriculture

HOMICIDES Murder rates have hit their lowest in almost four decades

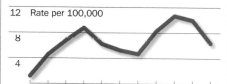

Rate per 100,000

1900 '10 '20 '30 '40 '50 '60 '70 '80 '90 '98*

*Preliminary number. Source: National Center for Health Statistics

EDITOR-IN-CHIEF: Norman Pearlstine
EDITORIAL DIRECTOR: Henry Muller

CHAIRMAN, CEO: Don Logan
EXECUTIVE VICE PRESIDENTS: Richard Atkinson, Elizabeth Valk Long, Jim Nelson

TIME

Founders: Briton Hadden 1898-1929 Henry R. Luce 1898-1967

MANAGING EDITOR: Walter Isaacson
DEPUTY MANAGING EDITOR: James Kelly
EXECUTIVE EDITORS: Stephen Koepp, Christopher Porterfield, John F. Stacks
ASSISTANT MANAGING EDITORS: Howard Chua-Eoan, Philip Elmer-DeWitt, Dan Goodgame, Priscilla Painton
INTERNATIONAL EDITORS: Donald Morrison (Asia), Christopher Redman (Europe), George Russell (The Americas), Steve Waterson (South Pacific), Charles P. Alexander
DIRECTOR OF OPERATIONS: Nancy Mynio
SPECIAL PROJECTS EDITOR: Barrett Seaman
SENIOR EDITORS: Tom Dusevic, James Geary, Nancy Gibbs, Richard Hornik, Adi Ignatius, James O. Jackson, Belinda Luscombe, Joshua Cooper Ramo, Bill Saporito, Janice C. Simpson, Richard Zoglin
ART DIRECTOR: Arthur Hochstein **DIRECTOR OF PHOTOGRAPHY:** Michele Stephenson **CHIEF OF REPORTERS:** Jane Bachman Wulf
GRAPHICS DIRECTOR: Joe Zeff **ADMINISTRATIVE EDITOR:** Suzanne Davis **COPY CHIEF:** Susan L. Blair **LETTERS EDITOR:** Betty Satterwhite Sutter
SENIOR WRITERS: Margaret Carlson, Adam Cohen, Richard Corliss, Christopher John Farley, Frank Gibney Jr., Christine Gorman, Paul Gray, John Greenwald, Robert Hughes, Daniel Kadlec, Jeffrey Kluger, Richard Lacayo, Michael D. Lemonick, Anthony Spaeth, Rod Usher, David Van Biema, James Walsh
STAFF WRITERS: John Cloud, Tammerlin Drummond, Tamala M. Edwards, Karl Taro Greenfeld, Nadya Labi, James Poniewozik, Romesh Ratnesar, Joel Stein
WRITER-REPORTERS: Daniel Eisenberg, Julie Grace, Jodie Morse, Michele Orecklin, Stacy Perman, Chris Taylor
SENIOR REPORTERS: Andrea Dorfman (Deputy Chief); Bernard Baumohl, Tam Martinides Gray, Ratu Kamlani, Ariadna Victoria Rainert, William Tynan (Department Heads); Harriet Barovick, David Bjerklie, Val Castronovo, Georgia Harbison, Jeannette Isaac, Daniel S. Levy, Barbara Maddux, Valerie Johanna Marchant, Emily Mitchell, Adrianne J. Navon, Alice Park, Sue Raffety, Susan M. Reed, Elizabeth Rudulph, Megan Rutherford, Andrea Sachs, Alain L. Sanders, David E. Thigpen
REPORTERS: Elizabeth L. Bland, Barbara Burke, Andrew Goldstein, Janice M. Horowitz, Unmesh Kher, Lina Lofaro, Ellin Martens, Lisa McLaughlin, Aixa Pascual, Desa Philadelphia, Cinda Siler, Flora Tartakovsky, Rebecca Winters
CONTRIBUTORS: Eugenie Allen, Jonathan Beaty, Peter Beinart, Sandra Burton, George J. Church, Jay Cocks, James Collins, Dan Cray, Amy Dickinson, Barbara Ehrenreich, Kevin Fedarko, Andrew Ferguson, Elizabeth Gleick, Frederic Golden, Jeff Greenfield, Lewis Grossberger, Molly Ivins, Pico Iyer, Leon Jaroff, Michael Kinsley, Walter Kirn, John Kohan, Charles Krauthammer, Elaine Lafferty, Erik Larson, Eugene Linden, Janice Maloney, Kim Masters (West Coast Contributing Editor), Thomas McCarroll, William McWhirter, Lance Morrow, Peggy Noonan, Christopher Ogden, Richard Schickel, Wilfrid Sheed, R.Z. Sheppard, Hugh Sidey, John Skow, Ian Smith, M.D., George M. Taber, Terry Teachout, Calvin Trillin, Garry Trudeau, Robert Wright
COPY DESK: Barbara Dudley Davis, Judith Anne Paul, Shirley Barden Zimmerman (Deputies); Bruce Christopher Carr, Dora Fairchild, Evelyn Hannon, Jill Ward (Copy Coordinators); Doug Bradley, Robert Braine, Barbara Collier, Julia Van Buren Dickey, Judith Kales, Sharon Kapnick, Jeannine Laverty, Peter J. McGullam, M.M. Merwin, Maria A. Paul, Jane Rigney, Elyse Segelken, Terry Stoller, Amelia Weiss (Copy Editors)
CORRESPONDENTS: Marguerite Michaels (News Director) **Senior Foreign Correspondent:** Johanna McGeary **Chief Political Correspondent:** Eric Pooley **Senior Correspondents:** David S. Jackson, J. Madeleine Nash, Michael Weisskopf **National Correspondents:** Margot Hornblower, Jack E. White **Washington:** Michael Duffy, Matthew Cooper, Ann Blackman, Jay Branegan, Massimo Calabresi, James Carney, John F. Dickerson, Sally B. Donnelly, Barry Hillenbrand (International Correspondent), Viveca Novak, Elaine Shannon, Dick Thompson, Mark Thompson, Karen Tumulty, Douglas Waller, Adam Zagorin, Melissa August **New York:** Edward Barnes, Ann Dowell, Elaine Rivera **Chicago:** Ron Stodghill II, Wendy Cole **Detroit:** Nichole Christian **Atlanta:** Sylvester Monroe, Timothy Roche **Austin:** S.C. Gwynne **Miami:** Tim Padgett **Los Angeles:** Cathy Booth, Jeanne McDowell, Jeffrey Ressner, James Willwerth, Richard Woodbury **San Francisco:** Michael Krantz **London:** J.F.O. McAllister, Helen Gibson **Paris:** Thomas Sancton (Chief European Correspondent), Bruce Crumley **Berlin:** Charles Wallace **Brussels:** James L. Graff **Central Europe:** Andrew Purvis **Moscow:** Paul Quinn-Judge, Andrew Meier, Yuri Zarakhovich **Rome:** Greg Burke **Jerusalem:** Lisa Beyer **Cairo:** Scott MacLeod **South Africa:** Peter Hawthorne **New Delhi:** Michael Fathers, Maseeh Rahman **Islamabad:** Hannah Bloch **Beijing:** Jaime A. FlorCruz **Hong Kong:** John Colmey, Terry McCarthy (East Asia) **Tokyo:** Tim Larimer, Donald Macintyre **Latin America:** Tim McGirk **Bureau Administration:** Sheila Charney, Don Collins Jr., Corliss M. Duncan, Lona C. Harris, Anne D. Moffett, Sharon Roberts, Neang Seng, Judith R. Stoler **News Desks:** Eileen Harkin, Brian Doyle, Mitch Frank, Andrew Keith, Christine Laidlaw, Alexander Smith, Diana Tollerson
ART: Marti Golon, Cynthia A. Hoffman (Deputy Art Directors); Thomas M. Miller (Senior Art Director); Daniel Esqueda Guadalajara, Tim Oliver, W. Pine III (Associate Art Directors); Jennifer Roth, Kenneth B. Smith (Assistant Art Directors); Ron Plyman, Jennifer Taney (Designers) **Covers:** Linda Louise Freeman (Cover Coordinator); Gregory Heisler (Contributing Photographer); Graphics: Ed Gabel, Joe Lertola (Associate Graphics Directors); Kathleen Adams, Deborah Wells (Researchers) **Special Projects:** Susan Langholz (Art Director); Deena Goldblatt (Assistant Art Director) **International:** John White (Asia), Paul Lussier (Europe), Edel Rodriguez (The Americas), Susan Olle (South Pacific)
PHOTOGRAPHY: MaryAnne Golon (Picture Editor), Richard L. Booth, Hillary Raskin (Deputy Picture Editors); Robert B. Stevens, Eleanor Taylor (Associate Picture Editors); Ames Adamson (Operations Manager); Gary Ekou Roberts, Cristina T. Scalet, Nancy Smith-Alam, Marie Tobias (Assistant Editors) **Traffic:** Wayne S. Chun, Urbano Delvalle, Anna Marie McCague **Special Projects:** Jay Colton, Jessica Taylor Taraski **International:** Lisa Botos (Asia), Paul Durrant (Europe), Mark Rykoff (The Americas) **Bureaus:** Martha Robson Bardach, James Colburn, Barbara Nagelsmith, Andrei Polikanov, Anni Rubinger, Mary Studley **Contributing Photographers:** J. Kyle Keener, William Campbell, Karin Cooper, Dirck Halstead, Barry Iverson, Cynthia Johnson, Brooks Kraft, André Lambertson, Steve Liss, Christopher Morris, Carl Mydans, James Nachtwey, Robert Nickelsberg, David Rubinger, Anthony Suau, Ted Thai, Diana Walker
LETTERS: Gloria J. Hammond (Deputy); Robert Cushing, Sonia Figueroa, Winston Hunter, Tom Moran, Edith Rosa, Patrick Smith
TIME FOR KIDS: Claudia Wallis (Managing Editor); Martha Pickerill (Assistant Managing Editor); Nelida Gonzalez Cutler (Senior Editor); Sarah Micklem (Art Director); Adam Berkin (Education Editor); Joan Menschenfreund (Picture Editor); Michelle R. Derrow, Jay R. Ehrlich (Staff Writers); Jennifer Kraemer-Smith (Associate Art Director); Laura C. Girardi (Writer/Administrator); Craig Stinehour (Production Director); Leanna Landsmann (President); Keith Garton (Publisher)
TIME ONLINE: Richard L. Duncan (Editor); Matthew Diebel (Deputy Editor); Morris Barrett (Production Manager); Melanie McLaughlin (Art Director); Karl Schatz (Picture Editor); Jonathan Gregg (Senior Editor); Mark Coatney (News Editor); Adam Embick (Senior Producer); Nick Oredson, Elizabeth Owen (Producers); Ann C. Villet (Associate Producer); Andrew Arnold (Production Developer); Michael Goldfarb, Tony Karon, Frank Pellegrini, Jessica Reaves (Writers); Michael Street (Assistant Designer)
TIME DIGITAL: Joshua Quittner (Editor); Steven Henry Madoff (Deputy Editor); Maryanne Murray Buechner, Anita Hamilton (Associate Editors); Owen Thomas (Assistant Editor); Bill Syken (Reporter)
RESEARCH CENTER: Lynn M. Dombek (Assistant Director); Ann Marie Bonardi, Kathleen Dowling, Sandra Lee Jamison, Charlie Lampach, Karen L. McCree, Angela Thornton
MAKEUP: Robyn M. Mathews (Chief); Amy Pittman, Lynn Ross (Assistant Managers); Sarah Bentley, Maureen Cluen, Christianne Modin, David Richardson
EDITORIAL OPERATIONS: Meghan Milkowski (Manager); Kin Wah Lam (Creative Services Manager); Gerard Abrahamsen, Brian Fellows (Supervisors); Nora Jupiter (Assistant Manager, International); Lois Rubenstein Andrews, Keith Aurelio, Gregg Baker, Trang Ba Chuong, Charlotte Coco, Silvia Castañeda Contreras, Osmar Escalona, Garry Hearne, Raphael Joa, Sandra Maupin, Po Fung Ng, Linda Parker, Mark P. Polomski, Albert Rufino, Richard Shaffer, David Spatz
PRODUCTION: Kris Basciano, Paul Zelinski (Directors); Anne M. Considine, Joseph Eugenio, David Luke (Managers); Barry Ritz (Assistant Manager); Bernadette Cumberbatch, Patrick Hickey, Angie Licausi, Kathleen McCullagh, Christopher Speranza, Juanita Weems
TECHNOLOGY: Richard Fusco (Director); Ken Baierlein, Andrew Dyer (Associate Directors); Greg Gallent, Mark Selleck, Lamarr Tsufura (Managers); Evan Clemens, Don Collins Jr., Kevin Kelly, George Mendel, John Meyer, Aleksey Razhba, Michael M. Sheehan, Alexander Zubarev
HEADQUARTERS ADMINISTRATION: Alan J. Abrams, Jean Girardi-Lewis, Helga Halaki, Marilyn V.S. McClenahan, Barbara Milberg, Rudi Papiri, Joseph Pierro, Elliot Ravetz, Teresa Daggy Sedlak, Marianne Sussman, Raymond Violini, Miriam Winocour, Carrie A. Zimmerman

PRESIDENT: F. Bruce Hallett
PUBLISHER: Edward R. McCarrick
GENERAL MANAGER: Andrew Blau
VICE PRESIDENT: Karen Magee
ASSOCIATE PUBLISHER: Richard A. Raskopf
MARKETING DIRECTOR: Taylor C. Gray
PUBLIC AFFAIRS DIRECTOR: Diana Pearson
CONSUMER MARKETING: Susan M. Green, Roseann Hartfield, Lori Manheim, Deborah Thompson, Melvin Young (Directors); Karen Cho, Patricia Campbell, Amanda Bowen, Patti Devine, Kristiana Helmick, Bianca Janosevic, Wendy Kelly, Johnna Kietzmann, Sian Killingsworth, Jenny Kwong-Korall, Alissa Laufer, Kelly Leach, Deborah Ornstein, Dana Lucci, Stephanie Meltzer, Eric Purther, Mary Margaret Saleeby, Kenneth Sheldon, Jennifer Tanenbaum, Karen Weinmann **Time For Kids:** Nanette Zabala (Director); Arti Finn, Jennifer Park, Marcelo Presser, Jason Riccardi, Gretchen Sanders, Yvonne Quinlan **Time Canada:** Douglas Glazer (Director); Julia Crislip, Victor Rufo, Daniel Petroski **Time Distribution Services:** Christopher P. Moody (Director); Diana DeFrate, Elizabeth Means
ADVERTISING SALES: Atlanta: John Helmer (Manager); June Wendler **Boston:** Don Jones (Manager); John Shaughnessy **Chicago:** Tim Schlax (Manager); Barbara Dunn Cashion, Julie Lonergan, Alexis Ann Sternstein, Michael Ziegler **Dallas:** Clyde Boyce (Manager) **Detroit:** Katie Kiyo (Manager); Michael Clark, Terri Faletti, Joseph Giacalone, Sean Sullivan **Los Angeles:** Mark Updegrove (Manager); Kelley Dermody, Greg Fox, Jim Helberg **New York:** Maureen McAllister, Matt Turck (Managers); Kent Blosil, Peter Britton, Chris Carter, Joan Carter, Rickey Christie, Jacqueline Demchuk, Carrie Howard, Charles R. Kammerer, Nathan Stamos, Matthew E. Sterling, Newell Thompson, Georgette Walsh **San Francisco:** Fred Gruber (Manager); Erin Mervis, Thomas Petersen **Washington:** Hal Bonawitz (Manager); Suzanne C. Wagner **Time For Kids:** Amy Dunkin
ADMINISTRATION: Headquarters: Elena Falaro, Ellen Harvey, Adrienne Hegarty, Delia Leahy **Atlanta:** Michelle Ruge **Boston:** Bonnie Walter **Chicago:** Barbara Henkel, Nicole Wood **Dallas:** Rosario Spear **Detroit:** Monica Delise, Jan Eggly **Los Angeles:** Ani Barsamian, Monica Marie Mallen **New York:** Addie Boemio, Renee Geathers Bookhart, Melania Burgess, Jane Cole, Marie DiFiore, Tanya Tarek, Linda Vail **San Francisco:** Donna Masso, Sheila Phillips **Washington:** Charlotte Gay **MARKETING:** Katherine D. Douvres, Liza Greene, John Harvey, Meredith Welch (Directors); Teresa Belmonte, Betty Barth, Steve Cambron, Christina Colyras, Andrea Costa, Amy Epes, Nini Gassonhoven, Joe Johnson, Christine Lach, Kristen Kelly Licciardi, Wendy Metzger, Kathy Petersen, Julie Z. Rosenberg, Paton Ryan (Managers); Kristin Gambell, Jennifer Gerken, Jennifer Hayes, Inna Kern, Cynthia Murphy, Wendy Olesen, Trish Ryan-Sacks, Mary Shaw, Winnifred Stephenson, Orion Tait, Yodit Teklamariam, Amy Thorkilsen
FINANCE: Nancy Krauter, Gail Portier **Advertising:** Patti Brasfield, Daniele Campbell, Mary Dombrowski, Craig Ettinger, Barbara Loomis, Karen Maikisch-Markle, Regina Peters **Compensation:** Ruth Hazen, Marilynda Kelly Vianna **Editorial:** Morgan Krug, Camille Sanabria, Diana Spence, Karen Tortora
Production: Chris Marcantonio, Patty Stevens, Jacqueline Ohringer, Karen Ziegler
PUBLIC AFFAIRS: Debra S. Richman (Assistant Director); Todd Polkes (Manager); Julianna Evans, Adina Kaplan **LEGAL:** Robin Bierstedt, Robin Rabie
HUMAN RESOURCES: Amy Sommer, Amalia Zea

TIME INC.
EXECUTIVE EDITORS: Joëlle Attinger, José M. Ferrer III
DEVELOPMENT EDITOR: Jacob Young
EDITORS-AT-LARGE: Donald L. Barlett, Susan Casey, Steve Lopez, Steven M. Lovelady, Daniel Okrent, Roger Rosenblatt, Danyel Smith, James B. Steele
EDITORIAL SERVICES: Sheldon Czapnik (Director); Claude Boral (General Manager); Thomas E. Hubbard (Photo Lab); Lany Walden McDonald (Research Center); Beth Bencini Iskander, Kathi Doak (Picture Collection); Thomas Smith (Technology); Maryann Kornely (Syndication)
EDITORIAL TECHNOLOGY: Paul Zazzera (Vice President); Damien Creavin (Director)

THE TIME CENTENNIAL

★ *FACES IN TIME* ★ *LEADERS AND LOCATIONS* ★ *NAMES AND NUMBERS* ★ *THE CENTURY IN ARTS* ★ *WHO SAID IT?*

NEWS QUIZ

Take the test of the century—100 questions based on the events of the past 100 years, as covered in the pages of TIME [ANSWERS ON LAST PAGE OF QUIZ]

FACES IN TIME

Match each numbered description to the Man or Woman of the Year who fits it best.

1. "[This Person of the Year] showed that politics could be the art of the impossible; that force could speak softly and carry a small stick."

2. "[His] carefully cultivated air of mystic detachment cloaks an iron will, an inflexible devotion to simple ideas that he has preached for decades."

3. "[He] rose out of murky obscurity and carried his country with him up & up into brilliant focus before a pop-eyed world."

4. "[He] is obsessed with the idea that some day it may be possible to write a message on a pad at one's desk or bedside and have it instantaneously transmitted to the addressee anywhere on earth."

5. "With remarkable imagination and daring, he has embarked on a course, perhaps now irreversible, that is reshaping the world."

6. "A reminder of what was old and splendid, and also a fresh, imperative summons to make the present worthy of remembrance."

7. "He gave his countrymen exactly what he promised them— blood, toil, tears, sweat—and one thing more: untold courage."

8. "His mail brings him a daily dosage of opinion in which he is by turn vilified and glorified."

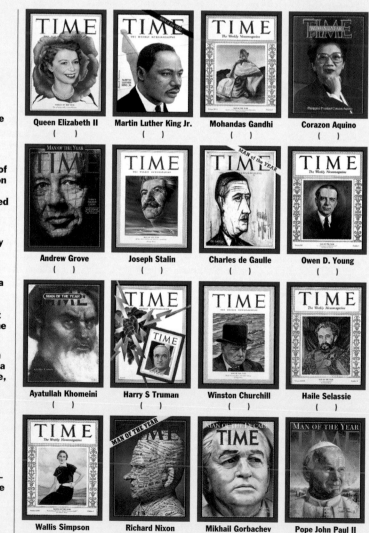

Queen Elizabeth II () Martin Luther King Jr. () Mohandas Gandhi () Corazon Aquino ()

Andrew Grove () Joseph Stalin () Charles de Gaulle () Owen D. Young ()

Ayatullah Khomeini () Harry S Truman () Winston Churchill () Haile Selassie ()

Wallis Simpson () Richard Nixon () Mikhail Gorbachev () Pope John Paul II ()

9. "Like most of mankind he was ill prepared for the destiny and responsibility which had been thrust upon him. He did not want the responsibility; the destiny rested awkwardly on his shoulders."

10. "Where most mid-20th century statesmen feel obliged to cloak their extraordinary qualities in a mantle of folksiness, he unabashedly regards himself as a historic figure and comports himself as a man of greatness."

11. "Curiously, it was in a jail that the year's end found the ... man whose mark on world history will undoubtedly loom largest of all."

12. "[This] was a year of blood and strength. The man whose name means steel in Russian, whose few words of English include the American expression 'tough guy,' was the man of [the year]."

13. "He emerged as a tough, determined world leader. Finally seizing firm control of his office, he was willing to break sharply with tradition in his privately expressed desire 'to make a difference' in his time."

14. "The firm that [he] built has survived in one of the most tumultuous industries in history, emerging to become one of the most powerful companies of our age."

15. "When he talks, it is not only to his flock of nearly a billion; he expects the world to listen. And the flock and the world listen, not always liking what they hear."

16. "Greatest ambition of [this newsmaker] seemed to be to drop from world publicity's most glaring spotlight to utter oblivion."

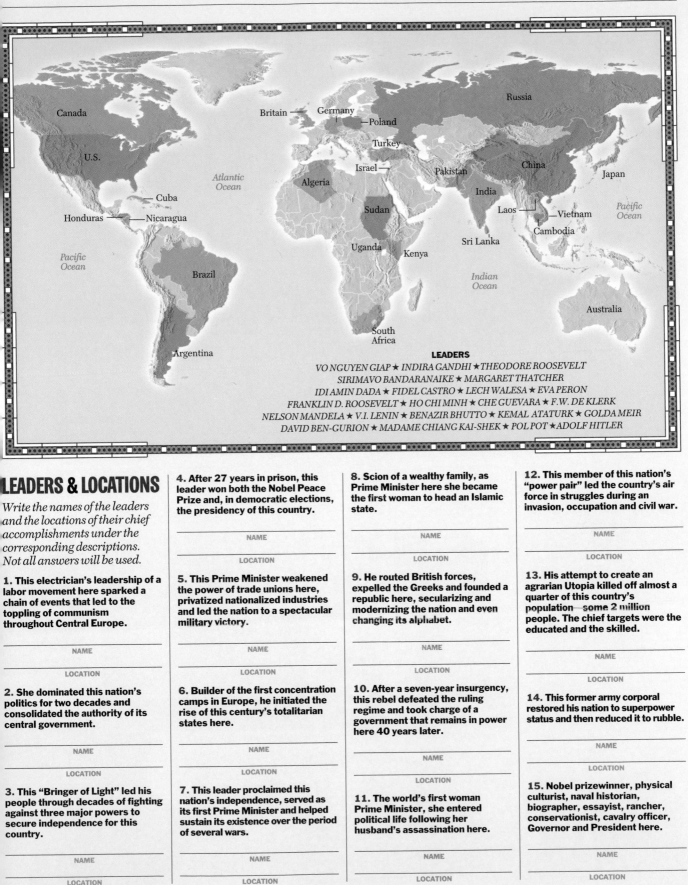

LEADERS

VO NGUYEN GIAP ★ INDIRA GANDHI ★ THEODORE ROOSEVELT
SIRIMAVO BANDARANAIKE ★ MARGARET THATCHER
IDI AMIN DADA ★ FIDEL CASTRO ★ LECH WALESA ★ EVA PERON
FRANKLIN D. ROOSEVELT ★ HO CHI MINH ★ CHE GUEVARA ★ F.W. DE KLERK
NELSON MANDELA ★ V.I. LENIN ★ BENAZIR BHUTTO ★ KEMAL ATATURK ★ GOLDA MEIR
DAVID BEN-GURION ★ MADAME CHIANG KAI-SHEK ★ POL POT ★ ADOLF HITLER

LEADERS & LOCATIONS

Write the names of the leaders and the locations of their chief accomplishments under the corresponding descriptions. Not all answers will be used.

1. This electrician's leadership of a labor movement here sparked a chain of events that led to the toppling of communism throughout Central Europe.

NAME

LOCATION

2. She dominated this nation's politics for two decades and consolidated the authority of its central government.

NAME

LOCATION

3. This "Bringer of Light" led his people through decades of fighting against three major powers to secure independence for this country.

NAME

LOCATION

4. After 27 years in prison, this leader won both the Nobel Peace Prize and, in democratic elections, the presidency of this country.

NAME

LOCATION

5. This Prime Minister weakened the power of trade unions here, privatized nationalized industries and led the nation to a spectacular military victory.

NAME

LOCATION

6. Builder of the first concentration camps in Europe, he initiated the rise of this century's totalitarian states here.

NAME

LOCATION

7. This leader proclaimed this nation's independence, served as its first Prime Minister and helped sustain its existence over the period of several wars.

NAME

LOCATION

8. Scion of a wealthy family, as Prime Minister here she became the first woman to head an Islamic state.

NAME

LOCATION

9. He routed British forces, expelled the Greeks and founded a republic here, secularizing and modernizing the nation and even changing its alphabet.

NAME

LOCATION

10. After a seven-year insurgency, this rebel defeated the ruling regime and took charge of a government that remains in power here 40 years later.

NAME

LOCATION

11. The world's first woman Prime Minister, she entered political life following her husband's assassination here.

NAME

LOCATION

12. This member of this nation's "power pair" led the country's air force in struggles during an invasion, occupation and civil war.

NAME

LOCATION

13. His attempt to create an agrarian Utopia killed off almost a quarter of this country's population—some 2 million people. The chief targets were the educated and the skilled.

NAME

LOCATION

14. This former army corporal restored his nation to superpower status and then reduced it to rubble.

NAME

LOCATION

15. Nobel prizewinner, physical culturist, naval historian, biographer, essayist, rancher, conservationist, cavalry officer, Governor and President here.

NAME

LOCATION

THE CENTURY IN ARTS

SNOW WHITE

Match the excerpt from TIME *to the corresponding photo of the artist or work.*

★ ★ ★

1. "He was the artist with whom virtually every other artist had to reckon, and there was scarcely a 20th century movement that he didn't inspire, contribute to or . . . beget."

2. "Loosely strung together on a scheme that plays the younger and older generations off against each other, it sizzles with musical montage, tricky electronics and sleight-of-hand lyrics that range between 1920s ricky-tick and 1960s raga."

3. "[This work] is as exciting as a Western, as funny as a haywire comedy . . . A combination of Hollywood, the Grimm Brothers, and the sad, searching fantasy of universal childhood, it is an authentic masterpiece."

4. "By day [the building] is a soaring column the color of an old cannon; by night it is a giant, glowing shaft punctuating the . . . skyline. It is the definitive statement of what a skyscraper can be by the architect whom most purists hail as the master of glass-and-steel design."

5. "[This painter's work] is apt to resemble a child's contour map of the Battle of Gettysburg, [but] he is the darling of a highbrow cult which considers him 'the most powerful painter in America.'"

6. "[This author's work] has survived export triumphantly. In a beautiful translation, surrealism and innocence blend to form a wholly individual style. Like rum *calentano*, the story goes down easily, leaving a rich, sweet burning flavor behind."

7. "With bright, geometric designs, hemlines pioneeringly economical in length and a silhouette breezily loose, [this Londoner] set off the Youthquake look of the '60s."

8. "Still the brightest boy in the class, [the author] holds up his hand. It is noticed that his literary trousers are longer, less bell-bottomed, but still precious."

9. "In the . . . annals of family fights on stage, there has been nothing quite like [this play's] mortal battle of the sexes for sheer nonstop grim-gay savagery. The human heart is not on view, but the playgoer will know that h has seen human entrails."

10. "[This] is no simple catalogue of hard-luck adventures in a world where might is white. Before it is over, [the novelist's] hero can face up to one of life's bitterest questions, 'How does it feel to be free of illusion?' and give an honest answer: 'Painful and empty.'"

11. "[This work] pretty much deserves its exclamation point. A folk musical laid in the Indian territory just after the turn of the century, it is thoroughly refreshing without being oppressively rustic."

12. "Back in 1948, when everybody was trying to blow like Diz, [this artist's] nine-man

MARTHA GRAHAM

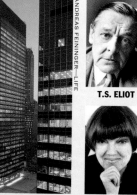

T.S. ELIOT

MARY QUANT

SEAGRAM BUILDING

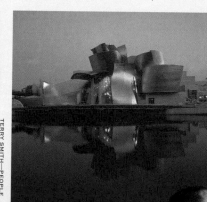

GUGGENHEIM MUSEUM BILBAO

THE GREAT GATSBY

F. SCOTT FITZGERALD

LOUIS ARMSTRONG

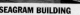

CITIZEN KANE

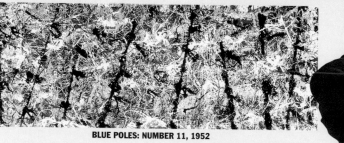

BLUE POLES: NUMBER 11, 1952

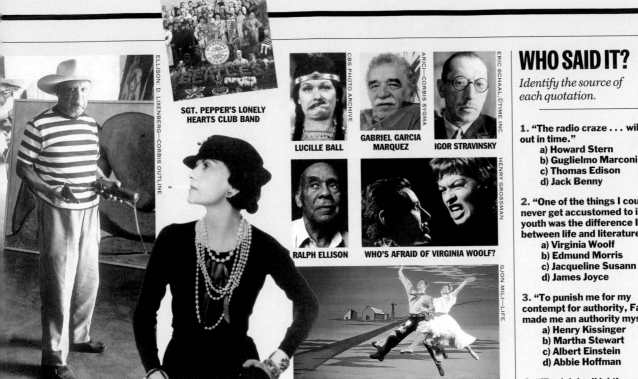

SGT. PEPPER'S LONELY
HEARTS CLUB BAND

LUCILLE BALL

GABRIEL GARCIA
MARQUEZ

IGOR STRAVINSKY

RALPH ELLISON

WHO'S AFRAID OF VIRGINIA WOOLF?

PABLO PICASSO

COCO CHANEL

OKLAHOMA!

ELLISON: D. LIXENBERG—CORBIS OUTLINE

CBS PHOTO ARCHIVE

ARICI—CORBIS SYGMA

ERIC SCHAAL ©TIME INC.

HENRY GROSSMAN

GJON MILI-LIFE

ELLIOT ERWITT—MAGNUM

WHO SAID IT?

*Identify the source of
each quotation.*

1. "The radio craze . . . will die
out in time."
 a) Howard Stern
 b) Guglielmo Marconi
 c) Thomas Edison
 d) Jack Benny

2. "One of the things I could
never get accustomed to in my
youth was the difference I found
between life and literature."
 a) Virginia Woolf
 b) Edmund Morris
 c) Jacqueline Susann
 d) James Joyce

3. "To punish me for my
contempt for authority, Fate
made me an authority myself."
 a) Henry Kissinger
 b) Martha Stewart
 c) Albert Einstein
 d) Abbie Hoffman

4. "[Rock 'n' roll is] the most
brutal, ugly, degenerate, vicious
form of expression it has been
my displeasure to hear."
 a) Frank Sinatra
 b) Ayatullah Khomeini
 c) Margaret Thatcher
 d) Billy Graham

5. "I can feel the sufferings of
millions; and yet, if I look up into
the heavens, I think that it will
all come right, that this cruelty
will end, and that peace and
tranquillity will return again."
 a) Salman Rushdie
 b) Robert Frost
 c) Helen Keller
 d) Anne Frank

6. "I don't have to be what you
want me to be; I'm free to be
what I want."
 a) Harvey Milk
 b) Muhammad Ali
 c) Georgia O'Keeffe
 d) Martha Graham

7. "Research your own
experiences for the truth.
Absorb what is useful . . . Add
what is specifically your own."
 a) Mohandas Gandhi
 b) Albert Einstein
 c) Henry Ford
 d) Bruce Lee

8. "There's not a white man in
this country who can say he never
benefited from being white."
 a) Bayard Rustin
 b) Thurgood Marshall
 c) Bobby Seale
 d) Maya Angelou

9. "An eye for an eye will make
the whole world go blind."
 a) Desmond Tutu
 b) Dorothy Day
 c) Mother Teresa
 d) Mohandas Gandhi

pickup band was trimming
Gillespie's blast-furnace sound to
a clean, low Bunsen flame."

13. "It has found important new
techniques in picture-making and
story-telling . . . It is not afraid to
say the same thing twice if twice-
telling reveals a fourfold truth . . .
It is a work of art created by grown
people for grown people."

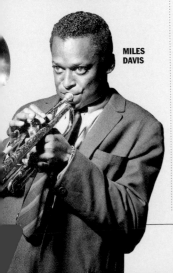

WAITING FOR GODOT

MILES
DAVIS

14. "With its lost . . . straw-
clutching outcasts, its bullying
and later blinded magnate, its
endless rain of symbolic and
allegorical smallshot, its scarred
and almost sceneryless universe,
[this work] can be most variously
interpreted—somewhat after the
fashion of the blind men and the
elephant."

15. "[The building] has hit [the
city] with the force of an
architectural meteorite. No
question that it's there . . . You
turn a corner, and—*pow!*—an
apparition appears in glass and
half-shiny silver . . . massively
undulating, something that
seems . . . to have been dropped
from another cultural world."

16. "Whether or not [he] had
written down the Armageddon of
the West, he had showed up the
lightweight poetry dominating
American magazines . . . [His]
poem went off like a bomb in a
genteel drawing-room, as he
intended it to."

17. "He had perfect pitch and
perfect rhythm. His improvised
melodies and singing could be as
lofty as a moon flight or as low-
down as the blood drops of a
street thug dying in the gutter."

18. "She not only appropriated
styles, fabrics and articles of
clothing that were worn by men
but also, beginning with how she
dressed herself, appropriated
sports clothes as part of the
language of fashion. One can see
how her style evolved out of
necessity and defiance."

19. "Nothing could deflect her
from what she believed to be her
sacred mission: to 'chart the
graph of the heart' through
movement. 'That driving force of
God that plunges through me is
what I live for,' she wrote, and
believed every word of it."

20. "[He] experimented with
virtually every technique of 20th
century music: tonal, polytonal
and 12-tone serialism. He
reinvented and personalized each
form while adapting the melodic
styles of earlier eras to the new
times. In the end, his own musical
voice always prevailed."

21. "She was far more than a
clown. Her mobile face could
register a whole dictionary of
emotions; her comic timing was
unmatched; her devotion to the
truth of her character never
flagged. She was a tireless
perfectionist."

NAMES & NUMBERS

Match each description with the appropriate name, number or term. Not all answers will be used.

1. The world's first synthetic plastic

2. Number of people killed in the worldwide influenza epidemic of 1918

3. Computer used by the Allies to break German codes

4. Dollar price of a Ford Model A in 1927

5. Long-hidden cave discovered in 1940, whose walls are covered with Ice Age art

6. The first fully electronic computer

7. End result of a scientific research project in Scotland in the 1990s

8. Percent increase of Third World greenhouse emissions in the past decade

9. Where Mary Leakey found the skull of a human ancestor who lived 1.8 million years ago

10. Number of people who have died of AIDS worldwide

11. Celestial phenomenon discovered by Allan Sandage and Thomas Matthews in 1961

12. Number of languages spoken in the 227 countries of the world

13. Comet that crashed into the planet Jupiter in 1994

14. Number of dollars that U.S. credit-card holders owe today

15. Device first demonstrated at Bell Telephone Laboratories in 1947

16. Number of servings of Coca-Cola sold per day

17. Raft used by Thor Heyerdahl to support his theory that pre-Incan peoples reached South Pacific islands by sea

18. Percentage of U.S. homes that had a bathtub in 1900

19. Percentage of U.S. homes that were connected to the Internet in 1998

20. Number of U.S. residences wired for electricity in 1925

21. 1928 discovery that revolutionized 20th century medicine

Dolly
Shoemaker-Levy 9
25 million
transistor
1 billion
Colossus
20
ENIAC
quasar
71
Olduvai Gorge
16 million
6701
Valium
penicillin
500 billion
Bakelite
RU-486
Lascaux
41.22
cyclotron
14
Deep Blue
10.5 million
550
Kon-Tiki
amniocentesis

★ MORE ★
WHO SAID IT?

10. "We are driven to this. We are determined to go on with this agitation. It is our duty to make this world a better place for women."
- a) Jane Fonda
- b) Betty Friedan
- c) Emmeline Pankhurst
- d) Estée Lauder

11. "640K [of memory] ought to be enough for anybody."
- a) Bill Gates
- b) Steve Jobs
- c) Thomas Watson
- d) HAL

12. "Man is a part of nature, and his war against nature is inevitably a war against himself."
- a) Gloria Steinem
- b) Sigmund Freud
- c) Al Gore
- d) Rachel Carson

13. "You can kill 10 of my men for every one I kill of yours, yet even at those odds, you will lose and I will win."
- a) Saddam Hussein
- b) Slobodan Milosevic
- c) Ho Chi Minh
- d) Haile Selassie

14. "Take a method and try it. If it fails, admit it frankly and try another. But above all, try something."
- a) Margaret Sanger
- b) Franklin D. Roosevelt
- c) Madonna
- d) Martin Luther King Jr.

15. "I saw the best minds of my generation destroyed by madness."
- a) Norman Vincent Peale
- b) Carl Jung
- c) Gertrude Stein
- d) Allen Ginsberg

16. "This war . . . is one of those elemental conflicts which usher in a new millennium and which shake the world."
- a) V.I. Lenin
- b) Woodrow Wilson
- c) Lyndon Johnson
- d) Adolf Hitler

17. "It was the nation . . . that had the lion's heart. I had the luck to be called upon to give the roar."
- a) Winston Churchill
- b) Ayatullah Khomeini
- c) Juan Perón
- d) Kemal Ataturk

18. "In the long history of the world, only a few generations have been granted the role of defending freedom in its hour of maximum danger. I do not shrink from this responsibility—I welcome it."
- a) Fidel Castro
- b) John F. Kennedy
- c) Theodore Roosevelt
- d) Mikhail Gorbachev

★ MORE ★
WHO SAID IT?

19. "We must canonize our own saints, create our own martyrs . . . Black men and women who have made their distinct contributions to our racial history."
a) Marcus Garvey
b) W.E.B. Du Bois
c) Jesse Jackson
d) Martin Luther King Jr.

20. "If I'm going to be a symbol of something, I'd rather have it sex than some other things we've got symbols of."
a) Marlon Brando
b) Monica Lewinsky
c) Annette Funicello
d) Marilyn Monroe

21. "A revolution is not a dinner party . . . or doing embroidery; it cannot be so refined, so leisurely."
a) Mao Zedong
b) Malcolm X
c) Che Guevara
d) Imelda Marcos

22. "It's true hard work never killed anybody, but I figure, why take the chance?"
a) Mae West
b) Groucho Marx
c) Queen Elizabeth II
d) Ronald Reagan

23. "Make money, be proud of it; make more money, be prouder of it."
a) John D. Rockefeller
b) Henry R. Luce
c) Michael Jordan
d) Oprah Winfrey

24. "I will not sell miracle cures . . . I did not see Elvis . . . The truth is not out there."
a) Janet Reno
b) Ross Perot
c) Bart Simpson
d) Jim Bakker

25. "I fall, I stand still . . . I trudge on, I gain a little . . . I get more eager and climb higher and begin to see the widening horizon. Every struggle is a victory."
a) Helen Keller
b) Sir Edmund Hillary
c) Charles Lindbergh
d) Anne Frank

26. "Always be capable of feeling . . . any injustice committed against anyone anywhere in the world."
a) Bill Clinton
b) Che Guevara
c) Jesse Jackson
d) Diana, Princess of Wales

27. "Soul is a constant. It's cultural. It's always going to be there, in different flavors and degrees."
a) Billy Graham
b) Aretha Franklin
c) Martin Luther King Jr.
d) Oprah Winfrey

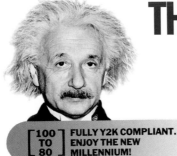

THE ANSWERS
★ ★ ★ ★ ★
*Check your mastery
of this century
and see if you're ready
for the next.*

[100 TO 80] **FULLY Y2K COMPLIANT. ENJOY THE NEW MILLENNIUM!** [79 TO 60] **ALMOST THERE. SOME DEBUGGING NEEDED** [59 TO 0] **SYSTEM ERROR. REBOOT BEFORE GOING TO NEXT CENTURY**

#991231130330

FACES IN TIME
1. Corazon Aquino—1986
2. Ayatullah Khomeini—1979
3. Haile Selassie—1935
4. Owen D. Young—1929
5. Mikhail Gorbachev—1989
6. Queen Elizabeth II—1952
7. Winston Churchill—1940
8. Martin Luther King Jr.—1963
9. Harry S Truman—1945
10. Charles de Gaulle—1958
11. Mohandas Gandhi—1930
12. Joseph Stalin—1942
13. Richard Nixon—1971
14. Andrew Grove—1997
15. Pope John Paul II—1994
16. Wallis Simpson—1936

TOTAL =

LEADERS & LOCATIONS
1. Lech Walesa/Poland
2. Indira Gandhi/India
3. Ho Chi Minh/Vietnam
4. Nelson Mandela/South Africa
5. Margaret Thatcher/Britain
6. V. I. Lenin/Russia
7. David Ben-Gurion/Israel
8. Benazir Bhutto/Pakistan
9. Kemal Ataturk/Turkey
10. Fidel Castro/Cuba
11. Sirimavo Bandaranaike/Sri Lanka
12. Madame Chiang Kai-shek/China
13. Pol Pot/Cambodia
14. Adolf Hitler/Germany
15. Theodore Roosevelt/U.S.

TOTAL =

NAMES & NUMBERS
1. Bakelite
2. 25 million
3. Colossus
4. 550
5. Lascaux
6. ENIAC
7. Dolly
8. 71
9. Olduvai Gorge
10. 16 million
11. quasar
12. 6701
13. Shoemaker-Levy 9
14. 500 billion
15. transistor
16. 1 billion
17. *Kon-Tiki*
18. 14
19. 20
20. 10.5 million
21. penicillin

TOTAL =

THE CENTURY IN ARTS
1. Pablo Picasso
2. *Sgt. Pepper's Lonely Hearts Club Band*
3. *Snow White and the Seven Dwarfs*
4. Mies van der Rohe's *Seagram Building*
5. Jackson Pollock
6. García Márquez's *One Hundred Years of Solitude*
7. Mary Quant
8. Fitzgerald's *The Great Gatsby*
9. Edward Albee's *Who's Afraid of Virginia Woolf?*
10. Ellison's *Invisible Man*
11. Rodgers and Hammerstein's *Oklahoma!*
12. Miles Davis
13. Orson Welles' *Citizen Kane*
14. Samuel Beckett's *Waiting for Godot*

15. Guggenheim Museum Bilbao
16. Eliot's *The Waste Land*
17. Louis Armstrong
18. Coco Chanel
19. Martha Graham
20. Igor Stravinsky
21. Lucille Ball

TOTAL =

WHO SAID IT?
1. (c) Thomas Edison
2. (d) James Joyce
3. (c) Albert Einstein
4. (a) Frank Sinatra
5. (d) Anne Frank
6. (b) Muhammad Ali
7. (d) Bruce Lee
8. (b) Thurgood Marshall
9. (d) Mohandas Gandhi
10. (c) Emmeline Pankhurst
11. (a) Bill Gates
12. (d) Rachel Carson
13. (c) Ho Chi Minh
14. (b) Franklin D. Roosevelt
15. (d) Allen Ginsberg
16. (d) Adolf Hitler
17. (a) Winston Churchill
18. (b) John F. Kennedy
19. (a) Marcus Garvey
20. (d) Marilyn Monroe
21. (a) Mao Zedong
22. (d) Ronald Reagan
23. (b) Henry R. Luce
24. (c) Bart Simpson
25. (a) Helen Keller
26. (b) Che Guevara
27. (b) Aretha Franklin

TOTAL =

★ *TALLY YOUR SCORE* ★

FACES IN TIME	=
LEADERS & LOCATIONS	=
NAMES & NUMBERS	=
THE CENTURY IN ARTS	=
WHO SAID IT?	=
TOTAL	=

By Bennett Singer and Dan Zinkus of the TIME Education Program

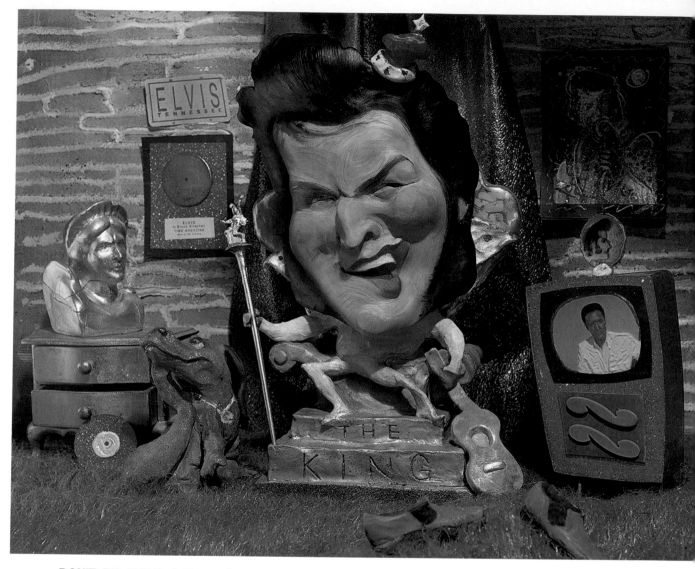

DON'T BE CRUEL O.K., so Elvis isn't TIME's Person of the Century. He didn't even make the TIME 100. Suspicious minds might think we've got a beef with the King. But more than 620,000 readers still love him tender— giving him the Hound Dog's share of the vote in our online poll. If he *is* still alive, there's always next century

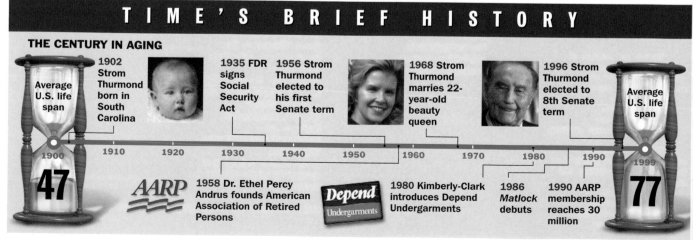

TIME'S BRIEF HISTORY

THE CENTURY IN AGING

Average U.S. life span

47

1902 Strom Thurmond born in South Carolina

1935 FDR signs Social Security Act

1956 Strom Thurmond elected to his first Senate term

1968 Strom Thurmond marries 22-year-old beauty queen

1996 Strom Thurmond elected to 8th Senate term

Average U.S. life span

77

1900 1910 1920 1930 1940 1950 1960 1970 1980 1990 1999

AARP

1958 Dr. Ethel Percy Andrus founds American Association of Retired Persons

Depend Undergarments

1980 Kimberly-Clark introduces Depend Undergarments

1986 *Matlock* debuts

1990 AARP membership reaches 30 million

FOLLOW THE LEADER

"Our country has deliberately undertaken a great social and economic experiment, noble in motive and far reaching in purpose."
HERBERT HOOVER,
on the 18th Amendment, instituting Prohibition; 1928

"Whether you like it or not, history is on our side. We will bury you."
NIKITA KHRUSHCHEV,
Soviet leader; Nov. 18, 1956

"No woman in my time will be Prime Minister . . ."
MARGARET THATCHER,
future PM; Oct. 26, 1969

"I *am* the Haitian people!"
FRANÇOIS ("PAPA DOC") DUVALIER,
circa 1971

"There is no reason for any individual to have a computer in their home."
KEN OLSON,
president, Digital Equipment Corp.; 1977

"Read my lips: NO NEW TAXES."
GEORGE BUSH,
at the G.O.P. Convention; Aug. 18, 1988

"I did not have sexual relations with that woman, Ms. Lewinsky."
BILL CLINTON,
President and bad husband; Jan. 26, 1998

Note: Boris Belitsky, one of Khrushchev's interpreters, said, "We will bury you" should have been translated as "We will stand over your grave" or "We will be present at your funeral," but the above is the familiar version.
Sources: Oxford Dict. 20th Cent. Quotations; Bartlett's Familiar Quotations; Oxford; Simpson's Contemp. Quotations; Cerf and Navasky, The Experts Speak; Noonan, What I Saw at the Revolution; New York Times

Many Happy Returns

IN CASE YOU DIDN'T GET ONE, HERE ARE THE HOLiday greetings the presidential types are mailing their many best friends. Counterclockwise from bottom, you'll find Hatch's card (with a Christmas song sheet inside), George W.'s (with a biblical message) and family portraits galore (McCain, Bauer, Gore, Keyes, Forbes, Buchanan); Bradley claims he didn't send cards. The most tastefully sedate one—can you believe it?—features a wreath from The Donald. But only the Clintons have the White House on theirs. That's why this mail is about keeping those letters and dollars coming.

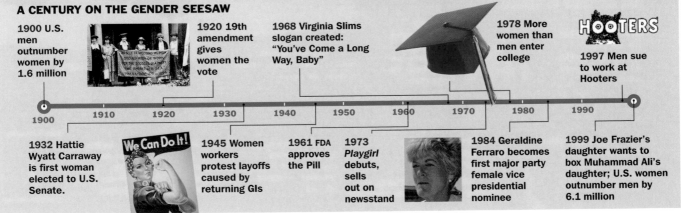

TIME'S BRIEF HISTORY

A CENTURY ON THE GENDER SEESAW

1900 U.S. men outnumber women by 1.6 million

1920 19th amendment gives women the vote

1968 Virginia Slims slogan created: "You've Come a Long Way, Baby"

1978 More women than men enter college

HOOTERS

1997 Men sue to work at Hooters

(timeline: 1900 1910 1920 1930 1940 1950 1960 1970 1980 1990)

1932 Hattie Wyatt Carraway is first woman elected to U.S. Senate.

We Can Do It!

1945 Women workers protest layoffs caused by returning GIs

1961 FDA approves the Pill

1973 *Playgirl* debuts, sells out on newsstand

1984 Geraldine Ferraro becomes first major party female vice presidential nominee

1999 Joe Frazier's daughter wants to box Muhammad Ali's daughter; U.S. women outnumber men by 6.1 million

Why the Stock Market Keeps Rising

I ALWAYS WANTED PORN-STAR FRIENDS. I FIGURED THEY'D know not only where all the good parties were but also where to buy fetching outfits for my female friends. But it turns out they know about something far more exciting than sex: money. Orgies are great and all, but they're a little early '99, a little *Eyes Wide Shut*, if you know what I mean. If I find a woman who can point me toward the next AOL, then I'm a man in search of a diamond ring.

Last week porn star Marylin Star was charged with soliciting insider trading secrets from her "friend" James McDermott, the now former chairman of Keefe, Bruyette & Woods, an investment bank. She made $88,000 investing in companies his firm was about to help merge, and tipped off a buddy, who scored $86,000. I had been missing out on this stock-market craze for too long, and I needed to do something about it. Since no venture capitalists seemed as if they were going to invest in my Jeff Foxworthy tribute site idea, I figured I needed a new plan.

So I called Jenna Jameson, a friend of Marylin Star's and an actress in such films as *Hell on Heels* and *Smells Like ... Sex*. She was driving through Scottsdale, Ariz., where she lives and owns a restaurant, Tequila, which she bought with proceeds from her shrewd sale of Disney stock. "Disney sucks this year," she said. "I think a lot of bad things went on with them. They split, and they never went up. They took over a bunch of companies, and it never worked out." I asked her what the next big thing was. "I have a lot of tips for you," she cooed in a voice that mixed little girl with Warren Buffett in a way I still can't

shake. "I'm really into the stock market. You're going to make a lot of money, dude." I thought I could make a lot of money by recording this and setting up a 900-PORN-IPO number.

"Last week I made $30,000," she said from her cell phone, pausing at a stoplight to sign an autograph for a fan. "I bought into Infospace.com and forgot about it. It ended up splitting. eBay is going to be huge, of course. I sell my underwear on eBay. One time I auctioned off a day on the set with me. I got $10,000." I'll put my money in any company that sells used underwear.

Jameson recently switched from Charles Schwab to Paine Webber, and says she is much happier. She touted two other high-tech stocks, CMGI and EDIG. Jameson was more bullish than Peter Lynch and, at least to me, much more convincing. "I just bought Parkervision today. It came out with a new computer chip."

Jameson also recommended plastics. I thought this was a clever reference to the advice Dustin Hoffman gets in *The Graduate* until I realized that women with fake 34Ds don't joke about plastics. "There is a new company coming out, Botex. It's actually a friend of mine." Oh yeah, baby. This was the insider stuff I was hoping for. "He makes this new kind of plastic they're going to be using on tennis shoes and tires that doesn't wear out. Once that comes out it will be really cool."

So what if I wasn't really hanging out with porn stars and I didn't have any money in the NASDAQ. It was a rush just to feel as if I was part of it. And I can't wait to tell my grandkids where their EDIG fortune came from. ∎

MATTHEW MARTIN FOR TIME

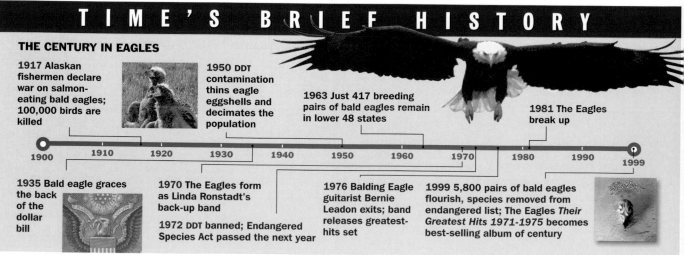

TIME'S BRIEF HISTORY

THE CENTURY IN EAGLES

1917 Alaskan fishermen declare war on salmon-eating bald eagles; 100,000 birds are killed

1950 DDT contamination thins eagle eggshells and decimates the population

1963 Just 417 breeding pairs of bald eagles remain in lower 48 states

1981 The Eagles break up

1900 1910 1920 1930 1940 1950 1960 1970 1980 1990 1999

1935 Bald eagle graces the back of the dollar bill

1970 The Eagles form as Linda Ronstadt's back-up band

1972 DDT banned; Endangered Species Act passed the next year

1976 Balding Eagle guitarist Bernie Leadon exits; band releases greatest-hits set

1999 5,800 pairs of bald eagles flourish, species removed from endangered list; The Eagles *Their Greatest Hits 1971-1975* becomes best-selling album of century

TOP, LEFT TO RIGHT: COLUMBUS DISPATCH—AP; JOHN LOVRETTA—THE HAWK EYE/AP

BATTLES

"You will be home before the leaves have fallen from the trees."

KAISER WILHELM
to the German troops, August 1914

"Stocks have reached what looks like a permanently high plateau."

IRVING FISHER,
Yale economist; Oct. 17, 1929

"This is the second time in our history that there has come back from Germany to Downing Street peace with honor. I believe it is peace for our time."

NEVILLE CHAMBERLAIN,
British Prime Minister; Sept. 30, 1938

"We're going to bomb them back into the Stone Age."

GENERAL CURTIS LEMAY
on the North Vietnamese; 1965

"That virus is a pussycat."

DR. PETER DUESBERG,
molecular-biology professor at U.C., Berkeley, on HIV; March 25, 1988

"Let me say directly to Fidel Castro: You're finished."

RONALD REAGAN,
former President; May 17, 1990

"The case is a loser."

JOHNNIE COCHRAN
on soon-to-be client O.J. Simpson's chances of acquittal, July 1994

Sources: Barbara Tuchman, *The Guns of August*; New York Times (2); LeMay, *Mission with LeMay*; Science; Orange Co. Register; Jeffrey Toobin, *Run of His Life*

Lest We Forget

IF YOU DID ANYTHING OF NOTE IN THE 20TH century, you've been celebrated this year. But we've found a few who managed to go unheralded. These are folks whose inventions are used every day but whose names, unfairly, are not. Herewith, the last unsung heroes of the 1900s:

Satori Kato **Instant coffee,** 1901
Mary Anderson. **Windshield wipers,** 1903
Hugh Moore. **Paper cup,** 1908
Jacques Brandenberger . . . **Cellophane,** 1908
Arthur Wynne. **Crossword puzzle,** 1913
Joseph Block. **Whistling kettle,** 1921
Andrew Olsen. **Pop-up tissue box,** 1921
George Squier. **Muzak,** 1922
Garrett A. Morgan **Traffic light,** 1923
Francis W. Davis **Power steering,** 1926
R. Stanton Avery **Self-adhesive label,** 1935
Edwin L. Peterson. **Answering machine,** 1945
Earl John Hilton. **Credit card,** 1950
Clinton Riggs **Yield sign,** 1950
Chavannes & Fielding. . . . **Bubble wrap,** 1957
Luther Simjian **ATM,** 1960
Herb Peterson **Egg McMuffin,** 1973

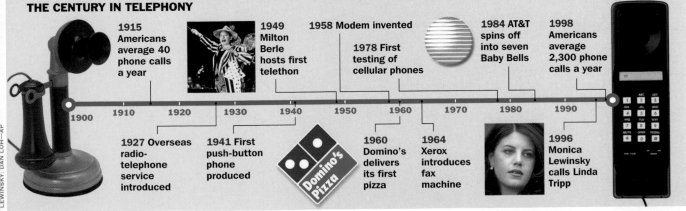

TIME'S BRIEF HISTORY

THE CENTURY IN TELEPHONY

1915 Americans average 40 phone calls a year

1949 Milton Berle hosts first telethon

1958 Modem invented

1978 First testing of cellular phones

1984 AT&T spins off into seven Baby Bells

1998 Americans average 2,300 phone calls a year

1900 1910 1920 1930 1940 1950 1960 1970 1980 1990

1927 Overseas radio-telephone service introduced

1941 First push-button phone produced

1960 Domino's delivers its first pizza

1964 Xerox introduces fax machine

1996 Monica Lewinsky calls Linda Tripp

LEWINSKY: DAN LOH—AP

What an amazing cast of characters! What a wealth of heroes and villains to choose from!

Some shook the world by arriving: Gandhi at the sea to make salt, Lenin at the Finland Station. Others by refusing to depart: Rosa Parks from her seat on the bus, that kid from the path of the tank near Tiananmen Square. There were magical folks who could make freedom radiate through the walls of a Birmingham jail, a South African prison or a Gdansk shipyard.

Others made machines that could fly and machines that could think, discovered a mold that conquered infections and a molecule that formed the basis of life. There were people who

who mat
and why
By Walter Isaacson

could inspire us with a phrase: fear itself, tears and sweat, ask not. Frighten us with a word: heil! Or revise the universe with an equation: $E=mc^2$.

So how can we go about choosing the Person of the Century, the one who, for better or worse, personified our times and will be recorded by history as having the most lasting significance?

Let's begin by noting what our century will be remembered for. Out of the fog of proximity, three great themes emerge:

Artwork for TIME by Edel Rodriguez

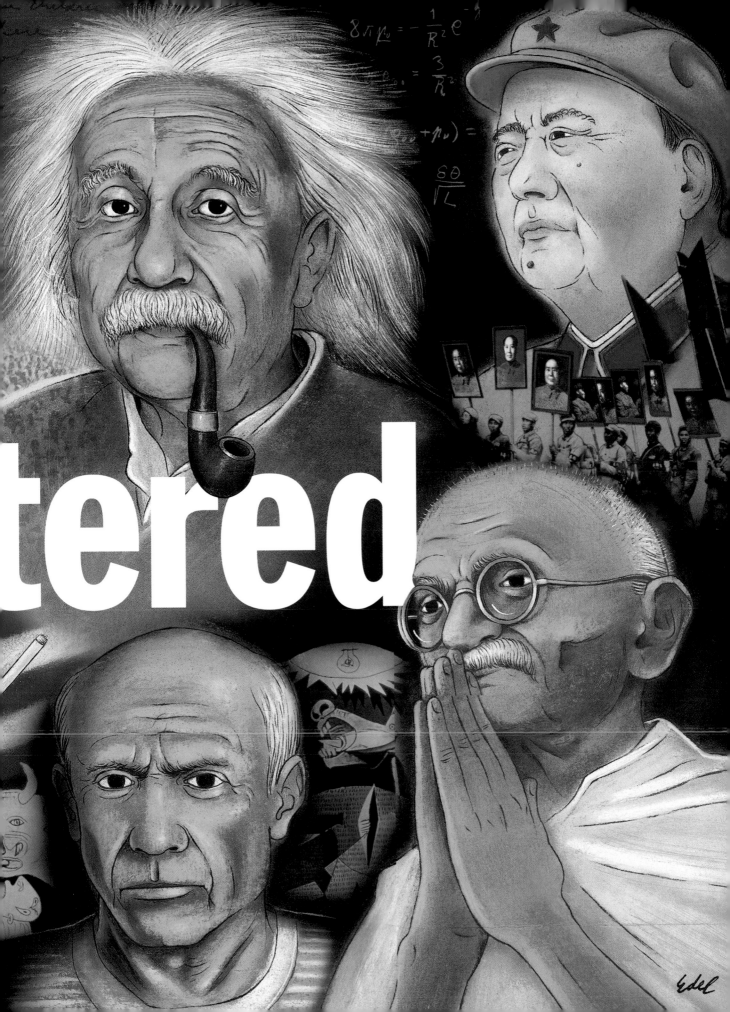

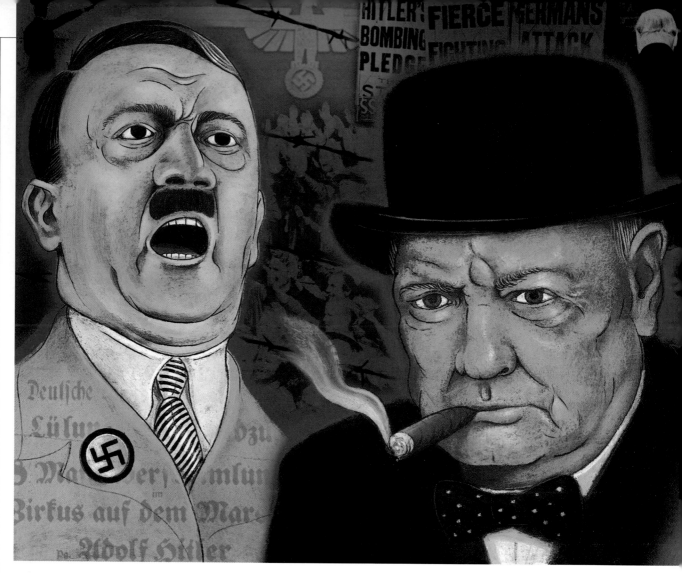

• The grand struggle between totalitarianism and democracy.

• The ability of courageous individuals to resist authority in order to secure their civil rights.

• The explosion of scientific and technical knowledge that unveiled the mysteries of the universe and helped secure the triumph of freedom by unleashing the power of free minds and free markets.

the century of democracy

Some people, looking at the first of these themes, sorrowfully insist that the choice has to be Hitler, Führer of the fascist genocides and refugee floods that plagued the century. He wrought the Holocaust that redefined evil and the war that reordered the world.

Competing with him for such devilish distinction is Lenin, who snatched from obscurity the 19th century ideology of communism and devised the modern tools of totalitarian brutality. He begat not only Stalin and Mao but in some ways also Hitler, who was enchanted by the Soviets' terror tactics. Doesn't the presence of such evil—and the continued eruption of totalitarian brutality from Uganda to Kosovo—make a mockery of the rationalists' faith that progress makes civilizations more civilized? Isn't Hitler, alas, the person who most influenced and symbolized this most genocidal of centuries?

No. He lost. So did Lenin and Stalin. Along with the others in their evil pantheon, and the totalitarian ideologies they repre-

sented, they are destined for the ash heap of history. If you had to describe the century's geopolitics in one sentence, it could be a short one: Freedom won. Free minds and free markets prevailed over fascism and communism.

So a more suitable choice would be someone who embodied the struggle for freedom: Franklin Roosevelt, the only person to be TIME's Man of the Year thrice (for 1932, 1934 and 1941). He helped save capitalism from its most serious challenge, the Great Depression. And then he rallied the power of free people and free enterprise to defeat fascism.

Other great leaders were part of this process. Winston Churchill stood up to Hitler even earlier than Roosevelt did, when it took far more courage. Harry Truman, a plainspoken man with gut instincts for what was right, forcefully began the struggle against Soviet expansionism, a challenge that Roosevelt was too sanguine about. Ronald Reagan and Mikhail Gorbachev helped choreograph the conclusion of that sorry empire's strut upon the stage. So too did Pope John Paul II, a Pole with a passion for both faith and freedom. And if you were to pick a hero who embodied America's contribution to winning the fight for freedom, it would probably be not Roosevelt, but instead the American G.I.

Nor is it proper to mythologize Roosevelt. The New Deal was at times a hodgepodge of conflicting economic ideas, marked more by enthusiasm than by coherence. It restored Americans' faith and hopes, saved them from fear itself, but never really managed to end the Depression. The war did that.

Nevertheless, Franklin Roosevelt stands out among the cen-

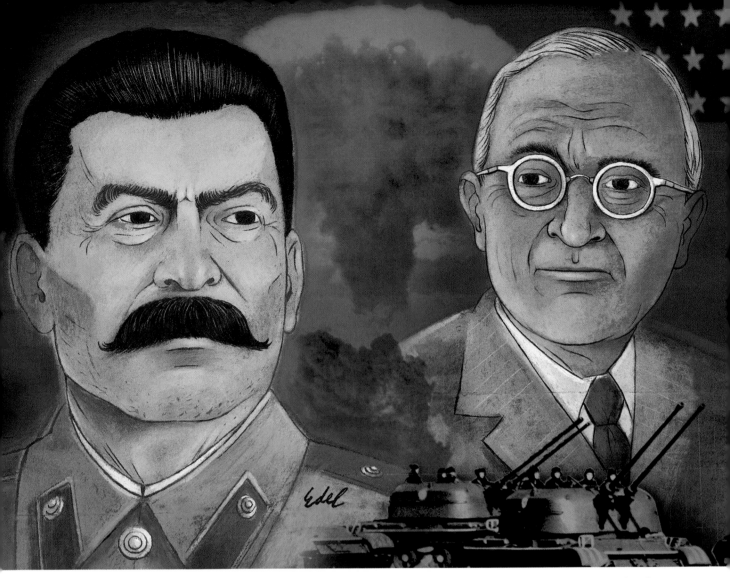

tury's political leaders. With his first-class temperament, wily manipulations and passion for experimentation, he's the jaunty face of democratic values. Thus we pick him as the foremost statesman and one of three finalists for Person of the Century. That may seem, to non-Americans, parochial. True, but this was, as our magazine's founder Henry Luce dubbed it in 1941, the American Century—politically, militarily, economically and ideologically.

When Roosevelt took office at the beginning of 1933 (the same week that Hitler assumed emergency powers in Germany), unemployment in the U.S. had, in three years, jumped from 4 million to 12 million, at least a quarter of the work force. Fathers of hungry kids were trying to sell apples on the street. F.D.R.'s bold experiments ("Above all, try something") included many that failed, but he brought hope to millions and some lasting contributions to the nation's foundation: Social Security, minimum wages, insured bank deposits and the right to join unions. Henceforth the national government (in the U.S. and most everywhere else) took on the duty of managing the economy and providing capitalism with a social safety net.

By New Year's Day of 1941, the Depression still lingered, and the threat from Hitler was growing. Roosevelt went to his second-floor White House study to draft the address that would launch his unprecedented third term. There was a long silence, uncomfortably long, as his speechwriters waited for him to speak. Then he leaned forward and began dictating.

"We look forward to a world founded upon four essential human freedoms," he said. He proceeded to list them: freedom of expression, freedom of worship, freedom from want, freedom from fear. One of the great themes of this century was the progress made toward each of them.

Roosevelt made another great contribution: he escorted onto the century's stage a remarkable woman, his wife Eleanor. She served as his counterpoint: uncompromisingly moral, earnest rather than devious, she became an icon of feminism and social justice in a nation just discovering the need to grant rights to women, blacks, ordinary workers and the poor. She discovered the depth of racial discrimination while touring New Deal programs (on a visit to Birmingham in 1938, she refused to sit in the white section of the auditorium), and subsequently peppered her husband with questions over dinner and memos at bedtime. Even after her husband's death, she remained one of the century's most powerful advocates for social fairness.

One political leader who rivals Roosevelt in embodying freedom's fight is Winston Churchill. Indeed, it's possible to imagine a President other than Roosevelt leading America through the war, but it's nearly impossible to imagine someone other than Churchill turning the world's darkest moments into Britain's finest hour.

He despised tyranny with such a passion that he, and by extension his nation, was willing to stand alone against Hitler when it was most critical. And unlike Roosevelt, he came early to the crusade against Soviet tyranny as well. His eloquent speeches strengthened the faith of all freedom-loving people in both the righteousness of their struggle and the inevitability of their cause.

So why is he not Person of the Century? He was, after all, TIME's Man of the Half-Century in 1950. Well, the passage of

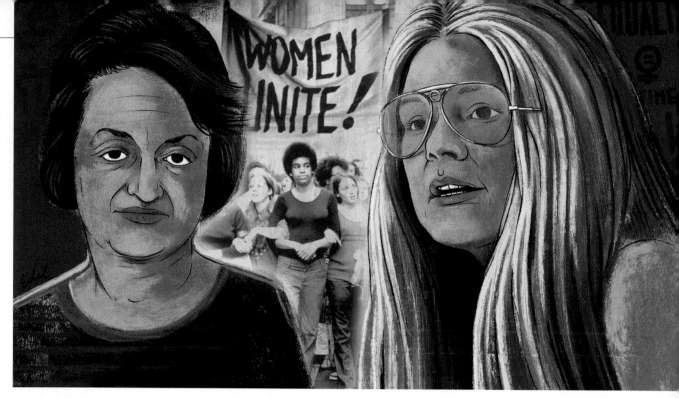

time can alter our perspective. A lot has happened since 1950. It has become clear that one of the great themes of the century has been the success of those who resisted authority in order to seek civil rights, decolonization and an end to repression. Along with this came the setting of the sun on the great colonial empires.

In his approach to domestic issues, individual rights and the liberties of colonial subjects, Churchill turned out to be a romantic refugee from a previous era who ended up on the wrong side of history. He did not become Prime Minister, he incorrectly proclaimed in 1942, "to preside over the liquidation of the British Empire," which then controlled a quarter of the globe's land. He bulldoggedly opposed the women's-rights movement, other civil-rights crusades and decolonization, and he called Mohandas Gandhi "nauseating" and a "half-naked fakir."

As it turned out, Churchill's tenacity was powerful enough to defy Hitler, but not as powerful as the resistance techniques of the half-naked fakir. Gandhi and others who fought for civil rights turned out to be part of a historic tide, one that Roosevelt and his wife Eleanor appreciated better than Churchill did.

Which brings us to …

the century of civil rights

n a century marked by brutality, Gandhi perfected a different method of bringing about change, one that would turn out (surprisingly) to have more lasting impact. The words he used to describe it do not translate readily into English: *Satyagraha* (holding firmly onto the deepest truth and soul-force) and *ahimsa* (the love that remains when all thoughts of violence are dispelled). They formed the basis for civil disobedience and nonviolent resistance. "Nonviolence is the greatest force at the disposal of mankind," he said. "It is mightier than the mightiest weapon of destruction devised by the ingenuity of man."

Part of his creed was that purifying society required purifying one's own soul. "The more you develop nonviolence in your own being, the more infectious it becomes." Or, more pithily: "We must become the change we seek."

He was, truth be told, rather weird at times. His own purification regime involved inordinate attention to the bowel movements of himself and those around him, and he liked testing his powers of self-denial by sleeping naked with young women. Nevertheless, he became not just a political force but a spiritual guide for those repelled by the hate and greed that polluted this century. "Generations to come," said Albert Einstein, "will scarce believe that such a one as this ever in flesh and blood walked upon this earth."

Gandhi's life of civil disobedience began while he was a young lawyer in South Africa when, because he was a dark-skinned Indian, he was told to move to a third-class seat on a train even though he held a first-class ticket. He refused, and ended up spending the night on a desolate platform. It culminated in 1930, when he was 61, and he and his followers marched 240 miles in 24 days to make their own salt from the sea in defiance of British colonial laws and taxes. By the time he reached the sea, several thousand had joined his march, and all along India's coast thousands more were doing the same. More than 60,000 were eventually arrested, including Gandhi, but it was clear who would end up the victors.

Gandhi did not see the full realization of his dreams; India finally gained independence, but a civil war between Hindus and Muslims resulted, despite his efforts, in the bloody birth of Pakistan. He was killed, on his way to prayers, by a Hindu fanatic.

His spirit and philosophy, however, transformed the century. His most notable heir was Martin Luther King Jr. "If humanity is to progress," King once declared, "Gandhi is inescapable."

King, who began studying Gandhi in college, was initially skeptical about the Mahatma's faith in nonviolence. But by the time of the Montgomery bus boycott, he later wrote, "I had come to see early that the Christian doctrine of love operating through the Gandhian method of nonviolence was one of the most potent weapons available to the Negro in his struggle for freedom." The bus boycott, sit-ins, freedom rides and, above all, the Selma march with its bloody Sunday on the Edmund Pettus Bridge showed how right he, and Gandhi, was.

Civil rights took a variety of forms this century. Women got the right to vote, gained control over their reproductive life and made strides toward achieving equal status in the workplace. Gays and lesbians gained the right to be proud of who they are.

Indeed, one defining aspect of our century has been the degree to which it was shaped not just by powerful political

leaders but also by ordinary folks who civilly disobeyed: Nelson Mandela organizing a campaign in 1952 to defy South Africa's "pass laws" by entering white townships, Rosa Parks refusing to give up her seat on a Montgomery bus just as Gandhi had on the South African train, the unknown rebel blocking the line of tanks rumbling toward Tiananmen Square, Lech Walesa leading his fellow Polish workers out on strike, the British suffragist Emmeline Pankhurst launching hunger strikes, American students protesting the Vietnam War by burning their draft cards, and gays and lesbians at Greenwich Village's Stonewall Inn resisting a police raid. In the end, they changed the century as much as the men who commanded armies.

the century of science and technology

t is hard to compare the influence of statesmen with that of scientists. Nevertheless, we can note that there are certain eras that were most defined by their politics, others by their culture, and others by their scientific advances.

The 18th century, for example, was clearly one marked by statecraft: in 1776 alone there are Thomas Jefferson and Benjamin Franklin writing the Declaration of Independence, Adam Smith publishing *The Wealth of Nations* and George Washington leading the Revolutionary forces. The 17th century, on the other hand, despite such colorful leaders as Louis XIV and the château he left us, will be most remembered for its science: Galileo exploring gravity and the solar system, Descartes developing modern philosophy and Newton discovering the laws of motion and calculus. And the 16th will be remembered for the

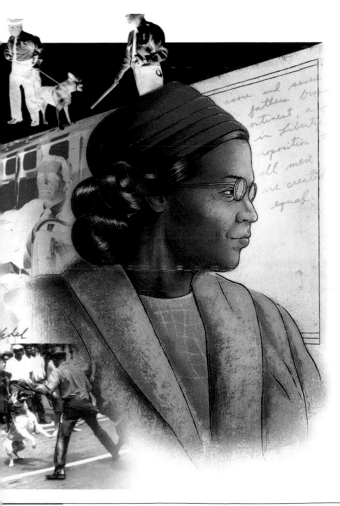

flourishing of the arts and culture: Michelangelo and Leonardo and Shakespeare creating masterpieces, Elizabeth I creating the Elizabethan Age.

So how will the 20th century be remembered? Yes, for democracy. And yes, for civil rights.

But the 20th century will be most remembered, like the 17th, for its earthshaking advances in science and technology. In his massive history of the 20th century, Paul Johnson declares: "The scientific genius impinges on humanity, for good or ill, far more than any statesman or warlord." Albert Einstein was more pithy: "Politics is for the moment. An equation is for eternity."

Just look at the year the century was born. The Paris Exposition in 1900 (50 million visitors, more than the entire population of France) featured wireless telegraphs, X rays and tape recorders. "It is a new century, and what we call electricity is its God," wrote the romantic historian Henry Adams from Paris.

In 1900 we began to unlock the mysteries of the atom: Max Planck launched quantum physics by discovering that atoms emit bursts of radiation in packets. Also the mysteries of the mind: Sigmund Freud published *The Interpretation of Dreams* that year. Marconi was preparing to send radio signals across the Atlantic, the Wright Brothers went to Kitty Hawk to work on their gliders, and an unpromising student named Albert Einstein finally graduated, after some difficulty, from college that year. So much for the boneheaded prediction made the year before by Charles Duell, director of the U.S. Patent Office: "Everything that can be invented has been invented."

So many fields of science made such great progress that each could produce its own contender for Person of the Century.

Let's start with medicine. In 1928 the young Scottish researcher Alexander Fleming sloppily left a lab dish growing bacteria on a bench when he went on vacation. It got contaminated with a *Penicillium* mold spore, and when he returned, he noticed that the mold seemed to stop the growth of the germs. His serendipitous discovery would eventually save more lives than were lost in all the century's wars combined.

Fleming serves well as a symbol of all the great medical researchers, such as Jonas Salk and David Ho, who fought disease. But he personally did little, after his initial *eureka!* moment, to develop penicillin. Nor has the fight against infectious diseases been so successful that it will stand as a defining achievement of the century.

The century's greater biological breakthrough was more basic. It was unceremoniously announced on Feb. 28, 1953, when Francis Crick winged into the Eagle Pub in Cambridge, England, and declared that he and his partner James Watson had "found the secret of life."

Watson had sketched out how four chemical bases paired to create a self-copying code at the core of the double-helix-shaped DNA molecule. In the more formal announcement of their discovery, a one-page paper in the journal *Nature*, they noted the significance in a famously understated sentence. "It has not escaped our notice that the specific pairing we have postulated immediately suggests a possible copying mechanism for the genetic material." But they were less restrained when persuading Watson's sister to type up the paper for them. "We told her," Watson wrote in *The Double Helix*, "that she was participating in perhaps the most famous event in biology since Darwin's book."

DNA is likely to be the discovery made in the 20th century that will be the most important to the 21st. The world is just a few years away from deciphering the entire sequence of more than 100,000 human genes encoded by the 3 billion chemical pairs of our DNA. That will open the way to new drugs, genetic engineering and designer babies.

So should Watson and Crick be Persons of the Century? Perhaps. But two factors count against them. Their role, unlike that of Einstein or Churchill, would have been performed by others if they hadn't been around; indeed, competitor Linus Pauling was

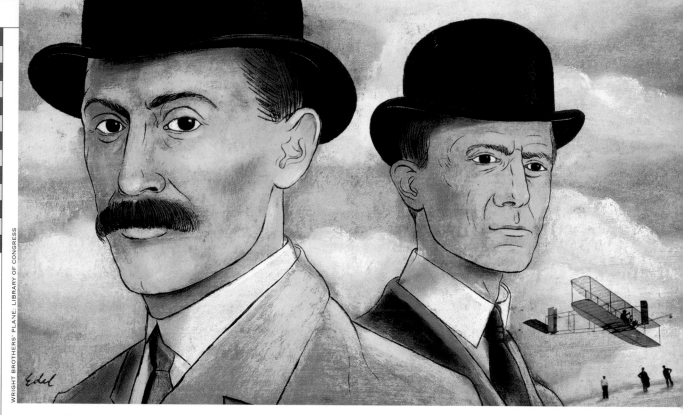

just months away from shouting the same *eureka!*. In addition, although the next century may be, this did not turn out to be a century of genetic engineering.

What about the technologists?

There's Henry Ford, who perfected ways to mass-produce the horseless carriages developed in Germany by Gottlieb Daimler and others. The car became the most influential consumer product of the century, bringing with it a host of effects good and bad: more personal freedom, residential sprawl, social mobility, highways and shopping malls, air pollution (though the end of the noxious pollution produced by horses) and mass markets for mass-produced goods.

Wilbur and Orville Wright also used the internal-combustion engine to free people from earthly bounds. Their 12-second flight in 1903 transformed both war and peace. As Bill Gates said in these pages, "Their invention effectively became the World Wide Web of that era, bringing people, languages, ideas and values together." The result was a new era of globalization.

Even more central to this globalization were the electronic technologies that revolutionized the distribution of information, ideas and entertainment. Five centuries ago, Gutenberg's advances in printing helped lead to the Reformation (by permitting people to own their own Bibles and religious tracts), the Renaissance (by permitting ideas to travel from village to village) and the rise of individual liberty (by allowing ordinary folks direct access to information). Likewise, the 20th century was transformed by a string of inventions that, building on the telegraph and telephone of the 19th century, led to a new information age.

In 1927 Philo Farnsworth was able to electronically deconstruct a moving image and transmit it to another room. "There you are," he said, "electronic television." (In the heated historical debate, both TIME and the U.S. Patent Office ended up giving him credit for the invention over his rival Vladimir Zworykin of RCA.)

In the 1930s Alan Turing first described the computer—a machine that could perform logical functions based on whatever instructions were fed to it—and then proceeded to help build one in the early 1940s that cracked the German wartime codes. His concepts were refined by other computer pioneers: John von Neumann, John Atanasoff, J. Presper Eckert and John Mauchly.

Meanwhile, another group of scientists—including Enrico Fermi and J. Robert Oppenheimer—was unlocking the power of the atom in a different way, one that led to the creation of a weapon that helped win the war and define the subsequent five decades of nervous peace that ensued.

In 1947 William Shockley and his team at Bell Labs invented the transistor, which had the ability to take an electric current and translate it into on-off binary data. Thus began the digital age. Robert Noyce and Jack Kilby, a decade later, came up with ways to etch many transistors—eventually millions—onto tiny silicon wafers that became known as microchips.

Many people—let's not pick on Al Gore here—deserve credit for creating the Internet, which began in 1969 as a network of university computers and began to take off in 1974 when Vint Cerf and Robert Kahn published a protocol that enabled any computer on the network to transmit to any other. A companion protocol devised by Tim Berners-Lee in 1990 created the World Wide Web, which simplified and popularized navigation on the Net. The idea that anyone in the world can publish information and have it instantly available to anyone else in the world created a revolution that will rank with Gutenberg's.

Together these triumphs of science and technology advanced the cause of freedom, in some ways more than any statesman or soldier did. In 1989 workers in Warsaw used faxes to spread the word of Solidarity, and schoolkids in Prague slipped into tourist hotels to watch CNN reports on the upheavals in Berlin. A decade later, dissidents in China set up e-mail chains, and Web-surfing students evaded clueless censors to break the government's monopoly on information. Just as the flow of ideas wrought by Gutenberg led to the rise of individual rights, so too did the unfetterable flow of ideas wrought by telephones, faxes, television and the Internet serve as the surest foe of totalitarianism in this century.

Fleming, Watson and Crick, the Wright Brothers, Farnsworth, Turing, Shockley, Fermi, Oppenheimer, Noyce—any of them could be, conceivably, a justifiable although somewhat narrow choice for Person of the Century. Fortunately, a narrow choice is not necessary

person of the century

n a century that will be remembered foremost for its science and technology—in particular for our ability to understand and then harness the forces of the atom and the universe—one person stands out as both the greatest mind and paramount icon of our age: the kindly, absentminded professor whose wild halo of hair, piercing eyes, engaging humanity and extraordinary brilliance made his face a symbol and his name a synonym for genius: Albert Einstein.

Slow in learning to talk as a child, expelled by one headmaster and proclaimed by another unlikely to amount to anything, Einstein has become the patron saint of distracted schoolkids. But even at age five, he later recalled, he was puzzling over a toy compass and the mysteries of nature's forces.

During his spare time as a young technical officer in a Swiss patent office in 1905, he produced three papers that changed science forever. The first, for which he was later to win the Nobel Prize, described how light could behave not only like a wave but also like a stream of particles, called quanta or photons. This wave-particle duality became the foundation of what is known as quantum physics. It also provided theoretical underpinnings for such 20th century advances as television, lasers and semiconductors.

The second paper confirmed the existence of molecules and atoms by statistically showing how their random collisions explained the jerky motion of tiny particles in water. Important as both these were, it was his third paper that truly upended the universe.

It was based, like much of Einstein's work, on a thought experiment: if you could travel at the speed of light, what would a light wave look like? If you were in a train that neared the speed of light, would you perceive time and space differently?

Einstein's conclusions became known as the special theory of relativity. No matter how fast one is moving toward or away from a source of light, the speed of that light beam will appear the same, a constant 186,000 miles per second. But space and time will appear relative. As a train accelerates to near the speed of light, time on the train will slow down from the perspective of a stationary observer, and the train will get shorter and heavier. O.K., it's not obvious, but that's why we're no Einstein and he was.

Einstein went on to show that energy and matter were merely different faces of the same thing, their relationship described by the most famous equation in all of physics: energy equals mass multiplied by the speed of light squared, $E=mc^2$. Although not exactly a recipe for an atomic bomb, it explained why one was possible. He also helped resolve smaller mysteries, such as why the sky is blue (it has to do with how the molecules of air diffuse sunlight).

His crowning glory, perhaps the most beautiful theory in all of science, was the general theory of relativity, published

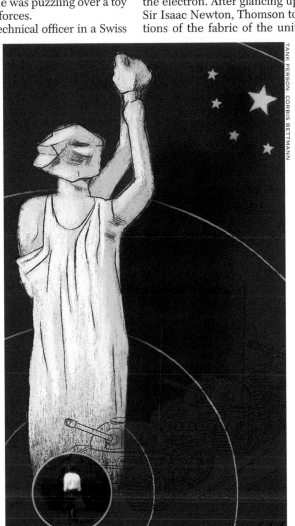

in 1916. Like the special theory, it was based on a thought experiment: imagine being in an enclosed lab accelerating through space. The effects you'd feel would be no different from the experience of gravity. Gravity, he figured, is a warping of space-time. Just as Einstein's earlier work paved the way to harnessing the smallest subatomic forces, the general theory opened up an understanding of the largest of all things, from the formative Big Bang of the universe to its mysterious black holes.

It took three years for astronomers to test this theory by measuring how the sun shifted light coming from a star. The results were announced at a meeting of the Royal Society in London presided over by J.J. Thomson, who in 1897 had discovered the electron. After glancing up at the society's grand portrait of Sir Isaac Newton, Thomson told the assemblage, "Our conceptions of the fabric of the universe must be fundamentally altered." The headline in the next day's *Times* of London read: "Revolution in Science ... Newtonian Ideas Overthrown." The New York *Times*, back when it knew how to write great headlines, was even more effusive two days later: "Lights All Askew in the Heavens/ Men of Science More or Less Agog Over Results of Eclipse Observations/ Einstein's Theory Triumphs."

Einstein, hitherto little known, became a global celebrity and was able to sell pictures of himself to journalists and send the money to a charity for war orphans. More than a hundred books were written about relativity within a year.

Einstein also continued his contributions to quantum physics by raising questions that are still playing a pivotal role in the modern development of the theory. Shortly after devising general relativity, he showed that photons have momentum, and he came up with a quantum theory of radiation explaining that all subatomic particles, including electrons, exhibit characteristics of both wave and particle.

This opened the way, alas, to the quantum theories of Werner Heisenberg and others who showed how the wave-particle duality implies a randomness or uncertainty in nature and that particles are affected simply by observing them. This made Einstein uncomfortable. As he famously and frequently insisted, "God does not play dice." (Retorted his friendly rival Niels Bohr: "Einstein, stop telling God what to do.") He spent his later years in a failed quest for a unified theory that would explain what appeared to be random or uncertain.

Does Einstein's discomfort with quantum theory make him less a candidate for Person of the Century? Not by much. His own work contributed greatly to quantum theory and to the semiconductor revolution it spawned. And his belief in the existence of a unified field theory could well be proved right in the new century.

More important, he serves as a symbol of all the scientists—such as Heisenberg, Bohr, Richard Feynman and Stephen Hawking, even the ones he disagreed with—who built upon his work to decipher and harness the forces of the cosmos. As James Gleick wrote earlier this year in the TIME 100 series, "The scientific touchstones of our age—the Bomb, space travel, electronics—all bear his fingerprints." Or, to quote a TIME cover story from 1946 (produced by Whittaker Chambers): "Among 20th-Century men, he blends to an extraordinary degree those highly distilled powers of intellect, intuition and imagination which are rarely combined in one mind, but which, when they do occur together, men call genius. It was all but inevitable that this genius should appear in the field of science, for 20th-Century civilization is first & foremost technological."

Einstein's theory of relativity not only upended physics, it also jangled the underpinnings of society. For nearly three centuries, the clockwork universe of Galileo and Newton—which was based on absolute laws and certainties—formed the psychological foundation for the Enlightenment, with its belief in causes and effects, order, rationalism, even duty.

Now came a view of the universe in which space and time were all relative. Indirectly, relativity paved the way for a new relativism in morality, arts and politics. There was less faith in absolutes, not only of time and space but also of truth and morality. "It formed a knife," historian Paul Johnson says of relativity theory, "to help cut society adrift from its traditional moorings." Just as Darwinism became, a century ago, not just a biological theory but also a social theology, so too did relativity shape the social theology of the 20th century.

The effect on arts can be seen by looking at 1922, the year that Einstein won the Nobel Prize, James Joyce published *Ulysses* and T.S. Eliot published *The Waste Land*. There was a famous party in May for the debut of the ballet *Renard*, composed by Stravinsky and staged by Diaghilev. They were both there, along with Picasso (who had designed the sets), Proust (who had been proclaimed Einstein's literary interpreter) and Joyce. The art of each, in its own way, reflected the breakdown of mechanical order and of the sense that space and time were absolutes.

In early 1933, as Hitler was taking power, Einstein immigrated to the U.S., settling in Princeton as the world's first scientific supercelebrity. That year he help found a group to resettle refugees, the International Rescue Committee. Thus he became a symbol of another of the great themes of the century: how history was shaped by tides of immigrants, so many of them destined for greatness, who fled oppressive regimes for the freedom of democratic climes.

As a humanist and internationalist, Einstein had spent most of his life espousing a gentle pacifism, and he became one of Gandhi's foremost admirers. But in 1939 he signed one of the century's most important letters, one that symbolizes the relationship between science and politics. "It may become possible to set up nuclear chain reactions," he wrote President Roosevelt.

"This new phenomenon would also lead to the construction of bombs." When Roosevelt read the letter, he crisply ordered, "This requires action."

roosevelt, Gandhi, Einstein. Three inspiring characters each representing a different force of history in the past century. They were about as different as any three men are likely to be. Yet each in his own way, both intentionally and not, taught us the century's most important lesson: the value of being both humble and humane.

Roosevelt, scarcely an exemplar of humility, nonetheless saved the possibility of governmental humility from the forces of utopian and dystopian arrogance. Totalitarian systems—whether fascist or communist—believe that those in charge know what's best for everyone else. But leaders who nurture democracy and freedom—who allow folks to make their own choices rather than dictating them from on high—are being laudably humble, an attitude that the 20th century clearly rewarded and one that is necessary for creating humane societies.

Gandhi, unlike Roosevelt, was the earthly embodiment of humility, so much so that at times it threatened to become a conceit. He taught us that we should value the civil liberties and individual rights of other human beings, and he lived for (and was killed for) preaching tolerance and pluralism. By exhibiting these virtues, which the century has amply taught us are essential to civilization, we express the humility and humanity that come from respecting people who are different from us.

Einstein taught the greatest humility of all: that we are but a speck in an unfathomably large universe. The more we gain insight into its mysterious forces, cosmic and atomic, the more reason we have to be humble. And the more we harness the huge power of these forces, the more such humility becomes an imperative. "A spirit is manifest in the laws of the universe," he once wrote, "in the face of which we, with our modest powers, must feel humble."

Einstein often invoked God, although his was a rather depersonalized deity. He believed, he said, in a "God who reveals himself in the harmony of all that exists." His faith in this divine harmony was what caused him to reject the view that the universe is subject to randomness and uncertainty. "The Lord God is subtle, but malicious he is not." Searching for God's design, he said, was "the source of all true art and science." Although this quest may be a cause for humility, it is also what gives meaning and dignity to our lives.

As the century's greatest thinker, as an immigrant who fled from oppression to freedom, as a political idealist, he best embodies what historians will regard as significant about the 20th century. And as a philosopher with faith both in science and in the beauty of God's handiwork, he personifies the legacy that has been bequeathed to the next century.

In a hundred years, as we turn to another new century—nay, ten times a hundred years, when we turn to another new millennium—the name that will prove most enduring from our own amazing era will be that of Albert Einstein: genius, political refugee, humanitarian, locksmith of the mysteries of the atom and the universe. ∎

On the topic of global warming,

we offer something rare.

A clear view.

The world's most interesting magazine.

albert ei

(1879-1955)

He was the pre-eminent scientist in a century dominated by science. The touchstones of the era—the Bomb, the Big Bang, quantum physics and electronics—all bear his imprint

By Frederic Golden

PERSON
OF THE
CENTURY

h e was the embodiment of pure intellect, the bumbling professor with the German accent, a comic cliché in a thousand films. Instantly recognizable, like Charlie Chaplin's Little Tramp, Albert Einstein's shaggy-haired visage was as familiar to ordinary people as to the matrons who fluttered about him in salons from Berlin to Hollywood. Yet he was unfathomably profound—the genius among geniuses who discovered, merely by thinking about it, that the universe was not as it seemed.

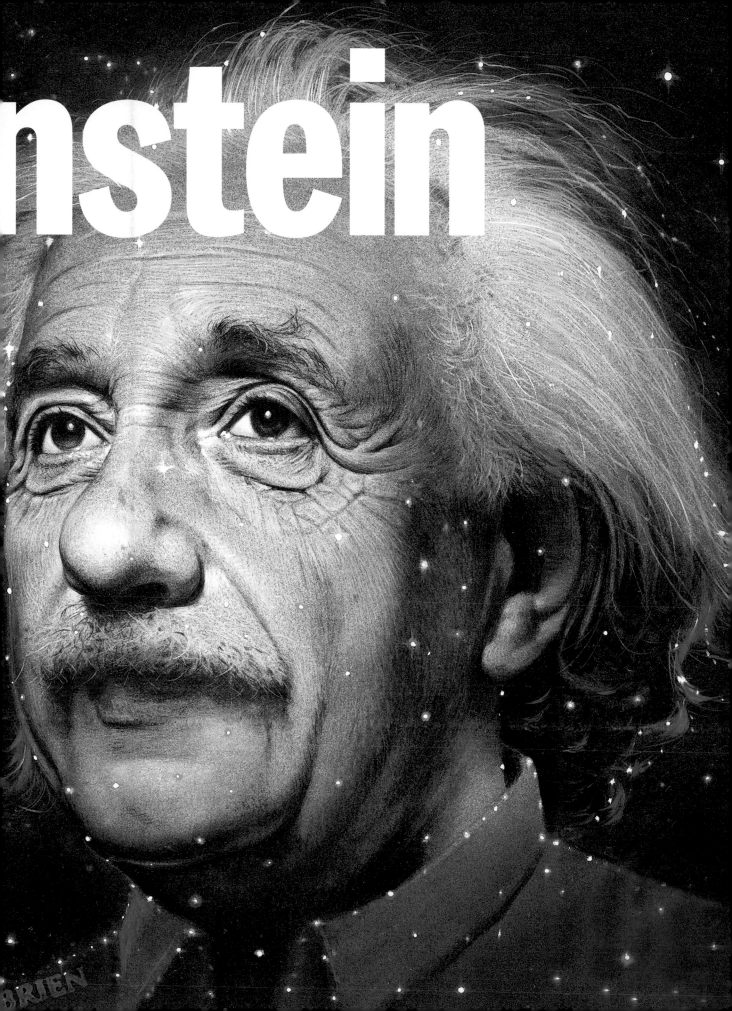

nstein

Even now scientists marvel at the daring of general relativity ("I still can't see how he thought of it," said the late Richard Feynman, no slouch himself). But the great physicist was also engagingly simple, trading ties and socks for mothy sweaters and sweatshirts. He tossed off pithy aphorisms ("Science is a wonderful thing if one does not have to earn one's living at it") and playful doggerel as easily as equations. Viewing the hoopla over him with humorous detachment, he variously referred to himself as the Jewish saint or artist's model. He was a cartoonist's dream come true.

Much to his surprise, his ideas, like Darwin's, reverberated beyond science, influencing modern culture from painting to poetry. At first even many scientists didn't really grasp relativity, prompting

tled private life contrasts sharply with his serene contemplation of the universe. He could be alternately warmhearted and cold; a doting father, yet aloof; an understanding, if difficult, mate, but also an egregious flirt. "Deeply and passionately [concerned] with the fate of every stranger," wrote his friend and biographer Philipp Frank, he "immediately withdrew into his shell" when relations became intimate.

Einstein himself resisted all efforts to explore his psyche, rejecting, for example, a Freudian analyst's offer to put him on the couch. But curiosity about him continues, as evidenced by the unrelenting tide of Einstein books (Amazon.com lists some 100 in print).

The pudgy first child of a bourgeois Jewish couple from southern Germany,

LOTTE JACOBI ARCHIVES

relativity's rebel : he combined rare genius with a deep m

Arthur Eddington's celebrated wisecrack (asked if it was true that only three people understood relativity, the witty British astrophysicist paused, then said, "I am trying to think who the third person is"). To the world at large, relativity seemed to pull the rug out from under perceived reality. And for many advanced thinkers of the 1920s, from Dadaists to Cubists to Freudians, that was a fitting credo, reflecting what science historian David Cassidy calls "the incomprehensiveness of the contemporary scene—the fall of monarchies, the upheaval of the social order, indeed, all the turbulence of the 20th century."

instein's galvanizing effect on the popular imagination continued throughout his life, and after it. Fearful his grave would become a magnet for curiosity seekers, Einstein's executors secretly scattered his ashes. But they were defeated at least in part by a pathologist who carried off his brain in hopes of learning the secrets of his genius. Only recently Canadian researchers, probing those pickled remains, found that he had an unusually large inferior parietal lobe—a center of mathematical thought and spatial imagery—and shorter connections between the frontal and temporal lobes. More definitive insights, though, are emerging from old Einstein letters and papers. These are finally coming to light after years of resistance by executors eager to shield the great relativist's image.

Unlike the avuncular caricature of his later years who left his hair unshorn, helped little girls with their math homework and was a soft touch for almost any worthy cause, Einstein is emerging from these documents as a man whose unset-

he was strongly influenced by his domineering, musically inclined mother, who encouraged his passion for the violin and such classical composers as Bach, Mozart and Schubert. In his preteens he had a brief, intense religious experience, going so far as to chide his assimilated family for eating pork. But this fervor burned itself out, replaced, after he began exploring introductory science texts and his "holy" little geometry book, by a lifelong suspicion of all authority.

His easygoing engineer father, an unsuccessful entrepreneur in the emerging electrochemical industry, had less influence, though it was he who gave Einstein the celebrated toy compass that inspired his first "thought experiment": what, the five-year-old wondered, made the needle always point north?

At age 15, Einstein staged his first great rebellion. Left behind in Munich when his family relocated to northern Italy after another of his father's business failures, he quit his prep school because of its militaristic bent, renounced his German citizenship and eventually entered the famed Zurich Polytechnic, Switzerland's M.I.T. There he fell in love with a classmate, a Serbian physics student named Mileva Maric. Afflicted with a limp and three years his senior, she was nonetheless a soul mate. He rhapsodized about physics and music with her, called her his Dolly and fathered her illegitimate child—a sickly girl who may have died in infancy or been given up for adoption. They married despite his mother's objections, but the union would not last.

A handsome, irrepressible romantic in those years, he once had to apologize to the husband of an old flame after Mileva discovered Einstein's renewed correspon-

HULTON-DEUTSCH COLLECTION/CORBIS

EINSTEIN OVER TIME As a young scholar top, and, continuing clockwise, bicycling in California; posing in grand old age; with wife Elsa and stepdaughter Margot

dence with her. He later complained that Mileva's pathological jealousy was typical of women of such "uncommon ugliness. Perhaps remorseful about the lost child and distanced by his absorption with hi work—his only real passion—and his growing fame, Mileva became increasingly un happy. On the eve of World War I, she reluctantly accompanied Einstein to Berlin the citadel of European physics, but found the atmosphere insufferable and soon returned to Zurich with their two sons.

By 1919, after three years of long distance wrangling, they divorced. H agreed to give her the money from th

se and a total indifference to convention

tutoring in mathematics and physics. Despite speculation about her possible unacknowledged contributions to special relativity, she herself never made such claims.

Einstein, meanwhile, had taken up with a divorced cousin, Elsa, who jovially cooked and cared for him during the emotionally draining months when he made the intellectual leaps that finally resulted in general relativity. Unlike Mileva, she gave him personal space, and not just for science. As he became more widely known, ladies swarmed around him like moonlets circling a planet. These dalliances irritated Elsa, who eventually became his wife, but as she told a friend, a genius of her husband's kind could never be irreproachable in every respect.

Cavalier as he may have been about his wives, he had a deep moral sense. At the

height of World War I, he risked the Kaiser's wrath by signing an antiwar petition, one of only four scientists in Germany to do so. Yet, paradoxically, he helped develop a gyrocompass for U-boats. During the troubled 1920s, when Jews were being singled out by Hitler's rising Nazi Party as the cause of Germany's defeat and economic woes, Einstein and his "Jewish physics" were a favorite target. Nazis, how-

ever, weren't his only foes. For Stalinists, relativity represented rampant capitalist individualism; for some churchmen, it meant ungodly atheism, even though Einstein, who had an impersonal Spinozan view of God, often spoke about trying to understand how the Lord (der Alte, or the Old Man) shaped the universe.

In response to Germany's growing anti-Semitism, he became a passionate Zionist, yet he also expressed concern about the rights of Arabs in any Jewish state. Forced to quit Germany when the Nazis came to power, Einstein accepted an appointment at the new Institute for Advanced Study in Princeton, N.J., a scholarly retreat largely created around him. (Asked what he thought he should be paid, Einstein, a financial innocent, suggested $3,000 a year. The hardheaded Elsa got that upped to $16,000.) Though occupied with his lonely struggle to unify gravity and electromagnetism in a single mathematical framework, he watched Germany's saber rattling with alarm. Despite his earlier pacifism, he spoke in favor of military action against Hitler. Without fanfare, he helped scores of Jewish refugees get into an unwelcoming U.S., including a young photographer named Philippe Halsman, who would take the most famous picture of him (reproduced on the cover of this issue).

Alerted by the émigré Hungarian scientist Leo Szilard to the possibility that the Germans might build an atom bomb, he wrote F.D.R. of the danger, even though he knew little about recent developments in nuclear physics. When Szilard told Einstein about chain reactions, he was astonished: "I never thought about that at all," he said. Later, when he learned of the destruction of Hiroshima and Nagasaki, he uttered a pained sigh.

Following World War II, Einstein became even more outspoken. Besides campaigning for a ban on nuclear weaponry, he denounced McCarthyism and pleaded for an end to bigotry and racism. Coming as they did at the height of the cold war, the haloed professor's pronouncements seemed well meaning if naive; LIFE magazine listed Einstein as one of this country's 50 prominent "dupes and fellow travelers." Says Cassidy: "He had a straight moral sense that others could not always see, even other moral people." Harvard physicist and historian Gerald Holton adds, "If Einstein's ideas are really naive, the world is really in pretty bad shape." Rather it seems to him that Einstein's humane and democratic instincts are "an ideal political model for the 21st century," embodying the very best of this century as well as our highest hopes for the next. What more could we ask of a man to personify the past 100 years? ■

Nobel Prize he felt sure he would win. Still, they continued to have contact, mostly having to do with their sons. The elder, Hans Albert, would become a distinguished professor of hydraulics at the University of California, Berkeley (and, like his father, a passionate sailor). The younger, Eduard, gifted in music and literature, would die in a Swiss psychiatric hospital. Mileva helped support herself by

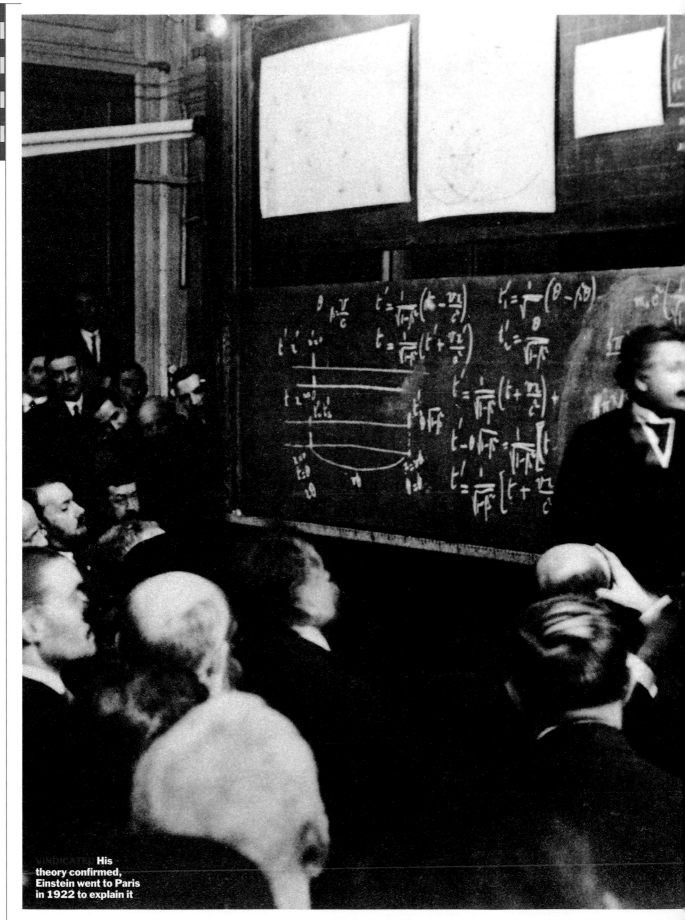

VINDICATED **His theory confirmed, Einstein went to Paris in 1922 to explain it**

a brief history of relativity

By Stephen Hawking

What is it? How does it work? Why does it change everything?
An easy primer by the world's most famous living physicist

toward the end of the 19th century scientists believed they were close to a complete description of the universe. They imagined that space was filled everywhere by a continuous medium called the ether. Light rays and radio signals were waves in this ether just as sound is pressure waves in air. All that was needed to complete the theory was careful measurements of the elastic properties of the ether; once they had those nailed down, everything else would fall into place.

Soon, however, discrepancies with the idea of an all-pervading ether began to appear. You would expect light to travel at a fixed speed through the ether. So if you were traveling in the same direction as the light, you would expect that its speed would appear to be lower, and if you were traveling in the opposite direction to the light, that its speed would appear to be higher. Yet a series of experiments failed to find any evidence for differences in speed due to motion through the ether.

The most careful and accurate of these experiments was carried out by Albert Michelson and Edward Morley at the Case Institute in Cleveland, Ohio, in 1887. They compared the speed of light in two beams at right angles to each other. As the earth rotates on its axis and orbits the sun, they reasoned, it will move through the ether, and the speed of light in these two beams should diverge. But Michelson and Morley found no daily or yearly differences between the two beams of light. It

Professor Hawking, author of A Brief History of Time, *occupies the Cambridge mathematics chair once held by Isaac Newton*

was as if light always traveled at the same speed relative to you, no matter how you were moving.

The Irish physicist George FitzGerald and the Dutch physicist Hendrik Lorentz were the first to suggest that bodies moving through the ether would contract and that clocks would slow. This shrinking and slowing would be such that everyone would measure the same speed for light no matter how they were moving with respect to the ether, which FitzGerald and Lorentz regarded as a real substance.

But it was a young clerk named Albert Einstein, working in the Swiss Patent Office in Bern, who cut through the ether and solved the speed-of-light problem once and for all. In June 1905 he wrote one of three papers that would establish him as one of the world's leading scientists—and in the process start two conceptual revolutions that changed our understanding of time, space and reality.

In that 1905 paper, Einstein pointed out that because you could not detect whether or not you were moving through the ether, the whole notion of an ether was redundant. Instead, Einstein started from the postulate that the laws of science should appear the same to all freely moving observers. In particular, observers should all measure the same speed for light, no matter how they were moving.

This required abandoning the idea that there is a universal quantity called time that all clocks measure. Instead, everyone would have his own personal time. The clocks of two people would agree if they were at rest with respect to each other but not if they were moving. This has been confirmed by a number of

experiments, including one in which an extremely accurate timepiece was flown around the world and then compared with one that had stayed in place. If you wanted to live longer, you could keep flying to the east so the speed of the plane added to the earth's rotation. However, the tiny fraction of a second you gained would be more than offset by eating airline meals.

Einstein's postulate that the laws of nature should appear the same to all freely moving observers was the foundation of the theory of relativity, so called because it implies that only relative motion is important. Its beauty and simplicity were convincing to many scientists and philosophers. But there remained a lot of opposition. Einstein had overthrown two of the Absolutes (with a capital A) of 19th century science: Absolute Rest as represented by the ether, and Absolute or Universal Time that all clocks would measure. Did this imply, people asked, that there were no absolute moral standards, that everything was relative?

This unease continued through the 1920s and '30s. When Einstein was award-

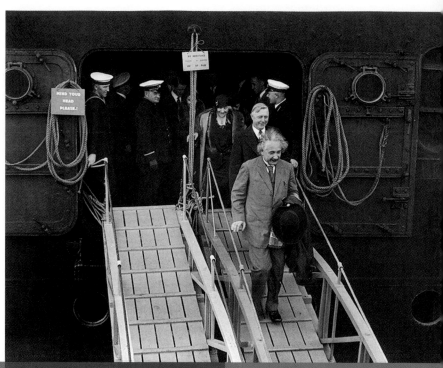

space and time, he discovered, were as pliable as rubber bands

ed the Nobel Prize in 1921, the citation was for important—but by Einstein's standards comparatively minor—work also carried out in 1905. There was no mention of relativity, which was considered too controversial. I still get two or three letters a week telling me Einstein was wrong. Nevertheless, the theory of relativity is now completely accepted by the scientific community, and its predictions have been verified in countless applications.

a very important consequence of relativity is the relation between mass and energy. Einstein's postulate that the speed of light should appear the same to everyone implied that nothing could be moving faster than light. What happens is that as energy is used to accelerate a particle or a spaceship, the object's mass increases, making it harder to accelerate any more. To accelerate the particle to the speed of light is impossible because it would take an infinite amount of energy. The equivalence of mass and energy is summed up in Einstein's famous equation $E=mc^2$, probably the only physics equation to have recognition on the street.

Among the consequences of this law is that if the nucleus of a uranium atom fissions (splits) into two nuclei with slightly less total mass, a tremendous amount of energy is released. In 1939, with World War II looming, a group of scientists who realized the implications of this persuaded Einstein to overcome his pacifist scru-

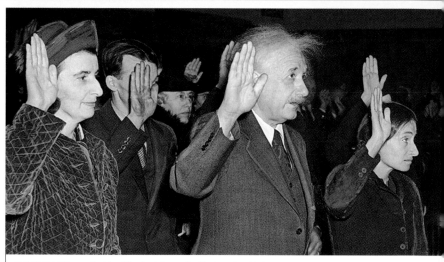

REFUGEE Hounded by Nazis, Einstein fled to the U.S. and became a citizen in 1940

ples and write a letter to President Roosevelt urging the U.S. to start a program of nuclear research. This led to the Manhattan Project and the atom bomb that exploded over Hiroshima in 1945. Some people blame the atom bomb on Einstein because he discovered the relation between mass and energy. But that's like blaming Newton for the gravity that causes airplanes to crash. Einstein took no part in the Manhattan Project and was horrified by the explosion.

Although the theory of relativity fit well with the laws that govern electricity and magnetism, it wasn't compatible with Newton's law of gravity. This law said that

if you changed the distribution of matter in one region of space, the change in the gravitational field would be felt instantaneously everywhere else in the universe. Not only would this mean you could send signals faster than light (something that was forbidden by relativity), but it also required the Absolute or Universal Time that relativity had abolished in favor of personal or relativistic time.

Einstein was aware of this difficulty in 1907, while he was still at the patent office in Bern, but didn't begin to think seriously about the problem until he was at the German University in Prague in 1911. He realized that there is a close relationship be-

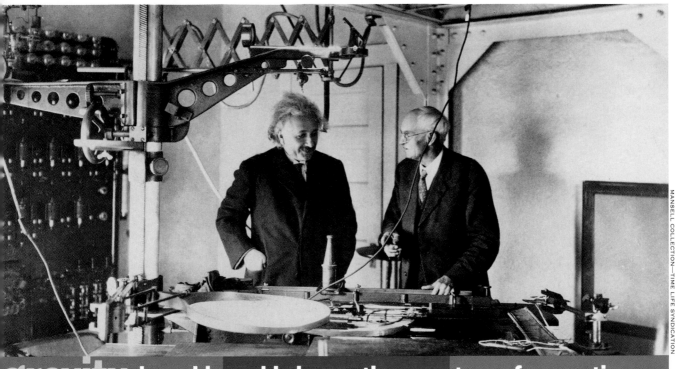

gravity, he said, could change the curvature of space-time

tween acceleration and a gravitational field. Someone in a closed box cannot tell whether he is sitting at rest in the earth's gravitational field or being accelerated by a rocket in free space. (This being before the age of *Star Trek*, Einstein thought of people in elevators rather than spaceships. But you cannot accelerate or fall freely very far in an elevator before disaster strikes.)

If the earth were flat, one could equally well say that the apple fell on Newton's head because of gravity or that Newton's head hit the apple because he and the surface of the earth were accelerating upward. This equivalence between acceleration and gravity didn't seem to work for a round earth, however; people on the other side of the world would have to be accelerating in the opposite direction but staying at a constant distance from us.

On his return to Zurich in 1912 Einstein had a brainstorm. He realized that the equivalence of gravity and acceleration could work if there was some give-and-take in the geometry of reality. What if space-time—an entity Einstein invented to incorporate the three familiar dimensions of space with a fourth dimension, time—was curved, and not flat, as had been assumed? His idea was that mass and energy would warp space-time in some manner yet to be determined. Objects like apples or planets would try to move in straight lines through space-time, but their paths would appear to be bent by a gravitational field because space-time is curved.

With the help of his friend Marcel

Grossmann, Einstein studied the theory of curved spaces and surfaces that had been developed by Bernhard Riemann as a piece of abstract mathematics, without any thought that it would be relevant to the real world. In 1913, Einstein and Grossmann wrote a paper in which they put forward the idea that what we think of as gravitational forces are just an expression of the fact that space-time is curved. However, because of a mistake by Einstein (who was quite human and fallible), they weren't able to find the equations that related the curvature of space-time to the mass and energy in it.

instein continued to work on the problem in Berlin, undisturbed by domestic matters and largely unaffected by the war, until he finally found the right equations, in November 1915. Einstein had discussed his ideas with the mathematician David Hilbert during a visit to the University of Göttingen in the summer of 1915, and Hilbert independently found the same equations a few days before Einstein. Nevertheless, as Hilbert admitted, the credit for the new theory belonged to Einstein. It was his idea to relate gravity to the warping of space-time. It is a tribute to the civilized state of Germany in this period that such scientific discussions and exchanges could go on undisturbed even in wartime. What a contrast to 20 years later!

The new theory of curved space-time

MOUNT WILSON Visiting the observatory where the Big Bang was discovered

was called general relativity to distinguish it from the original theory without gravity, which was now known as special relativity. It was confirmed in spectacular fashion in 1919, when a British expedition to West Africa observed a slight shift in the position of stars near the sun during an eclipse. Their light, as Einstein had predicted, was bent as it passed the sun. Here was direct evidence that space and time are warped, the greatest change in our perception of the arena in which we live since Euclid wrote his *Elements* about 300 B.C.

Einstein's general theory of relativity transformed space and time from a passive background in which events take place to active participants in the dynamics of the cosmos. This led to a great problem that is still at the forefront of physics at the end of the 20th century. The universe is full of matter, and matter warps space-time so that bodies fall together. Einstein found that his equations didn't have a solution that described a universe that was unchanging in time. Rather than give up a static and everlasting universe, which he and most other people believed in at that time, he fudged the equations by adding a term called the cosmological constant, which warped space-time the other way so that bodies move apart. The repulsive effect of the cosmological constant would balance the attractive effect of matter and allow for a universe that lasts for all time.

This turned out to be one of the great missed opportunities of theoretical physics. If Einstein had stuck with his original equations, he could have predicted that the universe must be either expanding or contracting. As it was, the possibility of a time-dependent universe wasn't taken seriously until observations were made in the 1920s with the 100-in. telescope on Mount Wilson. These revealed that the farther other galaxies are from us, the faster they are moving away. In other words, the universe is expanding and the distance between any two galaxies is steadily increasing with time. Einstein later called the cosmological constant the greatest mistake of his life.

General relativity completely changed the discussion of the origin and fate of the universe. A static universe could have existed forever or could have been created in its present form at some time in the past. On the other hand, if galaxies are moving apart today, they must have been closer together in the past. About 15 billion years ago, they would all have been on top of one another and their density would have been infinite. According to the general theory, this Big Bang was the beginning of the universe and of time itself. So maybe Einstein deserves to be the person of a longer period than just the past 100 years.

General relativity also predicts that time comes to a stop inside black holes, regions of space-time that are so warped that light cannot escape them. But both the beginning and the end of time are places where the equations of general relativity fall apart. Thus the theory cannot predict what should emerge from the Big Bang. Some see this as an indication of God's freedom to start the universe off any way God wanted. Others (myself included) feel that the beginning of the universe should be governed by the same laws that hold at all other times. We have made some progress toward this goal, but we don't yet have a complete understanding of the origin of the universe.

the reason general relativity broke down at the Big Bang was that it was not compatible with quantum theory, the other great conceptual revolution of the early 20th century. The first step toward quantum theory came in 1900, when Max Planck, working in Berlin, discovered that the radiation from a body that was glowing red hot could be explained if light came only in packets of a certain size, called quanta. It was as if radiation were packaged like sugar; you cannot buy an arbitrary amount of loose sugar in a supermarket but can only buy it in 1-lb. bags. In one of his groundbreaking papers written in 1905, when he was still at the patent office, Einstein showed that Planck's quantum

special relativity

Einstein's 1905 theory claims that light moves through a vacuum at a constant speed relative to any observer, no matter what the observer's motion—with bizarre consequences

relativity and time

A moving clock runs slower than a stationary one from the perspective of a stationary observer

❶ A man riding a moving train is timing a light beam that travels from ceiling to floor and back again. From his point of view, the light moves straight down and straight up.

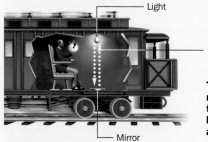

Light

Distance light pulse travels

The observer riding the train thinks the light bulb and mirror are standing still

Mirror

❷ From trackside, Einstein sees man, bulb and mirror moving sideways: the light traces a diagonal path. From Einstein's viewpoint, the light goes farther. But since lightspeed is always the same, the event must take more time by his clock.

Distance light pulse travels, as seen by Einstein, is farther

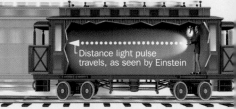

The observer watching the train thinks the light bulb and mirror are moving

More time has elapsed

relativity and length

A moving object appears to shrink in the direction of motion, as seen by a stationary observer

❶ The man now observes a light beam that travels the length of the train car. Knowing the speed of light and the travel time of the light beam, he can calculate the length of the train.

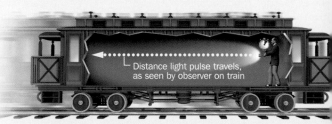

Distance light pulse travels, as seen by observer on train

The observer on the train sees only the motion of the light beam

❷ Einstein is not moving, so the rear of the train is moving forward from his point of view to meet the beam of light: for him the beam travels a shorter distance. Because the speed of light always the same, he will calculate the train's length as shorter–even after he allows for his faster-ticking clock. As the train approaches the speed of light, its length shrinks to nearly zero.

Distance light pulse travels, as seen by Einstein

Someone watching from outside sees the light beam moving but with the motion of the train added

Sources: *World Book Encyclopedia; Einstein for Beginners*

hypothesis could explain what is called the photoelectric effect, the way certain metals give off electrons when light falls on them. This is the basis of modern light detectors and television cameras, and it was for this work that Einstein was awarded the 1921 Nobel Prize in Physics.

Einstein continued to work on the quantum idea into the 1920s but was deeply disturbed by the work of Werner Heisenberg in Copenhagen, Paul Dirac in Cambridge and Erwin Schrödinger in Zurich, who developed a new picture of reality called quantum mechanics. No longer did tiny particles have a definite position and speed. On the contrary, the more accurately you determined the particle's position, the less accurately you could determine its speed, and vice versa.

Einstein was horrified by this random, unpredictable element in the basic laws and never fully accepted quantum mechanics. His feelings were expressed in his famous God-does-not-play-dice dictum. Most other scientists, however, accepted the validity of the new quantum laws because they showed excellent agreement with observations and because they seemed to explain a whole range of previously unaccounted-for phenomena. They are the basis of modern developments in chemistry, molecular biology and electronics and the foundation of the technology that has transformed the world in the past half-century.

When the Nazis came to power in Germany in 1933, Einstein left the country and renounced his German citizenship. He spent the last 22 years of his life at the Institute for Advanced Study in Princeton, N.J. The Nazis launched a campaign against "Jewish science" and the many German scientists who were Jews (their exodus is part of the reason Germany was not able to build an atom bomb). Einstein and relativity were principal targets for this campaign. When told of publication of the book *One Hundred Authors Against Einstein*, he replied, Why 100? If I were wrong, one would have been enough.

After World War II, he urged the Allies to set up a world government to control the atom bomb. He was offered the presidency of the new state of Israel in 1952 but turned it down. "Politics is for the moment," he once wrote, "while ... an equation is for eternity." The equations of general relativity are his best epitaph and memorial. They should last as long as the universe.

The world has changed far more in the past 100 years than in any other century in history. The reason is not political or economic but technological—technologies that flowed directly from advances in basic science. Clearly, no scientist better represents those advances than Albert Einstein: TIME's Person of the Century. ∎

general relativity

In 1915 Einstein broadened his special theory of relativity to include gravity. In general relativity, light always takes the shortest possible route from one point to another

the equivalence of gravity and acceleration

Without external clues, it's impossible to tell if you're being pulled downward by gravity or accelerating upward. Your legs will feel the same pressure; a ball will fall precisely the same way

The realization that gravity and acceleration are equivalent was a key insight that eventually allowed Einstein to construct his theory of general relativity.

LOTTE JACOBI ARCHIVE—UNIVERSITY OF NEW HAMPSHIRE

relativity and gravity

According to relativity, gravity is not a force; it's a warping of space-time (which is an amalgam of time and space) that happens in the presence of mass. The warping is analogous to tbe bending of a rubber sheet when a weight is placed on it

1 When starlight passes near a massive body, such as the sun, the shortest route is a curved line that follows the curvature of space-time. Thus, the starlight appears to be coming from a different point than its actual origin. The observation of this effect in 1919 convinced physicists that Einstein's strange theory was right.

Position of star

Observed position of star

Sun

Earth

Light entering the black hole

2 If a mass is concentrated enough, the curvature of space-time becomes infinite. This phenomenon is known as a black hole because a light beam that comes too close will never escape.

TIME Graphics by Ed Gabel and Joe Lertola

TIME

If there's a story in there,

we'll find it.

The world's most interesting magazine.

unfinished symphony

Strings may do what Einstein finally failed to do: tie together the two great irreconcilable ideas of 20th century physics

By J. MADELEINE NASH

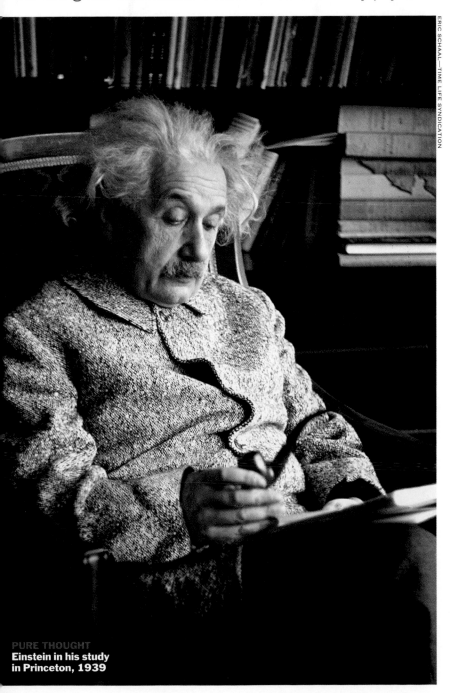

ERIC SCHAAL—TIME LIFE SYNDICATION

PURE THOUGHT
Einstein in his study in Princeton, 1939

i am generally regarded as a sort of petrified object, rendered deaf and blind by the years," Albert Einstein confided near the end of his life. He was, alas, correct. During the last three decades of his remarkable career, Einstein had become obsessed by the dream of producing a unified field theory, a series of equations that would establish an underlying link between the seemingly unrelated forces of gravity and electromagnetism.

In so doing, Einstein hoped also to resolve the conflict between two competing visions of the universe: the smooth continuum of space-time, where stars and planets reign, as described by his general theory of relativity, and the unseemly jitteriness of the submicroscopic quantum world, where particles hold sway.

Einstein worked hard on the problem, but success eluded him. That was no surprise to his contemporaries, who saw his quest as a quixotic indulgence. They were sure that the greatest of all their colleagues was simply wasting his time, relying on a conceptual approach that was precisely backward. In contrast to just about all other physicists, Einstein was convinced that in the conflict between quantum mechanics and general relativity, it was the former that constituted the crux of the problem. "I must seem like an ostrich who forever buries its head in the relativistic sand in order not to face the evil quanta," Einstein reflected in 1954. We know now, however, that it is Einstein's theory that ultimately fails. On extremely fine scales, space-time, and thus reality itself, becomes grainy and discontinuous, like a badly overmagnified newspaper photograph. The equations of general relativity simply can't handle such a situation, where the laws of cause and effect break down and particles jump from point A to point B without going through the space in between. In such a world, you can only calculate what will *probably* happen next—which is just what quantum theory is designed to do.

Einstein could never accept that the universe was at its heart a cosmic crapshoot, so that today his papers on unified field theory seem hopelessly archaic. But the puzzle they tried to solve is utterly fundamental. In simply recognizing the problem, Einstein was so daringly farsighted that only now has the rest of physics begun to catch up. A new generation of physicists has at last taken on the challenge of creating a complete theory—one capable of explaining, in Einstein's words, "every element of the physical reality." And judging from the progress they have made, the next century could usher

in an intellectual revolution even more exciting than the one Einstein helped launch in the early 1900s.

Already, in fact, theoretical physicists have succeeded in constructing a framework that offers the best hope yet of integrating gravity with nature's other fundamental forces. This framework is popularly known as string theory because it postulates that the smallest, indivisible components of the universe are not point-like particles but infinitesimal loops that resemble tiny vibrating strings. "String theory," pioneering theorist Edward Witten of Einstein's own Institute for Advanced Study has observed, "is a piece of 21st century physics that fell by chance into the 20th century."

The trouble is, neither Witten nor anyone else knows how many other pieces must fall into place before scientists succeed in solving this greatest of all puzzles. One major reason, observes Columbia University physicist Brian Greene, is that string theory developed backward. "In most theories, physicists first see an overarching idea and then put equations to it." In string theory, says Greene, "we're still trying to figure out the central nugget of truth."

Over the years, enthusiasm for string theory has waxed and waned. It enjoyed a brief vogue in the early 1970s, but then most physicists stopped working on it. Theorist John Schwarz of Caltech and his colleague Joel Scherk of the Ecole Normale Supérieure, however, persevered, and in 1974 their patience was rewarded. For some time they had noticed that some of the vibrating strings spilling out of their equations didn't correspond to the particles they had expected. At first they viewed these mathematical apparitions as nuisances. Then they looked at them more closely; the ghosts that haunted their equations, they decided, were gravitons, the still hypothetical particles that are believed to carry the gravitational force.

Replacing particles with strings eliminated at least one problem that had bedeviled scientists trying to meld general relativity and quantum mechanics. This difficulty arose because space lacks smoothness below subatomic scales. When distances become unimaginably small, space bubbles and churns frenetically, an effect sometimes referred to as quantum foam. Pointlike particles, including the graviton, are likely to be tossed about by quantum foam, like Lilliputian boats to which ripples in the ocean loom as large waves. Strings, by contrast, are miniature ocean liners whose greater size lets them span many waves at once, making them impervious to such disturbances.

nature rarely bestows gifts on scientists, however, without exacting a price, and the price in this case, takes the form of additional complications. Among other things, string theory requires the existence of up to seven dimensions in addition to the by now familiar four (height, width, length and time). It also requires the existence of an entirely new class of subatomic particles, known as supersymmetric particles, or "sparticles." Moreover, there isn't just one string theory but five. Although scientists could rule out none of them, it seemed impossible that all of them could be right.

But that, in fact, has turned out to be the case. In 1995, Witten, perhaps the most brilliant theorist working in physics today, declared that all five supersymmetric string theories represented different approximations of a deeper, underlying theory. He called it M theory. The insight electrified his colleagues and

a world made of string...

Matter is composed of atoms ...

Atoms are made of protons, neutrons and electrons ...

Electrons can't be divided further, but protons and neutrons are each made of three even tinier particles called quarks ...

Now it appears that quarks and electrons may not be particles at all but multi-dimensional entities called "branes," some of which manifest themselves as tiny loops of "string"

HANSEL MIETH—LIFE

inspired a flurry of productive activity that has now convinced many that string theory is, in fact, on the right track. "It smells right and it feels right," declares Caltech's Kip Thorne, an expert on black holes and general relativity. "At this early stage in the development of a theory, you have to go on smell and feel."

The *M* in M theory stands for many things, says Witten, including *matrix, mystery* and *magic*. But now he has added *murky* to the list. Why? Not even Witten, it turns out, has been able to write down the full set of mathematical equations that describe exactly what M theory is, for it has added still more layers of complexity to an already enormous problem. Witten appears reconciled to the possibility that decades may pass before M matures into a theory with real predictive power. "It's like when you're hiking in the mountains," he muses, "and occasionally you reach the top of a pass and get a completely new view. You enjoy the view for a bit, until eventually the truth sinks in. You're still a long way from your destination."

Einstein was brilliant, of course, but he was also lucky. When he developed the general theory of relativity, he dealt with a world that had just three spatial dimensions plus time. As a result, he

could use off-the-shelf mathematics to develop and solve his equations. M theorists can't: their science resides in an 11-dimensional world that is filled with weird objects called branes. Strings, in this nomenclature, are one-dimensional branes; membranes are two-dimensional branes. But there are also higher-dimensional branes that no one, including Witten, quite knows how to deal with. For these branes can fold and curl into any number of bewildering shapes.

Which shapes represent the fundamental structures in our universe? On this point, string theorists are currently clueless. For the world conjured into existence by M theory is so exotic that scientists are being forced to work not just at the frontier of physics but at the frontier of mathematics as well. Indeed, it may be that they lack some absolutely essential tool and will have to develop it, just as Isaac Newton was pushed by his investigations of the laws of motion to develop the calculus. As if that weren't hard enough, there is yet another major impediment to progress: unlike quantum mechanics, string theory and its offshoots have developed in the virtual absence of experimental evidence that could help steer theorists in productive directions.

Over the next decade, this situation could change. Hopes are running high that upcoming experiments at giant particle colliders in the U.S. and Europe will provide the first tantalizing glimpses of supersymmetry. More speculatively, these experiments could also detect the first subtle signs of additional dimensions.

What would Einstein have made of such wild imaginings? Columbia's Greene, for one, thinks he would have loved them. After all, Greene notes in his recently published book, *The Elegant Universe*, Einstein played around with the idea of extra dimensions as a strategy for producing a unified field theory.

In fact, Greene believes a young Einstein, starting his professional career now rather than at the turn of the past century, would have overcome his deep distrust of quantum mechanics and enthusiastically embraced branes and sparticles and superstrings. And given his almost superhuman ability to transcend conventional thinking and visualize the world in unprecedented ways, he might have been the one to crack the ultimate theory. It may in the end take an Einstein to complete Einstein's unfinished intellectual symphony. ∎

.. may explain all of physics

Quantum theory and relativity can't work together, but M theory, which incorporates the idea of strings, could meld the two at last

LENGTH

WIDTH

TIME

DEPTH

DIMENSIONS Conventional physics has four, including time. M theory suggests there are as many as 11—but the extra dimensions are almost certainly detectable only at subatomic scales

SUPERSYMMETRY Earlier theories suggested that each known particle has an as yet undetected counterpart. These so-called supersymmetric partners, including "squarks" and "selectrons," are consistent with M theory

STRINGS While the strings are identical, the way they vibrate determines whether they act as electrons or quarks, somewhat as a violin string can sound A or B, depending on how it's tuned

Source: *The Elegant Universe*, Brian Greene
TIME Graphic by Joe Lertola

the age of einstein

He became, almost despite himself, the emblem of all that was new, original and unsettling in the modern age

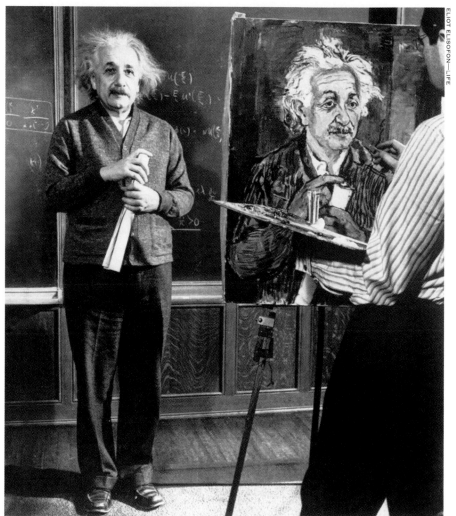

ARTIST'S INSPIRATION Einstein poses, with manuscript, for muralist Arthur Kaufman

By ROGER ROSENBLATT

for Einstein to become a modern icon, especially in America, required a total revision of the definition of a hero. Anti-intellectualism has been as integral a part of American culture as the drive for universal education, and the fact that both have existed concurrently may account for the low status of teachers. In America

it is not enough to be smart; one must compensate for one's intelligence by also showing the canniness and real-world power of the cowboy and the pioneer. Einstein did this. He was the first modern intellectual superstar, and he won his stardom in the only way that Americans could accept—by dint of intuitive, not scholarly, intelligence and by having his thought applied to practical things, such as rockets and atom bombs.

The recognition of the practical power of his ideas coincided with a time when such power was most needed. Einstein came to America in 1933 as the most celebrated of a distinguished group of European intellectuals, refugees from Hitler and Mussolini, who, as soon as they arrived, changed the composition of university faculties (largely from patrician to Jewish), and who also changed the composition of government. Until F.D.R.'s New Deal, the country had never associated the contemplative life with governmental action. Now there was a Brain Trust; being an "egghead" was useful, admirable, even sexy. One saw that it was possible to outthink the enemy. Einstein wrote a letter to Roosevelt urging the making of a uranium bomb, and soon a coterie of can-do intellectuals convened at Los Alamos to become the new cowboys of war machinery. Presidents have relied on eggheads ever since: Einstein begat Kissinger begat Rubin, Reich and Greenspan.

As for the appeal of his intuitive imagination, it helped that Einstein was initially not associated with a brand-name institution of higher learning and that his stature did not depend on official accreditation—both of which Americans at once insist on and do not trust. To the contrary, he was eagerly adopted by ordinary folks, though he spoke the obscure language of mathematics, because he seemed removed from snooty trappings. In fact, he seemed removed from the planet, to be out of things in the way the public often adores: a lovable dreamer.

So strong was the image he created that he affected both culture and politics in ways that were sometimes wholly opposite to his beliefs and intentions. That his theory of relativity was readily mistranslated as a justification for relativism says more about the way the world was already tending than about Einstein. His stature gave an underpinning to ideas that had nothing to do with his science or personal inclinations. The entire thrust of modern art, whether it took the form of Expressionism, Cubism, Fauvism or fantasy, was a conscious effort to rejigger the shapes of observable reality in the same spirit of liberation and experimentation that Einstein brought to science.

But relativism—that is, the idea that moral and ethical truth exists in the point of view of the beholder—owed nothing to Einstein (who believed the opposite), except a generalized homage to revolutionary thought. Art's elimination of semblances to the physical world corresponded vaguely with Einstein's way of seeing time and space, but it really sprung from an atmosphere of change, in which Einstein was yoked with Freud

ELIOT ELISOFON—LIFE

Marx, Picasso, Bergson, Wittgenstein, Joyce, Kafka, Duchamp, Kandinsky and anyone else with original and disruptive ideas and an aggressive sense of the new. By that tenuous connection did the discoverer of relativity become a major figure of a world consisting of individuals interpreting the world individually. He was similarly associated with the pluralism of modern music and the eclecticism of modern architecture.

In literature, things were ready to fall apart on their own, so any excuse to do so—especially one as revered as a theoretical restructuring of the universe—was embraced. In 1919 relativity exploded upon science. In 1922 T.S. Eliot's *The Waste Land* had a similar effect on literature. Yet when Eliot wrote, "these fragments I have shored against my ruins," people took up the fragments but ignored the shoring.

The key, though, in Eliot and other 20th century poets and novelists, lay in the prominence of the pronoun I—the center of relativistic thought. Thus spake the confessional poetry of the 1960s, the memoirs in the 1980s and 1990s, the prominence of the narrator in all of modern fiction. A commonplace paradox that was soon to characterize fiction was that the antihero, who was beset and disempowered by modern bureaucracies and machines, was simultaneously exalted by his diminished status.

relativism brought the underground man into his own—in Europe, with Dostoyevsky, Kafka, Beckett, Aichinger, Sartre, Mann and Pirandello; in America with Fitzgerald, Hemingway, Ellison, Capote and Salinger. The antihero, too, searched for unified meaning, but the narrative that held him was all about divisions, schisms and self-inspection. He sought to be by himself, like a god. In Robert Musil's *The Man Without Qualities* and Richard Wright's *The Outsider,* protagonists become serial killers out of the desire to be alone.

All this has nothing to do with relativity, but it had much to do with Einstein's contemplation of relativity. Einstein became the emblem not only of the desire to know the truth but also of the capacity to know the truth. In his 1993 novel, *Einstein's Dreams,* Alan Lightman writes, "In this world time is a visible dimension. Just as one may look off in the distance and see houses, trees, mountain peaks that are landmarks in space, so one may look out

in another direction and see births, marriages, deaths that are signposts in time, stretching off dimly into the far future." It does not take much of another stretch to attach godhead to such a vision, though that was hardly Einstein's own feeling.

However interesting this view made art, what it did for politics was pure destruction. Paul Johnson connects relativism to the extreme nationalism of 20th century political movements in his generally persuasive view of *Modern Times.* The relationship he cites is sometimes elliptical. What one can say is that the destruction of absolutes—monar-

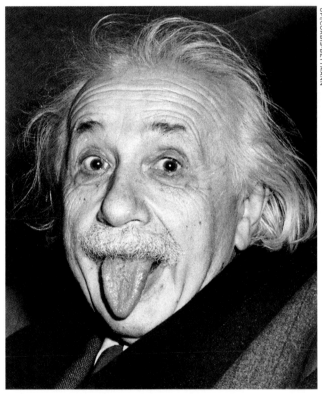

SCIENCE CLOWN Mugging for the press on his 72nd birthday

chies no less than Newtonian physics—created a vacuum, and in certain key places that vacuum was filled by maniacs and murderers.

There is a connection, though, between European Romanticism, which came into being at the tail end of the 18th century, and the totalitarian credos that bloomed like sudden deadly plants in the first third of the 20th. Einstein did not promote the image of man at the center of the cosmos, controlling the stars by thought. But, quite by accident, he was that image. Merely by being, he corroborated the Romantic view that people were 10 feet tall, capable of knowing heaven, and, in the Byronic mode, of speaking directly to God. The logical consequence of such "thinking" was that some people were more able to speak to God than were others, and that God, in turn, spoke to a se-

lected few. Throw in social Darwinism, and by the time the 20th century was under way, Romanticism led directly to Dachau, Auschwitz, the Gulags, the hills of skulls in Cambodia and most recently the fields of graves in Bosnia.

To read Einstein's essays in *Out of My Later Years* is to see that he held none of the artistic or political ideas that were extrapolated from his work. Whatever revisions he made of Newton, he continued to side with his predecessor on the issue of causality. He abhorred chaos and revolution for its own sake. He was devoted to constancy as much as to relativity, and to the illogical and the senses. In the end, his most useful gift may be not that he pulled the world apart but that once that was done, he strove to put it back together.

"The eternal mystery of the world is its comprehensibility," he quoted Kant, and added that the fact that the world is comprehensible "is a miracle." He also understood his responsibility for the weapons he helped create. "We scientists," he wrote, "whose tragic destination has been to help in making the methods of annihilation more gruesome and more effective, must consider it our solemn and transcendent duty to do all in our power in preventing these weapons from being used."

Why, finally, is he so important to the age? Not because he personified brainpower—not because he was "an Einstein"—but rather because he demonstrated that the imagination is capable of coming to terms with experience. Simply by gazing into existence, he concluded that time and space could be warped, that mass and energy were interchangeable. He understood that the world was a puzzle created for deciphering and, more, that a person's place in the order of things was to solve as much of the puzzle as possible. This is what makes a human human; this, and the governing elements of morals and humor.

Einstein's friend and fellow physicist Abraham Pais called him "the freest man I have known," by which he meant that by the pure act of thinking, Einstein controlled his destiny. His mind was utterly fearless, and by its uses he diminished fear in others. "It stands to the everlasting credit of science," Einstein wrote, "that by acting on the human mind, it has overcome man's insecurity before himself and before nature." And so he became a model of what humans might do if they put their mind to it. ∎

Best Children's Book
Charlotte's Web
by E.B. White (1952)

The most lovable spider in literature befriends a hapless barnyard pig named Wilbur and launches a campaign to save him from becoming someone's meal. The webs Charlotte weaves are tangled and enchanting.

Runners-Up
The Chronicles of Narnia by C.S. Lewis; *A Wrinkle in Time* by Madeleine L'Engle

Best Dance

The Four Temperaments by George Balanchine (1946)

No plot, no set, no Look-Ma-I'm-a-swan costumes—just a stageful of virtuoso dancers who hurtle through angular steps and abstract poses that evoke a limitless universe of emotions.
Runners-Up *Esplanade* by Paul Taylor; *Jardin aux Lilas* by Antony Tudor

Best TV Show
The Simpsons, created by Matt Groening (1989-)

Dazzlingly intelligent and unapologetically vulgar, the Simpsons have surpassed the humor, topicality and, yes, humanity of past TV greats.
Runners-Up *The Mary Tyler Moore Show; The CBS Evening News with Walter Cronkite*

the best of the century

The arts delivered shocking cultural news. Bleak can be beautiful. Less is more. An onrush of the modern and abstract started a running debate: Is it art? To add to the din, TIME's critics have made their choices of the best work. Argue away

Best Film
Citizen Kane, directed by and starring Orson Welles (1941)

Its power—a compound of rebel cheekiness, stylistic innovation and a tragicomic vision of media power—has never waned. It remains a work that seduces the young and inspires the old with thoughts of what the medium can achieve.
Runners-Up *Day for Night* by François Truffaut; *Chinatown* by Roman Polanski

Best Novel
Ulysses by James Joyce (1922)

Exhaustively portraying the events of a single day, June 16, 1904, in Dublin, it has comic exuberance, encyclopedic inclusiveness and a virtuoso display of diverse narrative styles that make most subsequent novels look like spin-offs.

Runners-Up *One Hundred Years of Solitude* by Gabriel García Márquez; *Lolita* by Vladimir Nabokov

Best Nonfiction Book
The Gulag Archipelago by Aleksandr Solzhenitsyn (1974)

This scalding and historic exposé of the vas Soviet prison network set up for dissidents

made international headlines when it first appeared in the West. It also got its author kicked out of his homeland.
Runners-Up *The Diary of a Young Girl* by Anne Frank; *The Double Helix* by James Watson

Best Song
Strange Fruit
by Billie Holiday (1939)

In this sad, shadowy song about lynching in the South, history's greatest jazz singer comes to terms with history itself.
Runners-Up
Corcovado by Antonio C. Jobim;
A Hard Rain's a-Gonna Fall by Bob Dylan

Best Opera
Peter Grimes
by Benjamin Britten (1945)

This tale of a troubled fisherman's fatal encounter with the bigoted residents of his seaside village is told with emotion and all-encompassing humanity by Britain's foremost composer.
Runners-Up
Wozzeck by Alban Berg;
Madama Butterfly by Giacomo Puccini

Carousel

Best Musical
Carousel by Rodgers and Hammerstein (1945)

They set the standard for the 20th century musical, and this show features their most beautiful score and the most skillful and affecting example of their musical storytelling.
Runners-Up
Guys and Dolls by Frank Loesser, Abe Burrows and Jo Swerling;
Evita by Andrew Lloyd Webber and Tim Rice

Best Comedy Routine
"Who's on First?" by Abbott and Costello (1938)

It's such a simple premise, and Abbott and Costello drive it about 20 ft. into the ground, but *"Who's on First?"* is not only the century's most famous comedy bit; it's also the best. It's absurdism mixed with the easy pleasure of confusion, and Bud Abbott plays the perfect cool logician to Lou Costello's frustrated inquisitor in this Beckettian farce.
Runners-Up
"Dead Parrot," Monty Python;
"Rope Tricks," Will Rogers

Best Sculpture

Bird in Space
by Constantin Brancusi
(this version c. 1941)

This totemic reduction of nature—the streamlining of a bird's body, the swish of its flight—was a prediction of the technological world to come in the second half of the century.

Runners-Up
Guitar by Pablo Picasso;
The Chariot
by Alberto Giacometti

Best Painting

The Red Studio
by Henri Matisse (1911)

Matisse's great poem to the art of painting shows how, in a space brimming with red and punctuated by renderings of his own pictures, the visual becomes the lord of all the senses.

Runners-Up
Still-Life with Chair Caning
by Pablo Picasso;
Dog Barking at the Moon
by Joan Miró

Best Classical Composition

Symphony of Psalms
by Igor Stravinsky (1930)

This reaffirmation of the glory of God begins in astringent lamentation and ends in radiant certitude.

Runners-Up
*String Quartet
in F Major* by Maurice Ravel;
Appalachian Spring
by Aaron Copland

Best Play

Six Characters in Search of an Author
by Luigi Pirandello (1921)

It crystallizes the century's chief concerns of life and art: man's existential predicament, the line between illusion and reality. And it's more fun than *Waiting for Godot*.

Runners-Up
Man and Superman by
George Bernard Shaw;
*Long Day's Journey
into Night*
by Eugene O'Neill

the best of the century

Best Design

The Eames molded plywood chair,
designed by Charles Eames (1946)

Eames took technology created to meet a wartime need (for splints) and used it to make something elegant, light and comfortable. Much copied but never bettered.

Runners-Up
*The S-1
steam
locomotive*
by Raymond
Loewy;
the Swatch watch

Best Poem

The Waste Land by
T.S. Eliot (1922)

Filled with post–World War I disillusionment and despair, this allusive, fragmented epic became a touchstone of modern sensibility, and its haunting, haunted language sang the passing of old certainties in acentury adrift.

Runners-Up
The Second Coming
by W.B. Yeats;
Home Burial
by Robert Frost

Best Photograph

Place de l'Europe, Paris
by Henri Cartier-Bresson (1932)

Cartier-Bresson demonstrated
the strange magic in moments
in which nothing much
happens but all sorts of
things are revealed.
Runners-Up
*Identifying the Dead,
Russian Front*
by Dmitri Baltermants;
Wall Street
by Paul Strand

Best Fashion

Levi's 501 jeans
by Levi Strauss & Co. (1960)

Although the precursors got their patented
copper rivets in 1873, 501s belong squarely in the 20th
century. Worn by everyone from Presidents to rock stars,
they can be dressed up or casual, hardworking or sexy.

Runners-Up
*The miniskirt;
Coco Chanel's little
black dress*

Best Building

The chapel at Ronchamp, France
by Le Corbusier (1955)

How do you create space for sacred ritual in
a secular age? It's hard to do better than this
erratically shaped church.
Runners-Up *The Seagram Building*
by Ludwig Mies van der Rohe;
Fallingwater by Frank Lloyd Wright

Best Album

Exodus by Bob
Marley & the
Wailers (1977)

Every song is a classic, from the
messages of love to the anthems of
revolution. But more than that, the
album is a political and cultural nexus,
drawing inspiration from the Third
World and then giving voice to it the
world over.
Runners-Up *Kind of Blue* by Miles Davis; *Are
You Experienced?* by Jimi Hendrix

franklin delano ro

(1882-1945)

He raised the edifice of the American Century by restoring a nation's promise of plenty and by intervening to save a world enveloped in darkness

By Doris Kearns Goodwin

from Warm Springs, Ga., where he died, the funeral train moved slowly through the rural South to a service in Washington, then past the now thriving cities of the North, and finally to Hyde Park, N.Y., in the Hudson River Valley, where he was born. Wherever it passed, Americans by the hundreds of thousands stood vigil, those who had loved him and those who came to witness a momentous passage in the life of the nation. Men stood with their arms around the shoulders of their wives and mothers. They stood in clusters, heads bowed, openly weeping. They clasped their hands in prayer. A father lifted his son to see the last car, which carried the flag-draped coffin. "I saw everything," the boy said. "That's good," the father said. "Now make sure you remember."

He had been President of the United States for 12 of the most tumultuous years in the life of the nation. For many, an America without Roosevelt seemed almost inconceivable. He had guided the nation through democracy's two monumental crises—the Great Depression and World War II. Those who watched the coffin pass were the beneficiaries of his nation's victory. Their children would live to see the causes for which he stood—prosperity and freedom, economic justice and political democracy—gather strength throughout the century, come to dominate life in America and in much of the world.

It is tempting to view these triumphs as the consequence of irresistible historical forces. But inevitability is merely an illusory label we impose on that which has already happened. It does not tell us what might have happened. For that, we need to view events through the eyes of those who lived them. Looked at that way, we understand that twice in mid-century, capitalism and democracy were in the gravest peril, rescued by the enormous efforts of countless people summoned to struggle by their peerless leader—Franklin Delano Roosevelt.

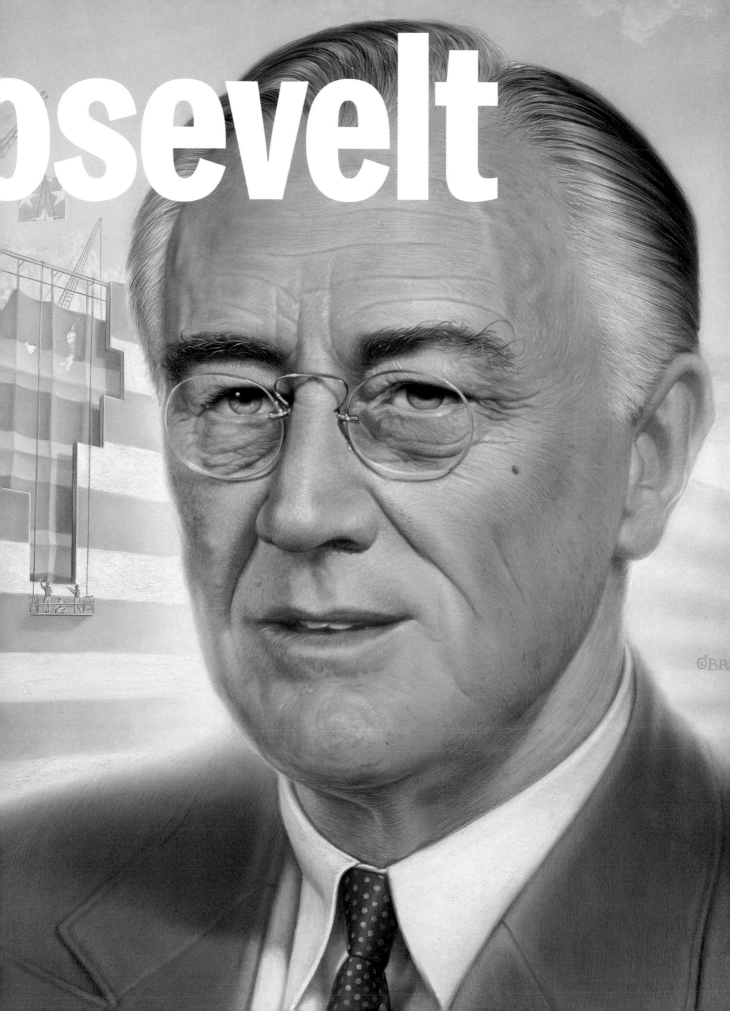

osevelt

"Men will thank God on their knees a hundred years from now that Franklin D. Roosevelt was in the White House," the New York *Times* editorialized at the time of his death. "It was his hand, more than that of any other single man, that built the great coalition of the United Nations. It was his leadership which inspired free men in every part of the world to fight with greater hope and courage. Gone is the fresh and spontaneous interest which this man took, as naturally as he breathed air, in the troubles and the hardships and

believed its moment had come. "If I vote at all," social critic Lewis Mumford said, "it will be for the Communists." "The destruction of the Democratic Party," argued University of Chicago professor Paul Douglas (who would later become a pillar of the same party), "would be one of the best things that could happen in our political life." "The situation is critical," political analyst Walter Lippman warned Roosevelt two months before he took office. "You may have no alternative but to assume dictatorial power."

never been a time other than the Civil W. when democratic institutions had been such jeopardy, Roosevelt fashioned a Ne Deal, which fundamentally altered the r lationship of the government to its peopl rearranged the balance of power betwee capital and labor and made the industri system more humane.

Massive public works projects put m lions to work building schools, roads, braries, hospitals; repairing bridges; di ging conservation trails; painting murals public buildings. The Securities and E

he had been an athlete, a man who had loved to swim and s

the disappointments and the hopes of little men and humble people."

Even through the grainy newsreels, we can see what the people at the time saw: the radiant smile, the eyes flashing with good humor, the cigarette holder held at a jaunty angle, the good-natured toss of the head, the buoyant optimism, the serene confidence with which he met economic catastrophe and international crisis.

W hen Roosevelt assumed the presidency, America was in its third year of depression. No other decline in American history had been so deep, so lasting, so far reaching. Factories that had once produced steel, automobiles, furniture and textiles stood eerily silent. One out of every four Americans was unemployed, and in the cities the number reached nearly 50%. In the countryside, crops that could not be sold at market rotted in the fields. More than half a million homeowners, unable to pay their mortgages, had lost their homes and their farms; thousands of banks had failed, destroying the life savings of millions. The Federal Government had virtually no mechanisms in place to provide relief.

As the Great Depression circled the globe, democracy and capitalism were everywhere in retreat. The propaganda of the day proclaimed that the choice was one of two extremes—fascism or communism. In Germany, economic collapse led to the triumph of the Nazi party and the installation of Adolf Hitler as Chancellor; in Italy, Benito Mussolini assumed dictatorial power with an ideology called Fascism; in the Soviet Union, Joseph Stalin and the communist ideology held sway.

"Capitalism is dying," theologian Reinhold Niebuhr argued. "Let no one delude himself by hoping for reform from within." The American Communist Party

Doris Kearns Goodwin wrote about the Roosevelts in No Ordinary Time *(1994)*

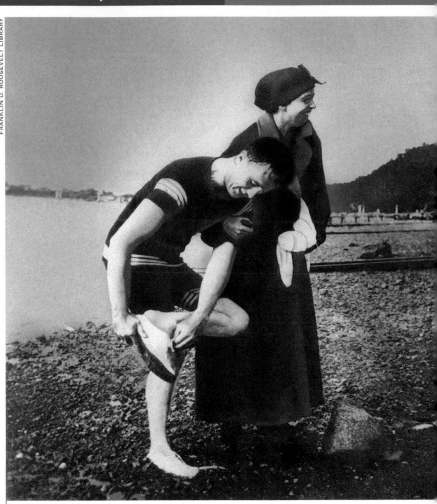

FRANKLIN D. ROOSEVELT LIBRARY

HAPPY DAY With Eleanor at Campobello in 1920; polio would strike the next year

THE ORATOR F.D.R. in an early campaig speaking against Warren Harding

It was Roosevelt's lasting accomplishment that he found a middle ground between the unbridled laissez-faire of the '20s and the brutal dictatorships of the '30s. His conviction that a democratic government had a responsibility to help Americans in distress—not as a matter of charity but as a matter of social duty—provided a moral compass to guide both his words and his actions. Believing there had

change Commission regulated a stock ma ket that had been run as an insiders' gam Federal funds protected home mortgag so that property owners could keep the homes; legislation guaranteed labor's rig to organize and established minimu wages and maximum hours. A sweepi Social Security system provided a measu of security and dignity to the elderly.

No factor was more important

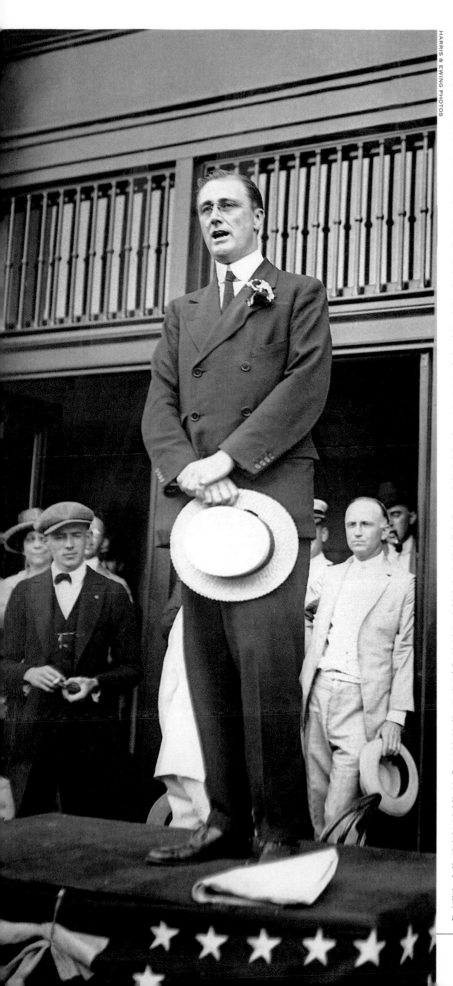

Roosevelt's success than his confidence in himself and his unshakable belief in the American people. What is more, he had a remarkable capacity to transmit his cheerful strength to others, to make them believe that if they pulled together, everything would turn out all right. The source of this remarkable confidence can be traced to his earliest days. "All that is in me goes back to the Hudson," Roosevelt liked to say, meaning not simply the peaceful, slow-moving river and the big, comfortable clapboard house but the ambiance of boundless devotion that encompassed him as a child. Growing up in an atmosphere in which affection and respect were plentiful, where the discipline was fair and loving, and the opportunities for self-expression were abundant, he came to trust that the world was basically a friendly and agreeable place. After schooling at Groton, Harvard and Columbia, he practiced law for a short period and then entered what would become his lifelong profession: politics. He won a seat in the New York State senate, became an Assistant Secretary in the Navy Department and ran as the vice-presidential candidate on the Democratic Party's unsuccessful ticket in 1920.

He was 39, at the height of his powers, when he was stricken with polio and became a paraplegic. He had been an athlete, a man who had loved to swim and sail, to play tennis and golf, to run in the woods and ride horseback in the fields. Determined to overcome his disability, he devoted seven years of his life to grueling physical therapy. In 1928, however, when he accepted the Democratic nomination for Governor of New York, he understood that victory would bring an end to his daily therapy, that he would never walk under his own power again. For the remainder of his life—through four years as Governor of New York and 12 years as President—the mere act of standing up with his heavy metal braces locked in place would be an ordeal. Yet the paralysis that crippled his body expanded his mind and his sensibilities. After what his wife Eleanor called his trial by fire, he seemed less arrogant, less superficial, more focused, more complex, more interesting. "There had been a plowing up of his nature," Labor Secretary Frances Perkins observed. "The man emerged completely warmhearted, with new humility of spirit and a firmer understanding of philosophical concepts." He had always taken great pleasure in people. But now, far more intensely than before, he reached out to know them, to pick up their emotions, to put himself in their shoes. No longer belonging to his old world in the same way, he came to empathize with the poor and the underprivileged, with people to whom fate had dealt a difficult hand.

what the people saw: radiant smile, eyes flashing

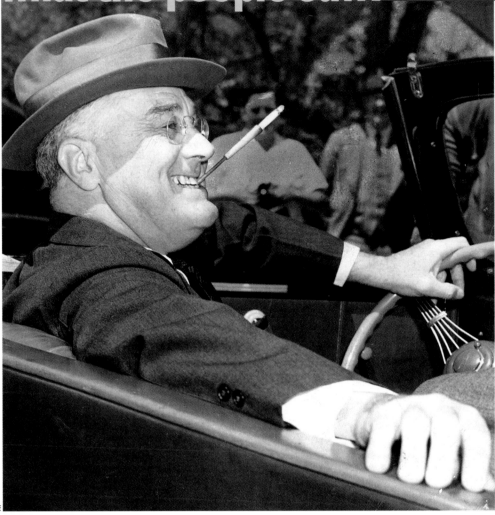

JAUNTY CONFIDENCE
Roosevelt, in Warm Springs,
Ga., 1939, exuded the
optimism his country needed

where the same voice. You coul follow without missing a singl word as you strolled by."

The press conference be came another critical tool i reaching the hearts and mind of the American people. At h very first conference, he an nounced he was suspending th wooden practice of requirin written questions submitted i advance. He promised to mee reporters twice a week an by and large kept his promise holding nearly 1,000 press con ferences in the course of h presidency. Talking in a relaxe style with reporters, he ex plained legislation, announce appointments and establishe friendly contact, calling them k their first name, teasing the about their hangovers, exudin warmth. Roosevelt's accessibi ity to the working reporte helped explain the paradox th though 80% to 85% of the new paper publishers regularly of posed his policies, his coverag was generally full and fair.

Though the national econc my remained in a depresse state until the war broke ou the massive programs of the New De had stopped the precipitous slide and prc vided an economic floor for tens of m lions of Americans. "We aren't on reli anymore," one woman noted with prid "My husband is working for the govern ment." The despair that had hung ov the land was lifted, replaced by a bustlir sense of movement and activity, a re newed confidence in the future, a revive faith in democracy. "There is a mysteriou cycle in human events," Roosevelt sai when he accepted his party's nominatic for a second term. "To some generatior much is given. Of other generations muc is expected. This generation has a rer dezvous with destiny."

In 1940 the U.S. and the democrat way of life faced a second crisis even mo fearful than the first as Hitler's armie marched through Holland, Belgium, Lu embourg and France, leaving Brita standing alone against the Nazi juggernau "Never," Winston Churchill admitted, aft the British army was forced to evacua

No other President had so thoroughly occupied the imagination of the American people. Using the new medium of the radio, he spoke directly to them, using simple words and everyday analogies, in a series of "fireside chats," designed not only to shape, educate and move public opinion forward but also to inspire people to act, making them participants in a shared drama. People felt he was talking to them personally, not to millions of others.

After his first address on the banking crisis, in which he explained to families why it was safer to return their money to the banks rather than keep it hidden at home, large deposits began flowing back into the banking system. When he asked everyone to spread a map before them in preparation for a fireside chat on the war in the Pacific, map stores sold more maps in a span of days than they had in an entire year. When he announced a rubber shortage that Americans could help fill, millions of householders, delighted at the call for service, reached into their homes

and yards to recover old rubber tires still hanging from trees as swings for their kids, as well as old garden hoses, rubber shoes and even rubber girdles.

roosevelt purposely limited his fireside talks to an average of two or three a year, in contrast to the modern presidential practice of weekly radio addresses. Timed at dramatic moments, they commanded gigantic audiences, larger than any other program on the radio, including the biggest prizefights and the most popular comedy shows. The novelist Saul Bellow recalls walking down the street on a hot summer night in Chicago while Roosevelt was speaking. Through lit windows, families could be seen sitting at their kitchen table or gathered in the parlor listening to the radio. Under the elm trees, "drivers had pulled over, parking bumper to bumper, and turned on their radios to hear Roosevelt. They had rolled down the windows and opened the car doors. Every-

from Dunkirk, "has a nation been so naked before its foes." At that moment, in all of Britain, there were only 600,000 rifles and 500 cannons, many of them borrowed from museums. With Britain on the verge of defeat, U.S. military leaders were unanimous in urging Roosevelt to stop sending our limited supply of weapons overseas and instead focus on rearming at home. At that time the U.S. Army stood only 18th in the world, trailing not only Germany, France, Britain, Russia, Italy, Japan and China, but also Holland, Spain, and Romania! So strong had been the recoil from war after

1918 that both the government and the private sector had backed away from making weapons, leaving the military with almost no modern planes, tanks or ships.

But Roosevelt was determined to send whatever he could to Britain, even if it meant putting America's short-term security in jeopardy. It was a daring decision. For if Britain were to fall in six months' time, as was predicted, and if Germany turned on the U.S. using our captured weapons, then, one general warned, everyone who was a party to the deal might expect to be found hanging from a lamppost. Undaunted, Roosevelt placed his confidence in Britain and its Prime Minister, Churchill. And his confidence proved well placed, for despite the terrifying situation the British found themselves in, with bombs raining down every night on their

ON HER OWN Eleanor Roosevelt's public activities broke the mold for First Ladies

OPEN TO ALL F.D.R. talks to homesteader Steve Brown in North Dakota in 1936

he came to empathize with the poor and the underprivileged

WARRIORS F.D.R., Eisenhower and Patton, standing at left, in Sicily, 1943

ALLIES Roosevelt, Churchill and Stalin meet at Yalta to plan Germany's occupation

as the tide of war turned, he began to put in place

cities and homes, they picked their way through the rubble every morning to get to work, refusing to be broken, proving Churchill's prediction that if the British and their empire were to last a thousand years, this would be their finest hour.

In those desperate days the seeds were planted for a historic friendship between the British Prime Minister and the American President. In the months that followed, Churchill spent weeks at a time at the White House, living in the family quarters on the second floor in a bedroom diagonally across from Roosevelt's. There was something so intimate in their friendship, Churchill's aide Lord Ismay noted. They would stroll in and out of each other's rooms as two schoolboys occupying adjacent dorm rooms might have, staying up until 2 or 3 a.m. talking, drinking brandy and smoking cigars. After each of Churchill's visits, Roosevelt was so exhausted he had to sleep 10 hours a day for three days straight until he recovered. But they took the greatest delight in each other. "It is fun to be in the same decade with you," Roosevelt told Churchill. "If anything happened to that man, I couldn't stand it," Churchill told a U.S. diplomat. "He is the truest friend; he has the farthest vision;

he is the greatest man I have ever known."

When Germany invaded Russia in 1941, Roosevelt once again defied prevailing opinion. To the isolationists, the invasion of Russia confirmed the wisdom of keeping America out of the war. America should rejoice, they argued, in watching two hated dictatorships bleed each other to death. Within the government, Roosevelt's military advisers argued that Russia had almost no chance of holding out. Still, Roosevelt insisted on including Russia in the lend-lease agreement. In the first year alone, America sent thousands of trucks, tanks, guns and bombers to Russia, along with enough food to keep Russian soldiers from starving, and enough cotton, blankets, shoes and boots to clothe the entire Russian army. The forbearance of the Russian army, in turn, bought the Allies the precious asset of time—time to mobilize the U.S. economy to produce the vast supply of weapons that was needed to catch up with and eventually surpass the Axis powers.

Roosevelt's critics were certain he would straitjacket the free-enterprise system once America began mobilizing for war. Through his first two terms, business had been driven by an almost primitive hostility to Roosevelt, viewing his support

for the welfare state and organized labor a an act of betrayal of his class. Indeed, so ar gry were many Republican businessmen a Roosevelt that they refused even to say th President's name, referring to him simpl as "that man in the White House." Yet, u der Roosevelt's wartime leadership, th government entered into the most produ tive partnership with private enterpris the country had ever seen, bringing to businessmen in to run the productio agencies, exempting business from ant trust laws, allowing business to write o the full cost of investments and guarantee ing a substantial profit. The output wa staggering. By 1943, American productio had not only caught up with Germany's 10 year lead but America was also outprodue ing all the Axis and the Allied powers con bined, contributing nearly 300,000 plane 100,000 tanks, 2 million trucks and 87,00 warships to the Allied cause. "The figure are all so astronomical," historian Bruc Catton marveled. "It was the equivalent building two Panama Canals every montl with a fat surplus to boot."

Above all, Roosevelt possessed a ma nificent sense of timing. He understoc when to invoke the prestige of the pres dency and when to hold it in reserve. H

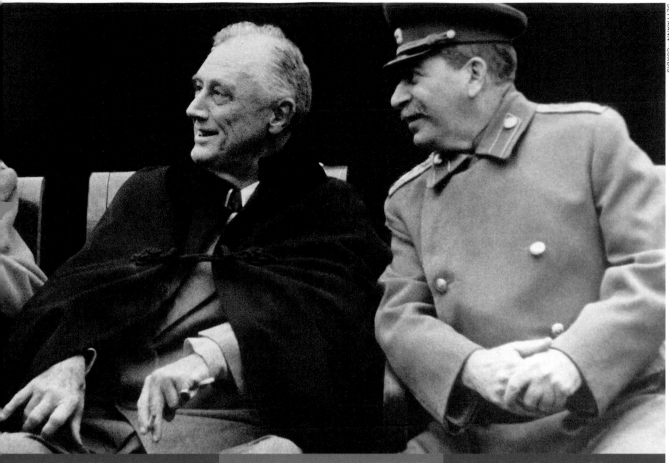

ments of his vision for the world that would follow the titanic conflict

picked a first-class military team—General George Marshall, Admiral Ernest King, General Henry Arnold and Admiral William Leahy—and gave its members wide latitude to run the war. Yet at critical junctures he forced action, and almost all those actions had a salutary effect on the war. He personally made the hotly debated decision to invade North Africa; he decided to spend $2 billion on an experimental atom bomb; and he demanded the Allies commit themselves to a postwar structure before the war was over.

S till, there were many days in the early years of the war when the situation looked bleak, when it seemed impossible that the Allies could overcome the lead the Axis powers enjoyed. Through those dark days, Roosevelt retained an imperturbable calm. To the endless wonder of his aides, he was able to relax and replenish his energies each night to face the struggles of the following day. Every evening he held a cocktail hour where the rule was that nothing could be said of politics or war; instead the conversation was deliberately turned to gossip, funny stories or reminiscences. Only Eleanor was allowed to bring

up serious subjects, to talk of civil rights or slum clearance. Roosevelt spent untold hours sorting his stamp collection, playing poker with his Cabinet members, watching mystery movies. Only when Eleanor chose the movies did he agree to sit through serious pictures—*The Grapes of Wrath* or a documentary on civil rights.

It was said jokingly in Washington that Roosevelt had a nightly prayer: Dear God, please make Eleanor a little tired. But as Roosevelt himself would be the first to admit, he would never have become the kind of President he was without his tireless wife. She was the agitator dedicated to what should be done; he was the politician concerned with what could be done. It was Eleanor who insisted that the government's wartime partnership with business must not be forged at the expense of labor. It was Eleanor who insisted that America could not fight racism abroad while tolerating it at home. It was Eleanor who championed the movement of women into the work force during the war. Many joined her in these efforts—civil rights leaders, labor leaders, liberal spokesmen. But her passionate voice in the highest councils of decision was always influential and often decisive.

To be sure, Franklin Roosevelt was far from perfect. Critics lamented his deviousness, his lack of candor, his tendency to ingratitude. His character flaws were widely discussed: his stubbornness, his vanity, his occasional vindictiveness, his habit of yessing callers just to be amiable. At times, his confidence merged into arrogance, diminishing his political instincts, leading to an ill-defined court-packing scheme and an unsuccessful attempt to purge his opponents in the 1938 by-elections. One must also concede the failures of vision that led to the forcible relocation of Japanese Americans, which deprived tens of thousands of men, women and children of Japanese descent of their fundamental civil liberties, and the devastating failure to bring more Jewish refugees into America before Hitler finally closed the doors to emigration.

But in the end, Roosevelt's great strengths far outweighed his weaknesses. As the tide of war began to turn decisively, in the year before his death, Roosevelt began to put in place the elements of his vision for the world that would follow the titanic conflict. It was to be a world in which all peoples were entitled to govern themselves. With this aim, he foresaw and

paralysis crippled his body but expanded his sensibilities

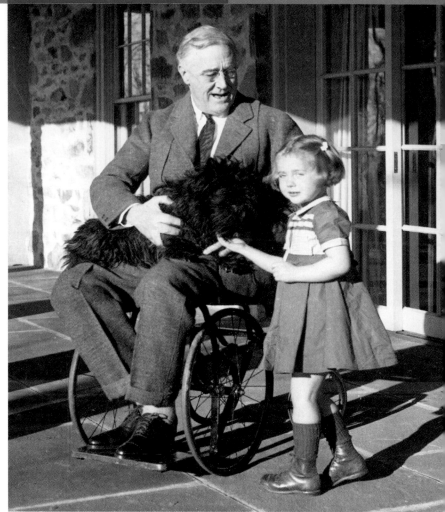

UNGUARDED MOMENT At Hyde Park,
F.D.R. with the caretaker's granddaughter

worked toward the end of the colonial imperialism that had dominated much of the globe. Through the U.N., which he was instrumental in establishing, we would, he hoped, finally have an international structure that could help keep the peace among the nations. His call for recognition of four universal freedoms so firmly established the still unfinished agenda for humanity that a recent British publication, assessing the century, noted that Franklin Roosevelt's Four Freedoms—from fear and from want, and of belief and expression—are possessed by more people, more securely, than ever before. Today, more than a half-century after his death, Roosevelt's vision, still unfulfilled, still endangered, remains the guardian spirit for the noblest and most humane impulses of mankind.

When he died, even his most partisan adversaries felt compelled to acknowledge the immensity of the man they had opposed. Senator Robert Taft, known as Mr. Republican, considered Roosevelt's death one of the worst tragedies that had ever happened to the country. "The President's death removes the greatest figure of our time at the very climax of his career, and shocks the world to which his words and actions were more important than those of any other man. He dies a hero of the war, for he literally worked himself to death in the service of the American people."

As Eleanor traveled the country in the months after her husband's death, she was overwhelmed by the emotion of all the people who came up to her, telling her how much they had loved her husband. Porters at the station, taxi drivers, doormen, elevator operators, passengers on the train, riders in the subway told her how much better their lives were as a result of his leadership.

Blacks talked of the pride they felt in the work they had accomplished at home, the courage they had shown in their battalions abroad—a pride that would fuel the civil rights movement in the decade ahead. Women talked of the camaraderie, the feelings of accomplishment they had experienced in the shipyards and the factories. And even though the factories were firing the women that summer and closing down the day-care centers that would not reopen for a generation, Eleanor could see that there had been a change of consciousness that would mean no turning back. She

talked to G.I.s who were going to college on Roosevelt's G.I. Bill of Rights, the remarkable piece of legislation that opened the door to the upward mobility of an entire generation. A social revolution had taken place; a new economic order had come into being; a vast middle class had been born.

An image formed in Eleanor's mind, that during the course of her husband's presidency a giant transference of energy had taken place between him and the people. In the early days, the country was fragile, weak and isolationist, while her husband was full of energy, vital and productive. But gradually, as the President animated his countrymen with his strength and confidence, the people grew stronger and stronger, while he grew weaker and weaker, until in the end he was so weakened he died, but the country emerged more powerful, more productive and more socially just than ever before. It was, to be sure, a romanticized view of her husband's presidency, but it suggests the ultimate mystery of Roo-

sevelt's leadership—his ability to use his moral authority, the degree of confidence he inspired, to strengthen the people and bind them together in a just cause.

His example strengthened democracy everywhere. "He became a legendary hero," the British philosopher Isaiah Berlin argued. "Peoples far beyond the frontiers of the U.S. rightly looked to him as the most genuine and unswerving spokesman of democracy. He had all the character and energy and skill of the dictators, and he was on our side."

It may well be true that crisis and war provide a unity of purpose and an opportunity for leadership that are rarely present in more tranquil times. But as the history of other countries illustrates, war and domestic upheaval are no guarantee of positive social change. That depends on the times, the nation and the exercise of leadership. In providing the indispensable leadership that preserved and strengthened democracy, Franklin Roosevelt emerges as the greatest political leader of the age. ▪

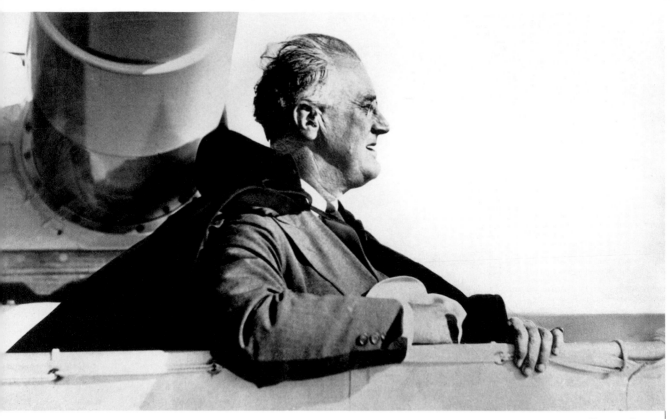

HIS EYE ON THE HORIZON Roosevelt on the deck of the U.S.S. *Houston* in 1939

captain courageous

By Bill Clinton

The U.S. President weighs F.D.R.'s legacy and finds timeless fortitude, persistence and respect for the common man

When our children's children read the story of the 20th century, they will see that above all, it is the story of freedom's triumph: the victory of democracy over fascism and totalitarianism; of free enterprise over command economies; of tolerance over bigotry. And they will see that the embodiment of that triumph, the driving force behind it, was President Franklin Delano Roosevelt.

In the century's struggle for freedom, Roosevelt won two decisive victories: first over economic depression and then over fascism. Though he was surrounded by

Clinton is the first Democratic President since F.D.R. to be elected to a second term.

turmoil, he envisioned a world of lasting peace, and he devoted his life to building a new era of progress. Roosevelt's leadership steered not only America but also the world through the roughest seas of the century. And he did it with a combination of skilled statesmanship, innovative spirit and, as Oliver Wendell Holmes Jr. put it, "a first-class temperament."

Even though Franklin Roosevelt was the architect of grand designs, he touched tens of millions of Americans in a very personal way. When I first worked on political campaigns in the 1960s, I could not help noticing the pictures of F.D.R. that graced the walls and mantels of so many of the homes I visited. To ordinary Americans, Roosevelt was always more than a great President, he was part of the family.

My own grandfather felt the same way. He came from a little town of about 50 people, had only a fourth-grade education and owned a small store. Still, he believed this President was a friend, a man who cared about him and his family's future. My grandfather was right about that. So were the millions of Americans who met President Roosevelt only through his radio fireside chats. Roosevelt earned his place in the homes and hearts of a whole generation, and we should all be proud that his picture now hangs in the people's house, the White House.

As a state legislator, Governor and President, Roosevelt pioneered the politics of inclusion. He built a broad, lasting, national coalition uniting different regions, different classes and different races. He identified with the aspirations of immigrants, farmers and factory workers—"the forgotten Americans," as he called them. He considered them citizens of America just as fully as he was.

Roosevelt knew in the marrow of his bones, from his own struggle with polio and his innate grasp of the American temper, that restoring optimism was the beginning of progress. "The only thing we have to fear is fear itself" was both the way he led his life and the way he led our nation.

No matter what the challenge, he believed that the facts were only one part of

TEARS OF GRIEF Naval CPO Graham Jackson plays a dirge at F.D.R.'s death

reality; the other part was how you react to them and change them for the better. In the depths of the Great Depression, the gravest economic threat the country ever faced, he lifted the nation to its feet and into action.

From his vision emerged the great American middle class that has been the engine of more than five decades of progress and prosperity. From his new ideas flowed the seemingly endless array of programs and agencies of the New Deal: bank reform, a massive public-works effort to get America working again, rural electrification, the G.I. Bill. And, of course, his most enduring domestic creation, Social Security, a bond between generations that every President since has honored. Roosevelt proved that for markets to flourish, government must be devoted to opportunity for all. He understood that the initiative of individuals and the responsibilities of community must be woven together.

To defeat the merciless aggression of fascism, President Roosevelt created an international alliance to defend the world's freedom, and he committed the United States to lead. He proved that our liberty is linked to the destiny of the world, that our security requires us to support democracy beyond our shores, that human rights must be America's cause. In the 20th century's greatest crisis, President Roosevelt decisively, irrevocably committed our country to freedom's fight.

Early in World War II, he defined the Four Freedoms that he said must be realized everywhere in the world: freedom of speech, freedom of worship, freedom from want, freedom from fear. These were, in his own words, "essential human freedoms." His expression of American ideals helped make them the world's ideals. Because of that commitment and its embrace by every American President since, today we can say, for the first time in history, a majority of the world's people live under governments of their own choosing.

roosevelt's leadership in war and his commitment to peace established the institutions of collective security that have prevented another world conflagration. The whole system of international cooperation stems from his commitment. It was President Roosevelt, after all, who conceived and named the United Nations, and he was one of the visionaries behind the establishment of the World Bank and the International Monetary Fund. In one of his last messages to Congress, he said their creation "spelled the difference between a world caught again in the maelstrom of panic and economic warfare, or a world in which nations strive for a better life through mutual trust, cooperation and assistance."

Much of my own political philosophy and approach to governance is rooted in Roosevelt's principles of progress. That's why one of the first things I did after I be-

came President was make a pilgrimage to Hyde Park. And that's why when Prime Minister Tony Blair came to visit, I took him on a tour of the F.D.R. Memorial. Rather than cling to old abstractions or be driven by the iron laws of ideology, Roosevelt crafted innovations to the circumstances in which he found himself. He sought, above all, practical solutions that worked for people. He called his pragmatic method "bold, persistent experimentation." If one thing doesn't work, he explained, "try another; but above all, try something."

Winston Churchill remarked that Franklin Roosevelt's life was one of the commanding events in human history. The triumph of freedom in the face of depression and totalitarianism was not foretold or inevitable. It required political courage and leadership. We now know what Roosevelt and his generation made of their "rendezvous with destiny." Their legacy is our world of freedom. If the example of Franklin Roosevelt and the American Century has taught us anything, it is that we will either work together as One America to shape events or we will be shaped by them. We cannot isolate ourselves from the world; we cannot lead in fits and starts. Now, to this generation entering the new millennium, as Roosevelt said, "much has been given" and "much is expected." ∎

Family news that

every parent should read.

(In that spare time no

parent actually has.)

The world's most interesting magazine.

mohandas ga

(1869-1948)

In an age of empire and military might, he proved that the powerless had power and that force of arms would not forever prevail against force of spirit

By Johanna McGeary

t he Mahatma, the Great Soul, endures in the best part of our minds, where our ideals are kept: the embodiment of human rights and the creed of nonviolence. Mohandas Karamchand Gandhi is something else, an eccentric of complex, contradictory and exhausting character most of us hardly know. It is fashionable at this fin de siècle to use the man to tear down the hero, to expose human pathologies at the expense of larger-than-life achievements. No myth

raking can rob Gandhi of his moral force or diminish the remarkable importance of this scrawny little man. For the 20th century—and surely for the ones to follow—it is the towering myth of the Mahatma that matters.

Consciously or not, every oppressed people or group with a cause has practiced what Gandhi preached. Sixties kids like me were his disciples when we went South in the Freedom Summer to sit in for civil rights and when we paraded through the streets of America to stop the war in Vietnam. Our passionate commitment, nonviolent activism, willingness to accept punishment for civil disobedience were lessons he taught. Martin Luther King Jr. learned them; so did Nelson Mandela,

Lech Walesa, Aung San Suu Kyi, the unknown Chinese who defied the tanks in 1989 and the environmental marchers in Seattle a few weeks ago.

It may be that this most Indian of leaders, revered as Bapuji, or Father of the Nation, means more now to the world at large. Foreigners don't have to wrestle with the confusion Indians feel today as they judge whether their nation has kept faith with his vision. For the rest of us, his image offers something much simpler—a shining set of ideals to emulate. Individual freedom. Political liberty. Social justice. Nonviolent protest. Passive resistance. Religious tolerance. His work and his spirit awakened the 20th century to ideas that

Painting for TIME by Tim O'Brien

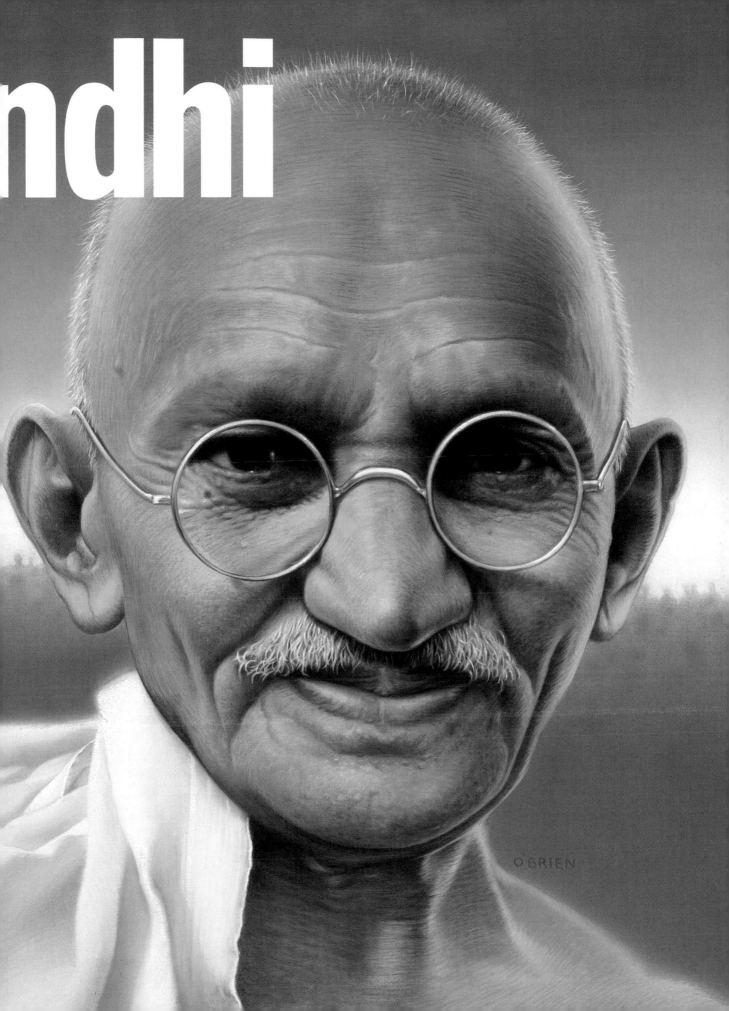

ndhi

O'BRIEN

serve as a moral beacon for all epochs.

Half a century after his death, most of us know little of Gandhi's real history or how the Mahatma in our minds came to be. Hundreds of biographies uncritically canonize him. Winston Churchill scorned him as a half-naked fakir stirring up sedition. His generation knew him as a radical political agitator; ours shrugs off a holy man with romantic notions of a pure, pre-industrial life. There is no either-or. The saint and the politician inhabited the same slender frame, each nourishing the other. His struggle for a nation's rights was one and the same with his struggle for individual salvation.

The flesh-and-blood Gandhi was a most unlikely saint. Just conjure up his portrait: a skinny, bent figure, nut brown and naked except for a white loincloth, cheap spectacles perched on his nose, frail hand grasping a tall bamboo staff. This was one of the century's great revolutionaries? Yet this strange figure swayed millions with his hypnotic spell. His garb was the perfect uniform for the kind of revolutionary he was, wielding weapons of prayer and nonviolence more powerful than guns.

Saints are hard to live with, and this one's personal habits were decidedly odd. Mondays were "days of silence," when he refused to speak. A devoted vegetarian, he indulged in faddish dietetic experiments that sometimes came near to killing him. He eschewed all spices as a discipline of the senses. He napped every day with a mud poultice on abdomen and brow. He was so insistent on absolute regularity in his daily regimen that he safety-pinned a watch to his home-spun dhoti, synchronized with the clock at his ashram. He scheduled his bowel movements for 20 minutes morning and afternoon. "The bathroom is a temple," he said, and anyone was welcome to chat with him there. He had a cleansing enema every night.

Gandhi bathed in water but used ashes instead of soap and had himself shaved with a dull straight razor because new blades were too expensive. He was always sweeping up excrement that others left around. Cleanliness, he believed, was godliness. But his passion for sanitation was not just finicky hygiene. He wanted to teach Indian villagers that human and animal filth caused most of the disease in the land.

Every afternoon, Gandhi did an hour or two of spinning on his little handwheel, sometimes 400 yards at a sitting. "I am spinning the destiny of India," he would say. The thread went to make cloth for his followers, and he hoped his example would convince Indians that homespun could free them from dependence on foreign products. But the real point of the spinning was to teach appreciation for manual labor, restore self-respect lost to colonial subjugation and cultivate inner strength.

The man was not unaware of his legend in the making—or the 90-plus volumes that would eventually be needed to preserve his words. Everything Gandhi ever said and did was recorded by legions of secretaries. Then he insisted on going over their notes

KANU GANDHI

THE ASCETIC
Gandhi pursued bizarre practices, and his beliefs strained his marriage

SERMON ON THE BEACH
The ocean, far right, with its salt and symbolism, was a poignant setting

the wellspring of his politics was religion;

M.K.GANDHI. ATTORNEY.

CAMERA PRESS—PIX INC.

THE PREQUEL
At his Johannesburg law office in British-ruled South Africa

ORIGINAL SPIN
He sought to free India from the British—and overwhelming modernity

and choosing the version he liked best. "I want only one gospel in my life," he said.

A strange amalgam of beliefs formed the complicated core of Gandhism. History will merely smile at his railing against Western ways, industrialism and material

est for goodness made him a great revolutionary

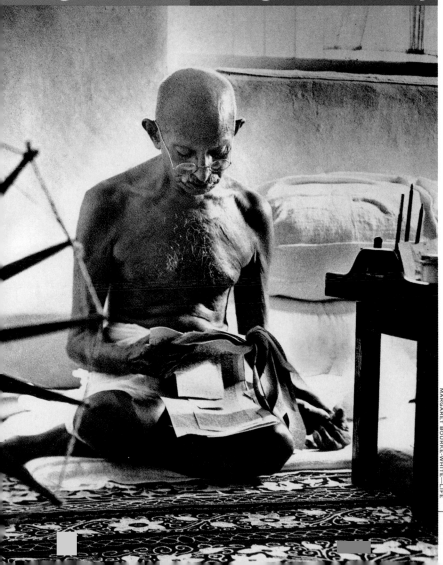

pleasures. He never stopped calling for a nation that would turn its back on technology to prosper through village self-sufficiency, but not even the Mahatma could hold back progress. Yet many today share his uneasiness with the way mechanization and materialism sicken the human spirit.

More central and even more controversial was Gandhi's cult of celibacy. At 13, he dutifully married and came quickly to lust for his wife Kasturba. At 16 he left his dying father's side to make love to her. His father died that night, and Gandhi could never forgive himself the "double shame." He neglected and even humiliated Kasturba most of his life and only after her death realized she was "the warp and woof of my life." At 36, convinced that sex was the basis of all impulses that must be mastered if man was to reach Truth, he renounced it. An aspirant to a godly life must observe the Hindu practice of Brahmacharya, or celibacy, as a means of self-control and a way to devote all energy to public service. Gandhi spent years testing his self-discipline by sleeping beside young women. He evidently cared little about any psychological damage to the women involved. He also expected his four sons to be as self-denying as he was.

Gandhi sought God, not orthodoxy. His daily prayers mixed traditional Hindu venerations with Buddhist chants, readings from the Koran, a Zoroastrian verse or two and the Christian hymn *Lead, Kindly Light.* That eclecticism reflected his great tolerance for all religions, one of his holiest—and least respected—precepts. "Truth," he preached, "is God," but he could never persuade India's warring religious sects to agree. His spiritual mentors were just as broad—Jesus, Buddha, Socrates, his mother. Gandhi later said his formative childhood impression was of her "saintliness" and her devout asceticism infused his soul. The family's brand of Hinduism schooled him in the sacredness of all God's creatures.

While studying in England to be a lawyer, he first read the Bible and the Bhagavad Gita, the Hindu religious poem that became his "spiritual dictionary." For Gandhi, the epic was a clarion call to the soul to undertake the battle of righteousness. It taught him to renounce personal desires not by withdrawal from the world but by devotion to the service of his fellow man. In the Christian New Testament he found the stirrings of passive resistance in the words of the Sermon on the Mount.

Those credos came together in the two principles that ruled his public life: what he called Satyagraha, the force of truth and love; and the ancient Hindu ideal of ahimsa, or nonviolence to all living things. He first put those principles to political work in South Africa, where he had gone to practice law and tasted raw discrimina-

"everybody is eager to garland my photos," he said of his ov

tion. Traveling to Johannesburg in a first-class train compartment, he was ordered to move to the "colored" cars in the rear. When he refused, he was hauled off the train and left to spend a freezing night in the station. The next day he was humiliated and cuffed by the white driver of a stagecoach. The experience steeled his resolve to fight for social justice.

In 1906, confronting a government move to fingerprint all Indians, Gandhi countered with a new idea—"passive resistance," securing political rights through personal suffering and the power of truth and love. "Indians," he wrote, "will stagger humanity without shedding a drop of blood." He failed to provoke legal changes, and Indians gained little more than a new-found self-respect. But Gandhi understood the universal application of his crusade. Even his principal adversary, the Afrikaner leader Jan Smuts, recognized the power of his idea: "Men like him redeem us from a sense of commonplace and futility."

South Africa was dress rehearsal for Gandhi's great cause, independence for India. From the day he arrived back home at 45, he dedicated himself to "Hind swaraj," Indian self-rule. More than independence, it meant a utopian blend of national liberty, individual self-reliance and social justice. Freedom entailed individual emancipation as well, the search for nobility of soul through self-discipline and denial. Most ordinary Indians, though, were just looking for an end to colonial rule. While his peace-and-love homilies may not have swayed them, they followed him because he made the British tremble.

"Action is my domain," he said. "It's not what I say but what I do that matters." He quickly became the commanding figure of the movement and brooked no challenge to his ultimate leadership. The force of his convictions transformed the Indian National Congress from upper-class movement to mass crusade. He made his little spinning wheel a physical bond between

élite and illiterate when both donned the khadi cloth. Despite the country's proclivities for ethnic and religious strife, he inspired legions of Indians to join peaceful protests that made a mockery of empire.

In the next 33 years, he led three major crusades to undermine the power and moral defenses of the British Raj. In 1919-22 he mustered widespread nonviolent strikes, then a campaign of peaceful noncooperation, urging Indians to boycott anything British—schools, courts, goods, even the English language. He believed mass noncooperation would achieve independence within a year. Instead, it degenerated into bloody rioting, and British soldiers turned their guns on a crowd in Amritsar, massacring 400. Gandhi called his underestimating of the violence inside Indian society his "Himalayan blunder." Still, villagers mobbed him wherever he went, calling him Mahatma. By 1922, 30,000 followers had been jailed, and Gandhi ordered civil disobedience. The British slowed the

momentum by jailing him for 22 months.

Gandhi was never a man to give up. On March 12, 1930, he launched his most brilliant stroke, national defiance of the law forbidding Indians to make their own salt. With 78 followers, he set out for the coast to make salt until the law was repealed. By the time he reached the sea, people all across the land had joined in. Civil disobedience spread until Gandhi was arrested again. Soon more than 60,000 Indians filled the jails, and Britain was shamed by the gentle power of the old man and his unresisting supporters. Though Gandhi had been elected to no office and represented no government, the Viceroy soon began negotiating with him.

World War II caught him by surprise. The unremitting pacifist did not grasp the evil of Hitler because he thought no man beyond redemption. He deeply offended Jews when he counseled them to follow the path of nonviolence. Gandhi did not want Britain's defeat, but recognized a political opportunity. In late 1940 he agreed to a modest campaign of individual civil disobedience he intended to be largely symbolic.

But other politicians pressed hard for nonviolent mass struggle against a Raj dangerously weakened by the threat of Japanese invasion. In 1942 Gandhi reluctantly endorsed the Quit India plan, calling on London for Indian independence "before dawn, if it could be had." He and the Congress leaders were arrested and jailed. Huge demonstrations soon flared into rioting and revolt. Mobs attacked any symbol of British power, and the disorder cut off British communications to its armies at the frontier. Government forces struck back hard, and nearly 1,000 Indians were killed before the uprising flamed out. Gandhi was finally freed on May 5, 1944. He had spent 2,338 days of his 74 years imprisoned.

By war's end, Britain was ready to let India go. But the moment of Gandhi's greatest triumph, on August 15, 1947, was also the hour of his defeat. India gained freedom but lost unity when Britain granted independence on the same day it created the new Muslim state of Pakistan. Partition dishonored Gandhi's sect-blind creed. "There is no message at all," he said that day and turned to fasting and prayer.

a t 77, he despaired that "my life's work seems to be over." Had liberty been won by the long years of peaceful and moral coercion or the violent spasm of Quit India? Resentment of Britain had been replaced by religious hatred. The killing before partition made it inevitable, and the slaughter afterward trampled on his appeals to tolerance and trust. All the village pilgrimages he made in 1946 and 1947 could not stop Muslims and Hindus from killing one another. All the famous fasts he undertook could not persuade them to live permanently in harmony. He blamed himself when Indians rejected the nonviolence he had made a way of life.

Assassination made a martyr of the apostle of nonviolence. The Hindu fanatic who fired three bullets into Gandhi at point-blank range on Jan. 30, 1948, blamed him for letting Muslims steal part of the Hindu nation, for not hating Muslims. Not long before, Gandhi had noted his new irrelevance. "Everybody is eager to garland my photos," he said. "But nobody wants to follow my advice."

He was both right and wrong. Interest in the flesh-and-blood Mohandas Karamchand has faded away. We revere the Mahatma while ignoring half of what he taught. His backward, romantic vision of a simple society seems woolly minded. Much of his ascetic personal philosophy has lost meaning for later generations. Global politics have little place today for his absolute pacificism or gentle tolerance.

Yet Gandhi is that rare great man held in universal esteem, a figure lifted from history to moral icon. The fundamental message of his transcendent personality persists. He stamped his ideas on history, igniting three of the century's great revolutions—against colonialism, racism, violence. His concept of nonviolent resistance liberated one nation and sped the end of colonial empires around the world. His marches and fasts fired the imagination of oppressed people everywhere. Like the millions of Indians who pressed around his funeral cortege seeking darshan—contact with his sanctity—millions more have sought freedom and justice under the Mahatma's guiding light. He shines as a conscience for the world. The saint and the politician go hand in hand, proclaiming the power of love, peace and freedom. ■

THE ADORING CROWDS
Everywhere he traveled, opposite page, he was greeted as Mahatma, the Great Soul

A HUNGER FOR PEACE
As India descended into partition, Gandhi fasted for calm, left—to no avail

A FINAL FIRE
After cremation, his ashes were strewn in the confluence of the Jumna and Ganges rivers

...levance, "but nobody wants to follow my advice."

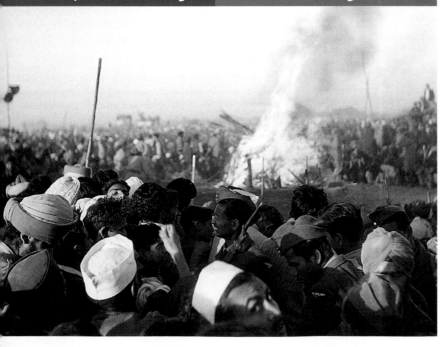

the sacred warrior

By Nelson Mandela

The liberator of South Africa looks at the
seminal work of the liberator of India

India is Gandhi's country of birth; South Africa his country of adoption. He was both an Indian and a South African citizen. Both countries contributed to his intellectual and moral genius, and he shaped the liberatory movements in both colonial theaters.

He is the archetypal anti-colonial revolutionary. His strategy of noncooperation, his assertion that we can be dominated only if we cooperate with our dominators, and his nonviolent resistance inspired anti-colonial and antiracist movements internationally in our century.

Both Gandhi and I suffered colonial oppression, and both of us mobilized our respective peoples against governments that violated our freedoms.

The Gandhian influence dominated freedom struggles on the African continent right up to the 1960s because of the power it generated and the unity it forged among the apparently powerless. Nonviolence was the official stance of all major African coalitions, and the South African A.N.C. remained implacably opposed to violence for most of its existence.

Gandhi remained committed to nonviolence; I followed the Gandhian strategy for as long as I could, but then there came a point in our struggle when the brute force of the oppressor could no longer be countered through passive resistance alone. We founded *Unkhonto we Sizwe* and added a military dimension to our struggle. Even then, we chose sabotage because it did not involve the loss of life, and it offered the best hope for future race relations. Mil-

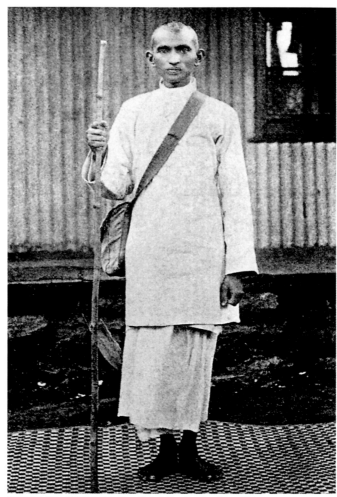

THE GOOD SHEPHERD Gandhi at the beginning of his crusade

itant action became part of the African agenda officially supported by the Organization of African Unity (O.A.U.) following my address to the Pan-African Freedom Movement of East and Central Africa (PAFMECA) in 1962, in which I stated, "Force is the only language the imperialists can hear, and no country became free without some sort of violence."

Gandhi himself never ruled out violence absolutely and unreservedly. He conceded the necessity of arms in certain situations. He said, "Where choice is set between cowardice and violence, I would advise violence... I prefer to use arms in defense of honor rather than remain the vile witness of dishonor..."

Violence and nonviolence are not mutually exclusive; it is the predominance of the one or the other that labels a struggle.

Gandhi arrived in South Africa in 1893 at the age of 23. Within a week he collided head on with racism. His immediate response was to flee the country that so degraded people of color, but then his inner resilience overpowered him with a sense of mission, and he stayed to redeem the dignity of the racially exploited, to pave the way for the liberation of the colonized the world over and to develop a blueprint for a new social order.

He left 21 years later, a near *maha atma* (great soul). There is no doubt in my mind that by the time he was violently removed from our world, he had transited into that state.

No ordinary leader—divinely inspired

He was no ordinary leader. There are those who believe he was divinely inspired, and it is difficult not to believe with them. He dared to exhort nonviolence in a time when the violence of Hiroshima and Nagasaki had exploded on us; he exhorted morality when science, technology and the capitalist order had made it redundant; he replaced self-interest with group interest without minimizing the importance of self. In fact, the interdependence of the social and the personal is at the heart of his philosophy. He seeks the simultaneous and interactive development of the moral person and the moral society.

His philosophy of Satyagraha is both a personal and a social struggle to realize the Truth, which he identifies as God, the Ab-

Mandela served as South Africa's first democratically elected President from 1994 to '99

lute Morality. He seeks this Truth, not in isolation, self-centeredly, but with the people. He said, "I want to find God, and because I want to find God, I have to find God along with other people. I don't believe I can find God alone. If I did, I would be running to the Himalayas to find God in some cave there. But since I believe that nobody can find God alone, I have to work with people. I have to take them with me. Alone I can't come to Him."

He sacerises his revolution, balancing the religious and the secular.

Awakening His awakening came on the hilly terrain of the so-called Bambata Rebellion, where as a passionate British patriot, he led his Indian stretcher-bearer corps to serve the Empire, but British brutality against the Zulus roused his soul against violence as nothing had done before. He determined, on that battlefield, to wrest himself of all material attachments and devote himself completely and totally to eliminating violence and serving humanity. The sight of wounded and whipped Zulus, mercilessly abandoned by their British persecutors, so appalled him that he turned full circle from his admiration for all things British to celebrating the indigenous and ethnic. He resuscitated the culture of the colonized and the fullness of Indian resistance against the British; he revived Indian handicrafts and made these into an economic weapon against the colonizer in his call for swadeshi—the use of one's own and the boycott of the oppressor's products, which deprive the people of their skills and their capital.

A great measure of world poverty today and African poverty in particular is due to the continuing dependence on foreign markets for manufactured goods, which undermines domestic production and dams up domestic skills, apart from piling up unmanageable foreign debts. Gandhi's insistence on self-sufficiency is a basic economic principle that, if followed today, would contribute significantly to alleviating Third World poverty and stimulating development.

Gandhi predated Frantz Fanon and the black-consciousness movements in South Africa and the U.S. by more than a half-century and inspired the resurgence of the indigenous intellect, spirit and industry.

Gandhi rejects the Adam Smith notion of human nature as motivated by self-interest and brute needs and returns us to our spiritual dimension with its impulses for nonviolence, justice and equality.

He exposes the fallacy of the claim that everyone can be rich and successful provided they work hard. He points to the millions who work themselves to the bone and still remain hungry. He preaches the gospel of leveling down, of emulating the kisan (peasant), not the zamindar (landlord), for "all can be kisans, but only a few zamindars."

He stepped down from his comfortable life to join the masses on their level to seek equality with them. "I can't hope to

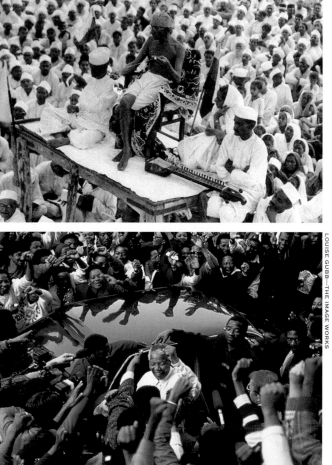

WITH THE POWER OF THE PEOPLE Gandhi, top, and Mandela

bring about economic equality ... I have to reduce myself to the level of the poorest of the poor."

From his understanding of wealth and poverty came his understanding of labor and capital, which led him to the solution of trusteeship based on the belief that there is no private ownership of capital; it is given in trust for redistribution and equalization. Similarly, while recognizing differential aptitudes and talents, he holds that these are gifts from God to be used for the collective good.

He seeks an economic order, alternative to the capitalist and communist, and finds this in sarvodaya based on nonviolence (ahimsa).

He rejects Darwin's survival of the fittest, Adam Smith's laissez-faire and Karl Marx's thesis of a natural antagonism between capital and labor, and focuses on the interdependence between the two.

He believes in the human capacity to change and wages Satyagraha against the oppressor, not to destroy him but to transform him, that he cease his oppression and join the oppressed in the pursuit of Truth.

We in South Africa brought about our new democracy relatively peacefully on the foundations of such thinking, regardless of whether we were directly influenced by Gandhi or not.

Gandhi remains today the only complete critique of advanced industrial society. Others have criticized its totalitarianism but not its productive apparatus. He is not against science and technology, but he places priority on the right to work and opposes mechanization to the extent that it usurps this right. Large-scale machinery, he holds, concentrates wealth in the hands of one man who tyrannizes the rest. He favors the small machine; he seeks to keep the individual in control of his tools, to maintain an interdependent love relation between the two, as a cricketer with his bat or Krishna with his flute. Above all, he seeks to liberate the individual from his alienation to the machine and restore morality to the productive process.

As we find ourselves in jobless economies, societies in which small minorities consume while the masses starve, we find ourselves forced to rethink the rationale of our current globalization and to ponder the Gandhian alternative.

At a time when Freud was liberating sex, Gandhi was reining it in; when Marx was pitting worker against capitalist, Gandhi was reconciling them; when the dominant European thought had dropped God and soul out of the social reckoning, he was centralizing society in God and soul; at a time when the colonized had ceased to think and control, he dared to think and control; and when the ideologies of the colonized had virtually disappeared, he revived them and empowered them with a potency that liberated and redeemed. ∎

the children
of gandhi

His strategy of nonviolence has spawned
generations of spiritual heirs around the world

DON FARBER—CORBIS SYGMA

Tibet: The Dalai Lama

At the site of Gandhi's cremation, he said, "To me, he was ... the consummate politician, a man who put his belief in altruism above any personal considerations. I was convinced too that his devotion to the cause of nonviolence was the only way to conduct politics"

Poland: Lech Walesa

Harassed by the communist regime, the founder of the Solidarity labor union insisted, "We shall not yield to violence." He said his protests, which began in 1981, were "a historic opportunity for a peaceful evolution." In 1989, as the Soviet bloc wobbled, Solidarity took over the Prime Ministership; in 1990, Walesa became President

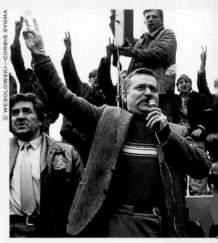

© WESOLOWSKI—CORBIS SYGMA

The U.S.: Martin Luther King Jr. And Rosa Parks

To desegregate Nashville's lunch counters in 1958, King, right, brought in James Lawson, a student of Gandhi's, to train protesters in nonviolence. But the most dramatic act of quiet defiance belonged to Rosa Parks, below, being fingerprinted in 1955. Her refusal to give up a seat in a Montgomery, Ala., bus galvanized the civil rights movement and boosted King's leadership

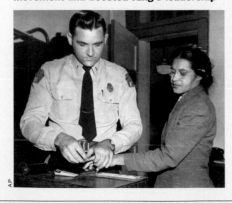

AP

CHARLES MOORE—BLACK STAR

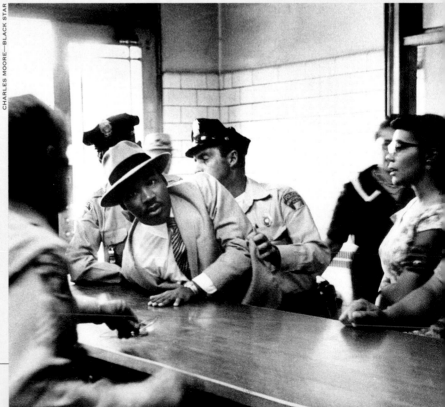

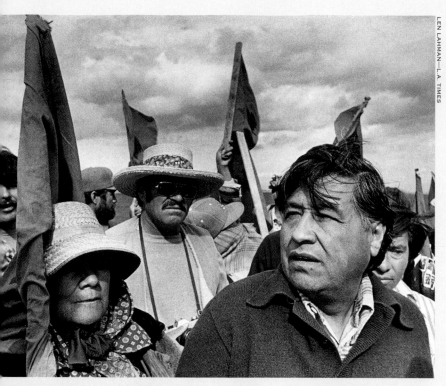

LEN LAHMAN—L.A. TIMES

The U.S.: Cesar Chavez

The United Farm Workers organizer, left, organized pickets, boycotts and, inspired by the Mahatma, hunger strikes. Agreeing with Gandhi, Chavez said, "Fasting is the last resort in place of the sword"

The U.S.: Larry Kramer

The famously cantankerous playwright, below left, inspired ACT-UP's famously confrontational protests for an AIDS cure in the late '80s. As a result, gay and lesbian civil rights are loud parts of public debate

Myanmar: Aung San Suu Kyi

Under house arrest, the opposition leader, below center, espouses nonviolence, despite the junta's tactics. Fighting, she says, "will perpetuate the tradition that he who is best at wielding arms, wields power"

Philippines: Benigno Aquino Jr.

A firebrand converted by Gandhi's story, he returned from U.S. exile in 1983, below, to talk Ferdinand Marcos into dismantling his dictatorship. Aquino was shot on arrival. His widow Corazon was later swept into power

DENNIS BRACK—BLACK STAR

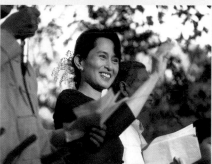

ROBIN MOYER

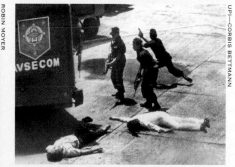

UPI—CORBIS BETTMANN

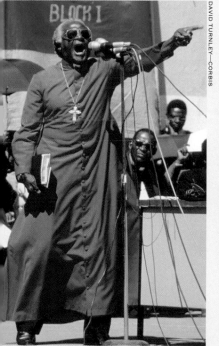

DAVID TURNLEY—CORBIS

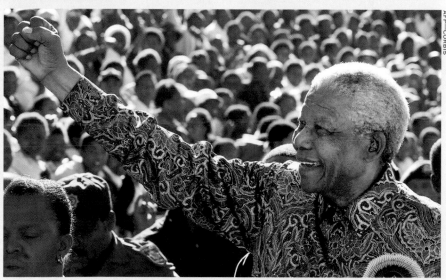

AFP—CORBIS

South Africa: Desmond Tutu and Nelson Mandela

The Anglican archbishop gave voice to the antiapartheid opposition while Mandela was in prison. "All violence is evil," he warned, "but a time may come when you have to decide between two evils—oppression or a violent overthrow of the oppressive regime." "When the honor of God is at stake," he said, "we will disobey iniquitous and unjust laws"

By NANCY GIBBS

ow can you not pick Hitler, demand the players around the table who take seriously the rules of TIME's parlor game: Who had the greatest impact on this century, for better or worse? It is too easy just to say that he lost, when in doing so he still changed everything. It was he who opened the veins of the Bloody Century, an epoch that has seen mayhem on a scale unimagined for centuries before. "As a result of Hitler," argued Elie Wiesel in TIME last year, "man is defined by what makes him inhuman." And while the Reich lasted 12 years rather than 1,000, its spores still survive and multiply. "The essence of Hitlerism—racism, ethnic hatred, extreme nationalism, state-organized murder—is still alive, still causing millions of deaths," wrote U.N. Ambassador Richard Holbrooke when he reluctantly nominated Hitler as the century's dominant character. "Freedom is the century's most powerful idea, but the struggle is far from over."

You could ask this of any year, any century: Which has the greater impact, good or evil, the heroes or the villains, Roosevelt and Churchill or Hitler and Stalin? To what extent do they depend on each other, when threats produce resolve, when terror engenders courage, when an ultimate challenge to principle has the effect of making principles stronger, forging them by fire? Thoughtful people who argue for Hitler as the Person of the Century do not want to honor him; they want to autopsy him, understand what made him strong and what finally killed him, and search, perhaps, for a vaccine for the virus that reappears still in ethnic enclaves, on websites, in the wilderness camps of skinhead anarchists and in the halls of Columbine High School, where two boys celebrated Hitler's birthday with a memorial massacre of children.

If impact were measured only in number of lives lost, one argument goes, Hitler would fall behind his fellow despots, Stalin and Mao. There are those who insist that Hitler is not the century's dominant figure because he was simply the latest in a long line of murderous figures, stretching back to before Genghis Khan. The only difference was technology: Hitler went about his cynical carnage with all the efficiency that modern industry had perfected.

And then there is the problem of impact. Which matters more, a life lost or a life changed forever? How many divisions does the Pope have, Stalin asked. Yet an idea that changes lives can have more power than an army that takes them—which leaves Gutenberg presiding over the 15th century, Jefferson over the 18th. Making

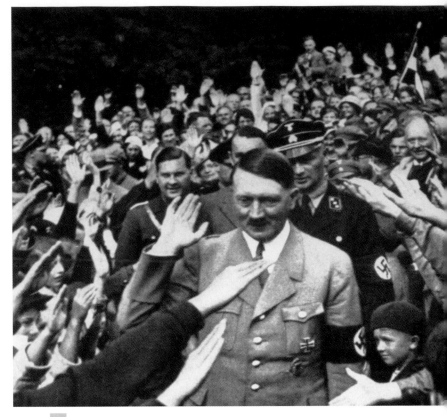

the necess

body counts the ultimate measure of influence precludes the possibility of heroic sacrifice, a single death that inspires countless others to live their lives differently, a young man in front of a column of tanks near Tiananmen Square. "Five hundred years from now, it won't be Hitler we remember," says theologian Martin Marty. "Hitler may have set the century's agenda; he was a sort of vortex of negative energy that sucked everything else in. But I think God takes fallible human beings like Roosevelt or Churchill and carves them for his purposes. In five centuries, we'll look back and say the story of the century was not Hitler or Stalin; it was the survival of the human spirit in the face of genocide."

If all Hitler had done was kill people in vast numbers more efficiently than anyone else ever did, the debate over his lasting importance might end there. But Hitler's impact went beyond his willingness to kill without mercy. He did something civilization had not seen before. Genghis Khan operated in the context of the nomadic steppe, where pillaging villages was the norm. Hitler came out of the most civilized society on Earth, the land of Beethoven and

Goethe and Schiller. He set out to kill pe ple not for what they did but for who th were. Even Mao and Stalin were killi their "class enemies." Hitler killed a millic Jewish babies just for existing.

It is this distinction that pulls us rig into the heart of the question. And that our long, modern conversation over t nature of evil. The debate goes back Socrates, who argued that anyone wl was acquainted with good could not i tentionally choose evil instead. Enligh enment thinkers went further, pushi concepts of good and evil into the realm superstition. But Hitler changed that. was he, perhaps more than any other fi ure, who demanded a whole rethinki about good, evil, God and man.

"Before Hitler, we thought we ha sounded the depths of human nature," a gues Ron Rosenbaum, author of *Explai ing Hitler*. "He showed how much low we could go, and that's what was so hor fying. It gets us wondering not just at t depths he showed us but whether there worse to come." The power of Hitler w to confound the modernist notion th judgments about good and evil were litt

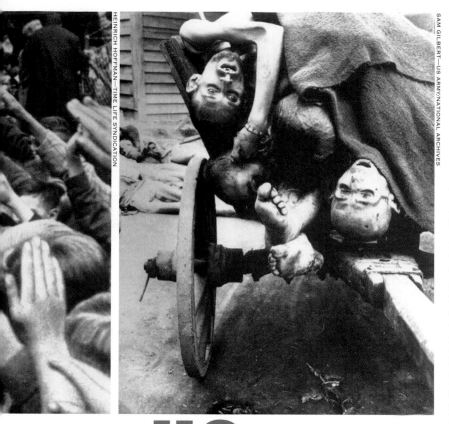

y evil?

Why all Adolf Hitler's destructiveness is not enough to make him the Person of the Century

ore than matters of taste, reflections of ocial class and power and status. Although some modern scholars drive past he notion of evil and instead explain litler's conduct as a reflection of his hildhood and self-esteem issues, for lost survivors of the 20th century he is onfirmation of our instinctive sense that vil does exist. It moves among us; it leads s astray and deploys powerful, subtle eapons against even the sturdiest souls.

There is a more nuanced, even insidius, argument for Hitler's pre-eminence: at good and evil are dependent on one lother. It is a fundamental tenet to many eligions that evil, while mysterious, may ear the way for good, that the soul is percted only in battle, that pain and ecstasy re somehow twins, that only a soul—or a lntury—that has truly suffered can truly ealize joy. Again we sense this instinc-vely—the pleasure we feel when a tooth ops hurting reminds us that we live our e in contexts and contrasts, and so perlaps you can argue that only by witnessg, and confronting, great evil were the rces of light able to burn most bright.

There are theologians and historians who have made this point. Most explicit are those who have called him God's punishment of European Jews for their secularization, then gone on to argue that it was mainly because of Hitler and the Holocaust that the biblical prophecy was fulfilled and the state of Israel born—only Western guilt on so massive a scale could have cleared the way to the Promised Land.

There is a political version of this equation: that at the beginning of the century, the West was ruled mainly by thin-blooded despots, with the exception of the more entrenched democracies of England and the U.S. Hitler did not believe the Western democracies capable of defending the principles they espoused—and as they wavered and appeased and betrayed in the face of his expansion, Hitler appeared to be right.

It was Churchill first, and then Roosevelt, who reawakened the West to its core values: freedom, civility, common decency in the face of evil, destructive forces of hate. The challenge that Hitler presented became the occasion for Churchill and Roosevelt and the lovers of freedom to battle the great diseases of the century: nihilism and defeatism. Churchill's apostles

argue for him as the century's titan on these grounds. It was by no means obvious, in the dark days of 1940, that the Western Allies could prevail against the Axis. His optimism about victory and his conviction that there were truths worth defending to the death were as important as his identifying the threat and standing up to it. Forty years later, when Ronald Reagan approached the cold war as a battle to be not only fought but also *won,* he was following a Churchillian strategy.

So did it take a Hitler, a mortal threat, to move the Allied democracies from complacent enclaves to the global powerhouses that by century's end would embrace most of the world's people? Here is a place to draw the line. "It may be true that we've got great medical breakthroughs, radar, sonar because of war," says theologian Marty, "but I don't like to make a theology out of that; it's an accidental product." Rosenbaum agrees that to focus on the benefits is to risk trivializing the tragedy itself. "There are a lot of people who want to say God was teaching us a lesson—evil is there so that we can learn by struggling against it. I find it kind of barbaric to envision a God who needs to slaughter a million babies in order to perhaps improve our character. I'm irritated by people who try to find some happy-ever-after improving lesson from this."

However much stronger the Western democracies were after the war, as they went on to discredit not only fascism but communism as well, that strength still came at a terrible cost. "How much happier a world it would be if one did not have to mount crusades against racism, segregation, a Holocaust, the extermination of 'inferior peoples,'" notes presidential historian Robert Dallek. "We don't need evil. We'd do fine without Hitler, Stalin, Pol Pot. Think of the amount of money and energy used in World War II—if only they could have been used in constructive ways. Good doesn't need evil. We'd be just as well rid of it."

If we must place the century in a time capsule, there are better candidates for Person of the Century than its greatest criminal. The large characters, heroes and villains alike, do set the scales on which we balance progress. Evil may be a powerful force, a seductive idea, but is it more powerful than genius, creativity, courage or generosity? The century has offered characters who stretched our understanding and faith in those qualities as well. The heroes not only defeated Hitler; they provided our lasting inspiration as well. "Just as Hitler made us believe we hadn't yet sounded the depths," notes Rosenbaum, "maybe Martin Luther King Jr. and the great artists of the century, like Nabokov, help us believe there are still heights we haven't found." ∎

Always the truth.

Occasionally, the awful truth.

The world's most interesting magazine.

the arts:
100 years of
attitude

How modernism became classic and how
modernity is racing beyond everyone's grasp

By RICHARD SCHICKEL

It all happened so fast. One minute *Madama Butterfly* was on the Gramophone, Harold Bell Wright's *The Shepherd of the Hills* was on the reading table, the pretty Gibson Girl you had seen in a magazine was on your mind. You wondered if you wanted to see Maude Adams in her return engagement as Peter Pan. Or perhaps brave the odors and chatter of the nickelodeon to watch that spunky new girl—her name, unpublicized at the time, was Mary Pickford—people were talking about in *Ramona*.

How sweet it was—the genteel culture of this century's first decade. There were noises off, of course: the clatter of ashcans in New York City's ateliers, for example. But—saints be praised!—New York's police commissioner had closed Shaw's *Mrs. Warren's Profession* after one performance because it was "revolting, indecent and nauseating when it was not boring." As late as 1912, a magazine editor quoted in Ann Douglas' *Terrible Honesty*) could write that "no-one paints life as it is—thank Heaven—for we could not bear it," and receive few arguments from its readers. It was an era in which the word irony described a passing attitude, not a cultural imperative, and celebrity was something pleasant that happened to deserving strivers, not the glue that held everything together, everyone in its thrall.

Yet to borrow a famous phrase from Karl Marx, "All that is solid melts into air"—was melting already, as of 1911, and forming large and inconvenient puddles on the floor, quite insusceptible to the morally muscular moppings of outraged critics. Here one directs the reader to the foldout chart elsewhere in these pages. Prepared with much disputatious—not to say rebellous—muttering by this magazine's critics, it lists the century's "best" work in every facet of the arts. Its most interesting aspect is the intensely clustered dates of the works representing the major expressive forms.

A period of just 11 years—1911 to 1922—contains the greatest painting, play, novel and poem of this century and encompasses as well major annunciatory works by the authors of what we deem our greatest musical composition and sculpture, and not a few runners-up

IN THE BEGINNING
Pickford, romance, melodrama

in several categories. To put it simply: there was in these few years an outburst of creative (and subversive) daring that may well be unsurpassed in human history.

1911. Matisse paints *The Red Studio*, "discarding perspective, abolishing shadows, repudiating the academic distinction between line and color," as his biographer Hilary Spurling puts it. Already burdened by the Fauve ("wild beast") misnomer, his public saw his work as a threat "to undermine civilization as they knew it." At virtually the same moment, his great rival Picasso creates his equally masterly Cubist collage *Still-Life with Chair Caning* and *Guitar*, which reverses the centuries-old traditions of sculpture, focusing the spectator's eye not on the final effect but on the process and materials by which it is obtained.

1913. Stravinsky premieres his ballet *The Rite of Spring* in Paris, setting the audience into a riotous frenzy with his rhythms—violent syncopation, sudden changes of meter, "barbaric" repetitions—subverting everyone's expectations for a predictable and reassuring beat. We are but a moment from *Wozzeck* (1925) and on the way to banishing tonality itself from opera.

1914. World War I begins. Its mindless slaughter heightens and validates the modernist vision. Picasso, watching the military vehicles rumble through Paris, sees in their camouflage painting a kind of Cubism, therefore a kind of modernist triumph. That same year James Joyce begins *Ulysses*, overturning our traditional expectations for action, plot, drama and the direct impact of one character on another in the novel. "Like Proust," Edmund Wilson writes, "he is symphonic rather than narrative … musical rather than dramatic."

1921. *Six Characters in Search of an Author* is performed in Rome. Pirandello challenges the conventional distinction between illusion and reality as well as authorial omniscience—the whole business of tyrannically driving "his" creations along to some preordained point. This prefigures what may be postmodernism's most interesting idea: it is the reader, not the writer, who is the final arbiter of a work's meaning. Which, naturally, renders meaning itself indeterminate.

1922. *Ulysses* is published. So is T.S. Eliot's *The Waste Land*. Some claim it is a hoax, a parody of modernism's obscurantist tendencies. Others see its analogies to

Joyce's work. Both are inferentially portraits of a pullulating urban landscape; both wear their classical erudition boldly. Which is to say, both writers embrace modernism's most basic hallmark—self- and cultural awareness—and know exactly what traditions they are undermining, The difference between them may be largely a matter of fastidiousness. *Ulysses* is finally an affirmation: "I put my arms around him yes and drew him down to me so he could feel my breasts all perfume yes and his heart was going like mad and yes I said yes I will yes." Eliot's nervous collage can only evoke the low vitality of his cityscape; he cannot embrace it. There are too many "young men carbuncular" within its limits, deceiving themselves with "systematic lies," failing to acknowledge "the agony and horror of modern life."

We need not choose between the visions. Both are true. Both are untru What we need to do is wonder at ho firmly this brief, incredibly fecund peri set the terms of the cultural argument th would preoccupy the rest of the centu The shock of the new drew much of its shaping, revolutionary force from frust tion with outworn artistic conventio and had been gathering strength and e

Photo-Illustration for TIME by John Blackford

Nor was it that everything interesting in high culture had been accomplished. Brancusi's and Hemingway's pursuit of pure form, stripped of all Victorian encrustations, proceeded. And most of the isms (Dadaism, Surrealism, Absurdism) in some way derive from what we might oxymoronically call classic modernism.

all proposed, seemed sometimes to wallow in, what appeared to be—often joyously, often grimly was—chaos. "Things fall apart," Yeats wrote in *The Second Coming* (in 1921, of course), "the centre cannot hold; mere anarchy is loosed upon the world." It was the century's earliest epitaph, and is still perhaps its most powerful one. And Yeats had yet to conjure with the metaphors of modern science—the theory of relativity; the uncertainty principle; the looming figure of Freud, pseudo-scientific poet of our subjectivity—let alone with Fascism and Stalinism. Or, possibly most addling to a poet, the rise of industrialized mass culture.

Lost in the bogs of Celtic myth, Yeats—unlike many of his peers in the modernist pantheon—was not much interested in modern design and architecture's streamlining ways. Or in the ability of books and magazines more and more perfectly to replicate artistic icons past and present. Or in the capacity of the movies to create their own time and space, independent of observed reality. We must imagine him, instead, mourning with the great critic Walter Benjamin the destruction of the artwork's "aura" or magic, deriving from its uniqueness, its firm roots in a specific historical place.

It is almost as if the producers of popular culture sensed, and tried instinctively to compensate for, this defect. For the content of movies, popular music, latterly television, has remained stubbornly locked to the 19th century traditions of melodrama and romance. We may admire the multiple narrators of *Citizen Kane*, not to mention its sheer panache; we may adore Bart Simpson, not least because he's such a self-conscious little transgressor, so aware of both his self-destructive impulses and his generally thwarted impulse to be better. But we have to admit that these remain rather lonely modernist gestures in mass culture. And pretty small potatoes compared with *Ulysses* or *The Waste Land.*

On the other hand, we also have to admit that in the last third of the century, modernism ran out of steam intellectually even as it gathered near dictatorial cultural power. Take the art world, for example: allied with the museums, the mass media and the marketplace, it began to wield, as early as the '70s, in Hilton Kramer's words, "a pervasive and often cynical authority over the very public it affects to despise." We live now in an age of empty "Sensation" (to borrow the title of the recent Brooklyn Museum of Art show) and debate not the subtleties of high craftsmanship but the appropriateness of public funding—talk about power!—for works that large segments of that public, not all of them ignoramuses, deplore. Strolling the latest Venice Biennale, novelist (and art critic) John Updike observed that it was nearly impossible to find anything that "reminded one of art in the old sense, even in the older modern sense," since "the desire to shock ... had become veritably frantic."

Perhaps that's because the universalist desire to reform all culture, make everyone see in a new way, is dead. What's true of literature is true of all the arts now: there are readers of J.M. Coetzee's *Disgrace,* there are Michael Crichton's readers, and the twain don't meet. Except, possibly, theoretically in cyberspace. F. Scott Fitzgerald had it right: "Culture follows money." And the money—perhaps even the creative zeal—is now in the new media. A radically reshaped culture is beginning to be created there. We can already begin to see what the generation born with a TV remote in its hand, hip-hop on the CD player and a computer screen in its face will do to traditional narrative. They'll speed it up, scramble it—and render it in new tonalities, using new palettes. You can see it in the way *Pulp Fiction* or *Run Lola Run* toys with time, in the down-the-rabbit-hole goofing of *Being John Malkovich,* in Keanu Reeves' encounter with that manic bullet in *The Matrix.* It's a kind of back formation from computer language, this narrative revolution manifesting itself in film. But it surely partakes of the new machine's ability to cast us adrift in ungrounded cyberspace, where all the spatial and temporal laws governing the representation of human reality will be revised, maybe repealed. It will extend to the other arts. It will reorder our perceptions more surely than Matisse and Stravinsky did, for a pixel—unlike paint, canvas or score paper—has no past to overturn, is radically innocent. It has no tradition to draw on, perhaps is not subject to "the anxiety of influence."

Peeping warily into the new century, the cultural traditionalist (anyone over the age of 40) feels like saying, with Estragon in *Waiting for Godot,* "I can't go on like this." He forgets the brave and cheeky response Samuel Beckett, last of the classic modernists, gave to Vladimir: "That's what you think." ∎

...rgy out of repression and dismissal for at least 50 years.

It was not that tunes would suddenly disappear from music or realistic representation of the world from art or narrative cohesion from fiction. Increasingly, though, these comfortable and reassuring sources of pleasure were segregated in a popular culture that was dismissed by finer sensibilities as aesthetically retrograde.

people
of the.
millennium

TIME
picks a person
of each century,
from
1000 to 1900

the most important people of the
millennium

william the
conqueror

(c. 1027-1087)

The Norman took what he believed wa his—England—and pioneered stat bureaucracy amid Europe's chao

Best Musical Innovation
When you sing, you begin with … About 1040, music teacher and monk Guido d'Arezzo introduced a system of naming pitches to help singers learn new music: ut, re, mi, fa, sol, la. When *ut* became *do* and *ti* was tacked on, the hills would come alive …

Best Campaign Finance
To assess new levies on his subjects to finance his army, William the Conqueror had every tract of land (and cow and horse and pig) in his kingdom recorded. The *Domesday Book* was viewed by contemporaries as proof of the King's avarice, one of the seven deadly sins.

Illustrated medieval music lesson

Best Novel
The Tale of Genji by the Lady Murasaki chronicled the amorous exploits of a prince in Kyoto, including trysts with his stepmother, the Empress of Japan (she bears his son, who inherits the throne). *Genji* is a best seller today in a racy version in modern language by a 77-year-old Buddhist nun.

Pet of the Millennium
Pyramid carvings show images of the forebears of chihuahuas, (called *techichis*). The canines become top dogs in the Yucatán and other large tracts of Mexico as their masters, the Toltecs, conquer the region— about 1,000 years "B.C." (that is, Before the Chalupa).

he was, contemporaries advise us, "grea in body … but not ungainly." He had harsh voice, but his speech was alway appropriate. His chroniclers laude his ability to "appraise the true significance c events" and make good "the fickle promises c fortune." They also remarked that he was "to relentless to care though all might hate him William the Conqueror was a man—or, mor important, a monarch—for a new age.

Europe entered the century as a study in disintegrated en pire. Rome had long since fallen. Charlemagne had briefly lai claim to its authority, but his heirs could not sustain a continen wide order. Christendom was a Babel of weak and squabblin kings, aristocrats whose holdings sometimes exceeded those c royalty, and a church that would spawn two competing Popes

It was a chaotic era, and William of Normandy, born aroun 1027, was the child of chaos. The illegitimate son of Robert, Duk of Normandy, he was known for most of his life as William th Bastard. Robert eventually recognized him, but only as he d parted on a fatal pilgrimage to the Holy Land, leaving his seve year-old a target for usurping barons. One by one, William guardians and advisers were cut down. The boy escaped assass nation only by a desperate flight to his mother's estate.

The retreat was temporary. The strapping redhead won h first battle at age 13. At 20 he defeated the usurpers. He fought su cessfully for and against the French King. He made a dynast marriage, over papal objections, to the daughter of the powerf Count of Flanders. (William was 5 ft. 10 in. tall, his Matilda bar ly 4 ft. They had at least nine children.) By 1065 he was absolu lord of a consolidated Normandy. Then he looked northward.

On the Bayeux Tapestry, the astonishing embroidere storyboard of the Battle of Hastings, one can see Edward th Confessor of England dying in January 1066 and Harold Goc winson, an earl, enthroned. A woolen comet (Halley' streams across a linen sky, auguring bad luck. William, wh believed the English crown had been promised him, lost n

Painting for TIME by Jack Unruh

time. Five hundred vessels eventually ferried 7,000 men and their 2,000 mounts. Contrary winds delayed the force on the French side of the English Channel for 15 days—just long enough for Norway to launch its own 300-ship attack on the north of England. When Harold, having defeated the Scandinavians, rushed south again with 7,000 troops, William was outside Hastings. "For God's sake, spare not," he told his men. His well-deployed knights and archers eventually overwhelmed the exhausted Anglo-Saxon infantry. "The living marched over the heaps of the dead," wrote an early historian. By nightfall, Harold was slain.

William was crowned that Christmas morning. Had he merely conquered, England would still have been pulled from its semi-Scandinavian orbit and into the ferment of Western Europe, and English would still have been transformed into a different language, one with words that came by way of France, words like different and language.

But he was not just a conqueror. He was also a controller, and his recasting of England has reverberated for centuries. It was not

Soap Opera Of the Century
Which one's Joan? Which one's Jackie? From 1028 to 1056, the postmenopausal sisters and co-Empresses Zoë and Theodora put the Byzantine in the Byzantine Empire by surviving traitorous husbands, coup attempts, street riots, greedy Patriarchs and one conniving eunuch brother-in-law, as well as the expected lust,

passion, jealousy and deceit. For a firsthand account of all the dirt, read *Chronographia,* the tell-all by court insider and philosopher Michael Psellus.

Signs and Portents

Best Fireworks
Chinese and Anasazi astronomers spot a supernova in the constellation Taurus in 1054

Most Prurient Coinage
Sodomia is defined in detail by the Catholic Church, c. 1050

Worst Monuments
Easter Island hews forests to raise monolithic statues; in 600 years, it will be treeless

enough to transfer lands owned by Anglo-Saxon nobility to his own supporters; he required these men to provide him with military service in return for their land and to owe him ultimate loyalty. He convened juries of locals to find fact and give a collective verdict under oath in land disputes. He commissioned a monument to centralized power: the *Domesday Book,* an invasive audit of the wealth of England. William has been credited with the emergence of the bureaucratic state in Europe; certainly his utter domination of a compact kingdom became a model for monarchs of the next 800 years.

But Norman order was cruel, and the systematic cronyism William installed bred a rapacious class of official epitomized by Robin Hood's Sheriff of Nottingham. When the grossly obese King died in 1087 (of a riding injury sustained while torching the city of Mantes), some of his servants rushed off to secure their properties; others stole his silver and furniture. His body broke in two while attendants tried to force it into a coffin; the stench cut the service short. In death, he lost control. But he had set in place a new order. —*By David Van Biema*

dictator of the century
mahmud of ghazna (971-1030)

HE WAS THE MOST FAMOUS AND CULTURED AMONG THE GHAZIS— the warriors of an expansionist Islam. They had raided rich cities on the edge of the Indian subcontinent before, but Mahmud was the first to build a Muslim empire in the region, defeating Hindu rajas and ransacking bejeweled temples. The loot (and the elephants)

helped Mahmud strengthen his grip on power in his kingdom—with headquarters in what is now Afghanistan—and made him into a patron of scientists and poets, including Firdawsi, author of the *Shahnamah,* an epic of Persia's kings. His dynasty would not long survive, but the Indian enterprise would be a model for his co-religionists, imparting to the region 1,000 years of shared history between Hindus and Muslims, implacable neighbors in a diverse cultural realm. Thus the nukes today.

A version of the epic Shahnamah, *funded by Mahmud*

propagandist of the century
(c. 1035-1099) pope urban II

OTHER PONTIFFS HAD DREAMED OF LIBERATING THE HOLY LAND from Muslim rule. But in 1095 Urban took a request for military aid from the Byzantine Emperor as an opportunity and went from city to city raising a religious frenzy—among all classes, but, most important, among younger sons who were not in line to inherit feudal property. "Enter upon the road to the Holy Sepulcher," he declared in the annals, "wrest that land from a wicked race, and subject it to yourselves. Jerusalem is a land fruitful above all others, a paradise of delights. That royal city, situated at the center of the earth, implores you to her aid." He offered remission of sins to all Crusaders, to whom Jerusalem fell in July 1099, with terrible massacres of Jews and Muslims. Western Christians would rule the Levant for nearly a century.

people
of the.
millennium

12th
century

(c. 1138-1193)

saladin

The Kurdish adventurer proved to the Crusaders
that God had no trouble favoring an "infidel"

Painting from Huizong's collection

Worst Brush-Off
The Emperor Huizong of China's Song dynasty ruled the richest and most cultivated nation on earth. A gifted calligrapher and painter, he personally supervised the imperial studios over a reign of 25 years. His skills as potentate, however, were wanting. In 1127 invaders conquered most of northern China, taking Huizong prisoner. He died a desolate exile in Manchuria.

Best Literary Innovation
The poet of Arthurian chivalry Chrétien de Troyes was the first to describe a mysterious "grail"—a beautiful vessel that, together with a lance, forms part of a strange procession witnessed by the knight Perceval, who cannot fathom its meaning. Later writers would insist it was the cup of the Last Supper, which Joseph of Arimathea used to preserve the blood of the crucified Jesus.

Best Financial Innovation
Paper money replaced barter and unwieldy strings of coins in vast areas of China. By the next century, the government will back the printed currency with gold and silver for use throughout the empire. The money will bear serial numbers and the warning: "Counterfeiters will be decapitated."

Best New School
In 1117 history recorded the first "master" at a place where the Thames narrowed enough so oxen could ford. Oxford soon saw Paris theologians on lecture tour. By the 14th century, the colleges of Oxford—which formed a university under a guild of masters—would vie with those of Paris as the most influential in Europe.

The seal of Oxford University

When Dante Alighieri compiled his great medieval *Who's Who* of heroes and villains, the *Divine Comedy*, the highest a non-Christian could climb was Limbo. Ancient pagans had to be virtuous indeed to warrant inclusion: the residents included Homer, Caesar, Plato and Dante's guide, Vergil. But perhaps the most surprising entry in Dante's catalog of "greathearted souls" was a figure "solitary, set apart."

That figure was Saladin. It is testament to his extraordinary stature in the Middle Ages that not only was Saladin the sole "modern" mentioned—he had been dead barely 100 years when Dante wrote—but also that a man who had made his name successfully battling Christianity would be lionized by the author of perhaps the most Christ-centered verse ever penned.

When Salah al-Din Yusuf ibn Ayyub was born in 1138 to a family of Kurdish adventurers in the (now Iraqi) town of Takrit, Islam was a confusion of squabbling warlords living under a Christian shadow. A generation before, European Crusaders had conquered Jerusalem, massacring its Muslim and Jewish inhabitants. The Franks, as they were called, then occupied four militarily aggressive states in the Holy Land. The great Syrian leader Nur al-Din predicted that expelling the invaders would require a holy war of the sort that had propelled Islam's first great wave half a millennium earlier, but given the treacherous regional crosscurrents, such a united front seemed unlikely.

Saladin got his chance with the death, in 1169, of his uncle Shirkuh, a one-eyed, overweight brawler in Nur al-Din's service who had become the de facto leader of Egypt. A seasoned warrior despite his small stature and frailty, Saladin still had a tough hand to play. He was a Kurd (even then a drawback in Middle Eastern politics), and he was from Syria, a Sunni state, trying to rule Egypt, a Shi'ite country. But a masterly 17-year campaign employing diplomacy, the sword and great good fortune made him lord of Egypt, Syria and much of Mesopotamia. The lands bracketed the Crusader states, and their combined might made

Love Story of the Century

Pierre Abélard was the theological provocateur of the age, confounding Roman Catholic tenets with reason, yet political enough to merit advancement in the church. But he loved—and was secretly married to—the erudite Héloïse at a time when married men could no longer be priests. After a melodrama that shifted from bedroom to birthing chamber to convent, Abélard was set upon by enemies in 1119 and castrated. He became a monk; she a nun. But they continued to correspond. "Sweeter to me is ever the word friend, or, if thou be not ashamed, concubine or whore," reads one of her purported letters. "What queen or powerful lady did not envy me my joys and my bed?"

THE MANSELL COLLECTION—TIME INC. (2)

plausible Nur al-Din's dream of a Muslim-Christian showdown.

That encounter took place near Hattin, within sight of the Golan Heights. Saladin had assembled a pan-Islamic force of 12,000 cavalry near Lake Tiberias. The Christians were lured on a long July march across Galilee's parched Plain of Lubiya. Saladin had the right bait—he had besieged the lakeside town in which a knight's wife was staying—and the Crusader force, frying in heavy armor and unable to fight its way to the water, was overwhelmed by the Muslims. When the Christian knights retreated to the coastal fortress of Tyre, Saladin turned his army inland. Jerusalem withstood him for less than two weeks. In stark contrast to the earlier Crusader bloodbath, his occupiers neither murdered nor looted. "Christians everywhere will remember the kindness we have bestowed upon them," he said.

In a shocked Europe, the Pope immediately called a Third Crusade. And although Richard the Lion-Hearted bested Saladin in battle after battle, he could not wrest the Holy City from him, and he returned to Europe. The city, always Islam's third holiest site, became even more central to the faithful. Saladin's family ruled less than 60 years longer, but his style of administration and his humane application of justice to both war and governance influenced Arab rulers for centuries. His tolerance was exemplary. He allowed Christian pilgrims in Jerusalem after its fall. The great Jewish sage Maimonides was his physician. Woven into chivalric legend as the worthy foeman, Saladin, scimitar flashing or compassionately sheathed, galloped from Dante into romances by Sir Walter Scott and eventually into young adult books that still ship in 24 hours through Amazon.com.

Both Saddam Hussein and Hafez Assad have at times invoked Saladin against Israel, the new "crusader." However, they seem unlikely to attain either the military triumph that safeguarded one world or the nobility that endeared him to another.

—By David Van Biema

Signs and Portents

Crime of the Century	Worst Foundation
Archbishop of Canterbury Thomas Becket is killed in his cathedral by knights of Henry II	The new bell tower in Pisa begins to lean as the third of eight planned stories is built

insider of the century
(c. 1122-1204) eleanor of aquitaine

SHE WAS THE MOST POWERFUL WOMAN at a time when the "lesser sex" was supposed to be seen, not heard. But how could anyone suppress Eleanor? She was heiress to the largest and richest fiefdom in France, then Queen of France, then Queen of England. She went on crusade and was rumored, ridiculously, to have planned to elope with Saladin (he would have been about 11). It was her idea to leave the French King, not the other way around. And when she brought her inheritance to her next husband, Henry II, she set in motion hundreds of years of Anglo-French wars. With her sons she staged an unsuccessful rebellion against her unfaithful husband; then she became the most celebrated political prisoner of the age, the object of troubadors' plaintive songs. She outlived Henry, who was more than 10 years her junior, to place two sons—first her favorite, Richard the Lion-Hearted, then John—on the English throne.

generalissimo
of the century

yoritomo (1147-1199)

NATIONAL GALLERY OF ART, WASHINGTON, D.C.

HE TOOK THE ANCIENT BUT honorary title of shogun (short for *sei-i-tai-shogun*, or great barbarian-subduing general) and gave it dictatorial weight, the most powerful rank in a samurai government that eclipsed all pretense at worldly power by the imperial family. Such regimes would dominate Japan for seven centuries, their warrior spirit lingering much longer. Exiled after his father's execution, Yoritomo wrought his revenge by exterminating a rival clan and seeing a child Emperor drowned. After defeating the aristocrats from Kyoto—the Emperor's capital—he established his own capital in the east, where he had been exiled, making the plain around modern-day Tokyo a new center of power. His turbulent family saga is to Japan what the Trojan War was to the West.

people
of the
millennium

genghis khan (c.1167-1227

The world conqueror swept through Asia like an apocalypse and set in motion forces more powerful than the sword

Best Agreement

English barons, allied with the clergy and merchants, wanted to protect their interests from a voracious, incompetent king. In 1215 they showed enough force to intimidate John I into agreeing that royal authority was not equivalent to arbitrary power and that taxation should benefit the kingdom, not the King. The document would become a first step in constitutional government—the Magna Carta.

Under duress: the seals of King John on the Magna Carta

Hot New Dynasty

In 1273 the Swiss-German Count Rudolf became the first Habsburg to wear a crown, that of the Holy Roman Empire. By the 20th century, the family with the pronounced physiognomy would have ruled, at one time or another, Germany, Spain, Portugal, the Netherlands, Switzerland, large portions of Italy, Austria, Hungary, slivers of North Africa, parts of the Balkans, vast sections of Latin America (including St. Augustine, Fla.) and the Philippines. They married into most of their property.

Best Piece Of Etiquette

The fork slowly—very slowly—began to win acceptance in Europe. It had caused a scandal when a Venetian Doge's Byzantine wife used it in the 11th century. Such "excessive delicacy," St. Peter Damian said disapprovingly, caused her body to "completely rot away." For centuries, the utensil remained an affected way to pick up morsels from a plate. As late as the 19th century, Neapolitans were still consuming spaghetti by hand, and the Viennese were eating their cake by knifepoint.

temujin was born clutching a blood clo the size of a knucklebone. His name wa war booty, taken from a captive rival b his proud warrior father and tacked o like a medal to his firstborn son. But histor echoes with another of his names, a title Temu jin would receive 39 years later. In 1206, by ac clamation of all the Mongols, he became Gen ghis Khan, the "Oceanic Ruler" who in the nex two decades would father an empire that rolle across Eurasia, linking the Pacific Ocean to the Blade Sea as amassed kingdoms as loot and nations as slaves. The legacy of Genghis Khan is as terrifying as genocide and as dreadful as th plague. But this is the paradox: it is also as seductive as Xanad and as momentous as the discovery of America.

His forebears were a blue-gray wolf and a fallow doe. Th coupling of these legendary ancestors, of predator and prey produced a human being from whom all Mongols would clair descent. But such fantastical beginnings did little to ease the ear ly life of the world conqueror—unless the myth was an omen fo living like a wild animal in the steppes around Lake Baikal. Hi father Yesugei was poisoned by enemies and his widowed moth er Hoelun chased away from their tribe with her brood, includ ing her eldest, nine-year-old Temujin. The outcasts ate field mic and marmots even as they fought off thieves out for their horse the most precious of nomad property. Bitterness cultivated heart of iron. After a half-brother grabbed a fish he had hooked Temujin would kill the offending sibling in a hail of arrows. H never showed remorse. His mother was furious at the waste of potential soldier in the revenge she envisioned. "We have no on to fight with us," she hectored, "except our own shadows."

Out of the shadows, however, Temujin would create a natio and the most disciplined fighting force on the planet. First, he es capcd the wild by making a good marriage. That alliance woul lead to more critical alliances as Temujin learned to ply diple macy and a ruthless militancy. Soon, his almost supernatura generalship would win him fiercely loyal followers, enough to of

Painting for TIME by Chang Park

set a multiplicity of traitors and false friends. He vanquished the fractious tribalism of the Mongols by dispersing clansmen among regiments in an army that used death as discipline and looting as reward. Conquered peoples were divided among the armies, swelling the ranks of fighters. Similarly, the technology of the conquered cultures was absorbed like more booty and enrolled in an intercultural war of conquest. Thus the elaborate catapults developed in Central Asia were deployed against the stout walls of China. And the explosive bombs and rockets pioneered in China were used in Mesopotamia and Europe.

Symbols of the Arab conquest

Better than Nothing
In 1202 the zero finally got a firm foothold in Europe. For two centuries, the system of numerals that included zero had been toyed with but rejected by Christian clerics as part of the "infidel" numerical system of the Arabs, who adopted it from Hindu savants. By the 16th century, zero had transfigured the art of European calculation.

Signs and Portents

Best New Weapon
Mastery of the longbow will give the English a military edge for more than a century

Most Painful Fad
Bands of Christians adopt self-flagellation as an act of contrition

Worst Fashion
Members of the Japanese court blacken their teeth for beauty's sake

Terror, however, was the Khan's greatest weapon. Cities that resisted the Mongols were made into examples. Their populations were slaughtered indiscriminately, with survivors marched before the Mongol armies to buffer counterattacks: human shields nearly eight centuries before Saddam Hussein. Cities that surrendered without a fight were spared, their citizens merely enslaved.

The great Khan's strategies led to the subjugation of the advanced civilizations of northern China and Persia. His sons and grandsons would extend the empire. Batu would command armies that struck deep into Russia and swept through Poland into Germany, Hungary and the Balkans. Kublai Khan, who would later build his stately pleasure dome in the city of Shangtu (Coleridge's Xanadu), conquered southern China and Burma. His brother Hulegu would not only destroy Baghdad but also devastate its irrigation network. Mesopotamia has never fully recovered.

The immense wealth of the Mongol empire and the suddenly free passage from west to east attracted merchants and adventurers, whose goods and tales would change the world. Marco Polo's stories became the dreams of Christopher Columbus. The quest for a passage to Cathay, the medieval name for northern China, would propel countless explorers through serendipitous discoveries in America. (In 1634, for example, the Frenchman Jean Nicolet left Quebec in search of China and discovered Green Bay, Wis.) Meanwhile, Franciscan missionary diplomats sent by the Pope to seek an alliance with the Khan against Islam brought back a black powder to a fellow Franciscan, the Oxford scientist Roger Bacon, the first European to write about gunpowder.

However, the most indirect, though by no means benign, gift of the Khan was the plague. Originating in the jungles of southern China and Burma, bubonic plague traveled with Mongol armies and then from caravan to caravan till it reached the Crimea in 1347. From there it would take a third of all Europeans. Bereft of labor and talent, the fledgling nation states were pressed to maximize tax collection, bureaucracy and state control of the force of arms, leading to the heightened competitiveness of the West just as Europe's ships sailed for the riches of a distant empire. The rest is the history of another world conquest. —*By Howard Chua-Eoan*

saint of the century
francis of assisi
(c. 1182-1226)

HE WAS BORN INTO A PROSPERING class at a time of European plenty. To encourage riches, the church preached industry, a get-ahead attitude that had little regard for outcasts, for lepers, for the poor. The revelation of Francis was that poverty was holy and that the spirit approached God when in want. He kissed lepers and gave away his possessions. He preached naked from the pulpit. The church saw his ideals as a dangerous communism and undermined him by co-opting his Friars Minor, which gorged itself with power after his death. Yet Francis changed the face of sanctity: heaven was now in the face of the abject and in the horror of disease. Lenin said if there had been 10 of Francis, there would have been no need for revolution.

mystic of the century
jalal ad-din rumi
(1207-1273)

GOD IS AVENGER; GOD IS KING. But Rumi, more than any other mystic in any other faith, dared to reveal God as beauty. He heard the divine in music; he saw it in the sun; he felt it in his companions. It was not an era that encouraged such perceptions. Rumi was a refugee from the onslaught of the Mongols, finding safe harbor in the cosmopolitan city of Iconium (now Konya, in modern-day Turkey), thousands of miles from his birthplace in Afghanistan. Yet he said that though people fled the Mongols, he served the Creator of the Mongols. No other poet found such ecstasy in daily wonderment, in song, in vision, in wine, in dance and most important, in friendship. His poems (the Persian Koran, some say) reverberate to this day in Iran, Turkey and Pakistan. They border on the erotic, with water seeking the thirsty as much as thirst seeks quenching, with the music of the reed flute longing for the reedbed from which the instrument had been plucked. The Sufi sect of the whirling dervishes dances to his rhythm; New Age meditations echo his songs.

people
of the.
millennium

14th
century

giotto
(c. 1267-1337)

With his brush, the severity of religious icon
melted into warm humanity, and the face o
the Godlike became the face of ma

Best Public Servant
A new sense of time slowly took over Europe as mechanical clocks began to measure out equal hours in town plazas and squares. Communities, however, set their clocks their own way, depending on when the sun rose or set on their horizon. And while clocks struck the hour, few had minute hands. Clock resettings were soon transformed into colorful civic ceremonies.

Best Worldly Epic
A round of tales told by 30 or so pilgrims off to the shrine of St. Thomas Becket, Geoffrey Chaucer's *Canterbury Tales* brims with fully fleshed characters like the Wife of Bath and the Pardoner that modern pilgrims will still find provocative—their bluster about the role of the sexes in marriage and their speculation about self and death prefiguring Shakespeare.

Dante and his encyclopedic epic

Best Otherworldly Epic
Midway into the tumult of Renaissance Florence, Dante Alighieri stopped to survey heaven, earth, hell and history—with himself and his vicissitudes at the psychological center. Consigning the great and the small to *Inferno, Purgatorio* or *Paradiso,* his *Divine Comedy* is a masterpiece of the Christian imagination and evidence that literature can be a potent weapon against the real world.

A sampling of Chaucer's Canterbury pilgrims

put yourself back to a time before tru mirrors. In Europe the art of paintin had been lost to the ruthless destruc tion of barbarians. No Western ma could see a real likeness of humankin upon a wall because no artist knew how to dra one. The pictures that adorned mediev churches—there was no secular painting—e chewed reality for decoration or dogma. Gilt-be dizened Madonnas with flat, staring eyes hold ing outsize infant Christs bespoke not man but the supernatu mystery of the faith.

Then came Giotto. He was an artisan like countless others the age, though he possessed something his predecessors and co temporaries did not: an inner eye that could see how human fi ures could be brought to life on a wall. He replaced golden bac drops with the hills, meadows and houses familiar to 14th centu Italians. In those earthly settings he placed three-dimensior Christs and Virgins, saints and sinners, painted as ordinary huma invested with natural emotions. His sweetly weary Madonna loc eyes with the observer as she swaddles a baby-size Jesus.

We who are jaded by the unnatural deconstructions of 20 century art cannot easily imagine the electric impact Giotto ma by painting natural human figures that reached out of the frames to communicate directly with the observer. This was n simply a marvel in a superstitious age but also the artistic birth the Renaissance. Giotto fathered a radical revolution of startli genius that set the course of Western art for the next 600 years

Little is known of the life and development of Giotto Bondone, born around 1267 to peasants in the bucolic valle outside Florence. Legend says the country boy tending flocks was discovered by the painter Cimabue, who saw hi draw a fine sheep upon a rock. A more likely tale has him hau ing Cimabue's Florentine bottega until the painter made him apprentice. There Giotto absorbed his mentor's strength drawing and sense of drama, but nature was his true teacher. divined how to depict, with brush and pigment, the hum

body according to the prescription of St. Francis: "Your God is of your flesh. He lives in your nearest neighbor, in every man."

And so Giotto painted his Bible stories and tales of saints across the cathedral walls of Italy. Yet we see his brilliance today in a bare handful of surviving documented works. The famous 28 scenes of St. Francis' life adorning the Upper Church in Assisi—to most of us the embodiment of his work—are of hotly disputed authorship. Yet many experts still believe no other known hand could have created the economical drama, narrative power and intense depiction of human emotion that mark the best of them.

Giotto's genius is definitively preserved in Padua in a small chapel completely decorated in powerful renditions of the life of the Virgin Mary and the Passion of Christ. In each panel a few simple figures anchored in the foreground vividly act out the joy, grief, fear and pity of the Christian story. Giotto's gift lay in transforming the viewer into a participant: people felt as if they could touch holy figures Ruskin once called "Mama, Papa and the Baby."

By breaking through the stilted conventions of medieval art, bringing his neighbors into direct communion with the sacred, Giotto single-handedly elevated painting from the service of symbolism to the mirror of mankind. **—By Johanna McGeary**

Worst Biological Agent
No King, no Pope, no war would affect Europe like the Black Death which began to sweep through i 1347. At least a third of the Continent's population perished and kingdoms were gripped by labor shortages. Scientists and historians believe the culprit wa the bacillus *Pasteurella pestis,* an organism that evolved a symbiotic relationship with rodents native to southern Asia. These became more frequent in Europe as trade burgeoned with Mongo territory. Fleas took the bacillus from rats to humans. Then huma gave it to human through infectious droplets in the breath.

Signs and Portents

Best Reincarnation	Worst Relocation
In 1391, the first Dalai Lama is born in central Tibet	Papacy leaves Rome for Avignon, becomes French pawn

dictator of the century

zhu **yuanzhang** (1328-1398)

ORPHANED, HOMELESS, HIS FACE SCARRED BY DISEASE, ZHU SUR-vived countless dangers to become a warlord, chase out the descendants of Genghis Khan and become the first Emperor of the Ming

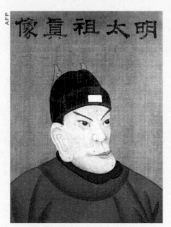

dynasty in China. Pained by the memory of his rootlessness, he decreed that peasants could not venture far from the villages of their birth. That demographic concentration led to an agricultural bonanza, with surpluses creating purchasing power and huge new internal markets for commodities, which in turn created textile, porcelain and other manufacturing centers. Such productivity would later attract foreigners: Spain extracted huge amounts of silver from its South American colonies to pay for Chinese goods. By the 16th century, ordinary Chinese were the most prosperous inhabitants on earth. All because of a homeless man.

terror of the century

(1336-1405) tamerlane

THE ENGLISH, WHO LIVED FAR BEYOND HIS CONQUESTS, KNEW TO tremble at the name. "The scourge of God," Christopher Marlowe quailed nearly 200 years after the death of the military genius from Samarkand. When the city of Isfahan defied him, Tamerlane slaughtered 70,000 of its inhabitants and raised a pyramid of heads. Chris-

tendom thought the haughty Ottoman Sultan Bayezit was threat enough. Then Bayezit insulted Tamerlane. Routed in battle, the Sultan was locked in a cage and driven mad. He bashed his brains out on the bars. More accurately known as Timur-i-Leng ("Timur the Lame," for an arrow wound to the heel), he loved beauty as much as war and turned Samarkand into a wonder of the world. There, to this day, his name is spoken of with pride and awe. He left a curse for anyone who dared disturb his tomb. Locals shake their head telling of the day the Soviets broke in to examine his skull. On that day the cataclysmic Nazi invasion of Russia began.

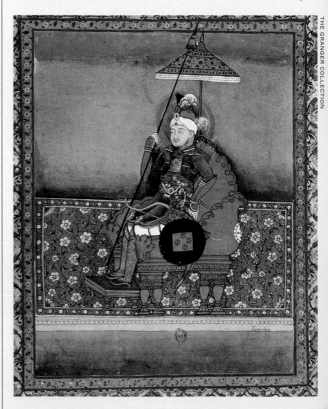

people
of the
millennium

johann gutenberg

(c. 1395-1468)

The obscure printer's innovation kindled reformation
and a yet unfinished information revolutio

*Manacles, above, for captives on
crowded slave ships, left*

Worst Judicial Mechanism
Kafkaesque before Kafka was
cool, Henry VII of England
introduced the prototype of the
Star Chamber. The procedure
gave defendants no right to
know the names of their
accusers.

Best Perspective
It's perspective itself. The
ancient Romans may have had
some idea of it, but it was
Renaissance architects like
Filippo Brunelleschi, designer
of the dome of the great
cathedral of Florence, who
became the true masters of
this most deceptive of arts,
inspiring a future filled with
Botticellis, Leonardos,
Raphaels, Michelangelos et al.

Worst Enterprise
In 1444 a Portuguese explorer-
entrepreneur purchased 230
Africans and began the
mechanics of the slave trade
that would later take millions
across the Atlantic. By 1511
the Dominican monk Bartolomé
de las Casas began lobbying
the Spanish King for African
slaves to be sent to America.
He reasoned that the Native
American populations needed
relief from mistreatment by
colonizers. At the end of his life,
Las Casas pondered the equal
cruelty met by the slaves and
wondered if God would ever
forgive him. Between 1500 and
1870, 12 million Africans would
be taken to the Americas.

Filippo Brunelleschi and his dome

the French peasant girl who rallied he
country's dispirited troops against the oc
cupying English forces; the Turkish rule
who conquered Constantinople and en
larged what would become the millennium
most durable empire; the Italian navigator wh
sailed the ocean blue in 1492. Joan of Arc, Sulta
Mehmet II and Christopher Columbus indi:
putably made lasting history. But it was one c
their 15th century contemporaries who create
a revolutionary way to spread not only their names and deeds b
the sum total of human knowledge around the globe.

Johann Gutenberg was born of well-to-do parents in t
Archbishopric of Mainz, Germany. Details of his life, early as we
as late, are sketchy, but he apparently trained as a goldsmi
and/or gem cutter and then became a partner in a printing sho
in Strasbourg.

When Gutenberg entered it, printing was a slow and labo
ous business. Each new page required the creation of a ne
printing form, usually an incised block of wood. He began loo
ing for ways to make metal casts of the individual letters of t
alphabet. The advantages of such a method were obvious,
must have been to Gutenberg. Equipped with a sufficient su
ply of metal letters, a printer could use and reuse them in any o
der required, running off not just handbills and brief documen
but a theoretically infinite number of individual pages. The
were technical obstacles to overcome, including the discovery
an alloy that would melt at low temperatures, so that it could
poured into letter molds, and of an ink that would crisply tran
fer impressions from metal to paper. And what force would
employed to make these impressions? Gutenberg hit upon t
idea of adapting a wine press for new uses.

By the time he was back in Mainz in 1448, Gutenberg ha
ironed out enough of these problems to persuade Johann Fu:
a goldsmith and lawyer, to invest heavily in his new printi
shop. Exactly what happened behind Gutenberg's closed doo
during the next few years remains unknown. But in 1455 vi

Artwork for TIME by Lauren Uram

itors to the Frankfurt Trade Fair reported having seen sections of a Latin Bible with two columns of 42 lines each printed—*printed*—on each page. The completed book appeared about a year later; it did not bear its printer's name, but it eventually became known as the Gutenberg Bible.

It was a revelation, at least to Western eyes: multiple copies of an entire volume produced by mechanical means. True, printing from movable type had been performed in Asia, but thousands of ideograms made the widespread use of the technique impractical. Gutenberg, who apparently knew nothing of the Asian innovations, was blessed not only with an inventive mind but also with a phonetic alphabet and its manageable cast of characters. Movable type was set to change the world.

Shortly before his completed Bible was released, Gutenberg was forced to turn over his shop and at least some of his equipment to his creditor Fust, who carried on the work, alone at first and later with the assistance of his son-in-law Peter Schöffer. The monopoly they may have had on Gutenberg's methods did not last long. Presses adapted to print from movable type rapidly spread across Europe. By 1500 an estimated 30,000 titles had been published.

THE BRIDGEMAN ART GALLERY

Best Blessing in Disguise
Constantinople and the remnant of the Byzantine Empire fell to the Ottoman Sultan Mehmet II in 1453. Far from declining, the city became the resplendent capital of the powerful Turks. And, shades of Starbucks, the conquerors opened coffeehouses throughout the city.

Worst Missed Opportunity
From 1405 to 1433, the eunuch Zheng He commanded seven voyages that projected Chinese power throughout Asia and East Africa. The massive armada dwarfed all navies. But the Ming Emperor took to isolationism, and the voyages ended. Then the Europeans came.

Signs and Portents

Worst Prosecutor
Tomás de Torquemada, head of the Spanish Inquisition, orders 2,000 Jews burned alive

Best Revenge
Native Americans introduce Europeans to a "bewitching vegetable"—tobacco

And that was only the b ginning of a tide of print th has been rising ever sinc We can hardly imagine world without an abundan of printed matter, and th we take for granted an inver tion that produced astonis ing consequences. Ear printed books tended to r semble, in appearance well as content, the han copied manuscripts th were replacing. The dissem nation of the writings Greek and Roman autho led to a revival of the classi learning that spurred the R naissance. Printed religio texts put the word of God c rectly into the hands of l readers. Such personal co tacts helped fuel the Protestant Reformation.

Before print, the ability to read was useful mainly to the éli and the trained scribes who handled their affairs. Affordab books made literacy a crucial skill and an unprecedented mea of social advancement to those who acquired it. Established h erarchies began to crumble. Books were the world's first mas produced items. But most important of all, printing proved to l the greatest extension of human consciousness ever created. isn't over: the 500-year-old information revolution continues c the internet. And thanks to a German printer who wanted a mo efficient way to do business, you can look that up. —**By Paul Gr**

explorer of the century
(1451-1506) christopher columbus

AFTER HIS DEATH, COLUMBUS WAS A LAUGHINGSTOCK. VASCO DA Gama got to the real Indies; Magellan crossed two oceans; Cortés conquered Mexico. But Columbus couldn't even handle a start-up colony in the Caribbean. It was the people who came to the new world he discovered who made him a perpetual paradox, a symbol of pride and contention, an emblem in their search for identity. The citizens of the U.S. took to naming places Columbia, and he became the

ethnic icon of millions of immigrants. Others dubbed him the "Civilizer," but that rubbed many the wrong way. Wasn't he the harbinger of disaster for native cultures and thus "the deadest of dead white males"? The debate goes on. Columbus was bullheaded and wrongminded about finding China across the sea. But he said he would never be forgotten, and 500 years later he's right.

THE GRANGER COLLECTION

SNARK—ART RESOURCE

soldier
of the century

joan of arc
(c. 1412-1431)

VOICES TOLD THE 17-YEAR-old farm girl that the uncrowned King, whom many believed illegitimate, was worth fighting and dying for. So Joan offered her services to Charles, declaring she could lift the siege of Orléans. She then led and inspired 10,000 men to do just that, defeating the English who occupied most of France. She said that the King must be anointed and crowned at Reims. And so he was, on July 17, 1429. Then Joan's campaign faltered. She was captured by the enemy, convicted of sorcery and burned at the stake. But until the end, she clung to her voices. France fought on, and on July 17, 1453, Charles' armies ended English rule. Economic historians say the railroads made France a nation. Perhaps. But Joan made France want to be one.

people
of the.
millennium

queen
elizabeth I

(1533-1603)

The goddess of the Reformatio
defeated Europe's greatest power and se
Britain on its epic journey to empir

Best Enlightened Despot

The third emperor of the Islamic Mogul dynasty, Akbar ruled an immense empire in India that included millions more Hindus than Muslims. Not only did the warrior king marry Hindu princesses, but he also lifted religious taxes on Hindus. He instituted a parliament of religions in 1575 in the hope of fostering amity and built Hindu temples. He started Din-i Ilahi, a combination of Islam, Christianity, Hinduism and Zoroastrianism. His successors, however, repudiated his new religion.

Worst Civil War

The religious wars that tore France apart from 1562 to 1598 pitted Catholics against Calvinists. The multitude of local conflicts would converge in the bloody St. Bartholomew's Day Massacre of French Protestants—Huguenots—on Aug. 24, 1572. It would climax with the demise of the Valois dynasty and the conversion to Catholicism of the Protestant heir to the throne, Henry of Navarre, who said, "Paris is well worth a Mass."

Best Import

Christopher Columbus brought the seeds of the cacao plant (backdrop below) to Spain in 1502. But no one knew what to do with the bitter bean until Hernando Cortes was served a goblet of liquid *xocoatl* (bitter water) at the court of the Aztec ruler Montezuma in 1519. With some added sweetening, chocolate became a hit in Spain, which kept the recipe a national secret for almost a century.

first feminist. First spinmeister. Megawat celeb. So might our age judge her. To 16th century England, Elizabeth I was th original feminine mystique: goddess Glo riana; Virgin Queen; finally and enduringly, Goo Queen Bess. The most remarkable woman rule in history can claim few traditional princel achievements, yet she gave her name to an age Hers was a prodigious political success stor built on the power of personality: the Queen a star. A woman so strong, a politician so skillful, a monarch so mag netic that she impressed herself indelibly on the minds of he people to reshape the fate of England. She brought her countr safely through the Reformation, inspired a cultural renaissanc and united a tiny, fragmented island into a nation of global reach

Elizabeth was born unpropitiously into a man's world and man's role. Desiring a son, Elizabeth's father Henry VIII d vorced his first wife and broke with the Roman Catholic Churc to marry Anne Boleyn. When Anne bore him a girl, he ordere his wife beheaded and the child princess declared a bastard Elizabeth grew up in loneliness and danger, learning the ur gency of keeping her balance on England's quivering politica tightrope. She was lucky to receive a boy's rigorous education tutored by distinguished scholars in the classics, history, philo ophy, languages and theology. She was serious and quick wi ted. "Her mind has no womanly weakness," said her teache Roger Ascham, but she equally loved music, dancing and gaiet During the bloody reigns of her Protestant half brother an zealously Catholic half sister, Elizabeth needed all her poise discipline and political acumen just to survive.

The bells of London tolled joyously on Nov. 17, 1558, whe Elizabeth ascended the throne. She made her coronation th first in a lifetime of scintillant spectacles, visual manifestation of her rule. As she walked down the carpet in Westminste Abbey, citizens scrambled behind her to cut off pieces. He power started as a grand illusion, but it was prophetic.

Painting for TIME by David Bowers

With her political and personal security threatened from beginning to end, Elizabeth needed all her courage, cunning and caution to reign. She took the throne of a poor, isolated and deeply humiliated country. As a Queen, she faced special problems of marriage and succession, religious division, domestic discontent and foreign threats. Her Church of England restored the country firmly to Protestantism, yet she allowed Catholics freedom of worship, easing the bitter religious strife of Mary's reign.

Elizabeth spent a lifetime contending with the issue of marriage and royal heirs and the challenges raised by men who would steal her scepter. Marriage is what 16th century women were for, and Queens needed heirs. She engaged in the most manipulative, interminable courtships, driven not by love but by politics—though she was tirelessly fond of suitors. Leading a weak country in need of foreign alliances, she brilliantly played the diplomatic marriage game: at one time she kept a French royal dangling farcically for nearly 10 years. Always she concluded that the perils of matrimony exceeded the benefits. She courted English suitors too, for both pleasure and politics. Yet when favorite Robert Dudley, Earl of Leicester, pressed too hard, she retorted, "I will have here but one mistress and no master." She did not wed because she refused to give up any power. "Beggarwoman and single far rather than Queen and married," she once said.

Playing consciously on the cult of the Virgin Mary, she drew devotion to herself, virgin mother of the nation. "This shall be for me sufficient," she told Parliament, "that a marble stone shall declare that a Queen, having reigned such a time, lived and died a virgin." She was, in the end, married to England.

Elizabeth's way of escaping gender restrictions and defining herself as a legitimate ruler lay in consummate imagemaking. She

Worst Orgy
Raphael, right, was, along with Leonardo and Michelangelo, one of the trinity of the High Renaissance. His death in 1520 is still a mystery, but an artist-chronicler of the time, Giorgio Vasari, believes it was the result of the painter's propensity for exhausting sexual debauchery.

SCALA—ART RESOURCE NY

Best (Near) Face-Off
Michelangelo had just completed his *David,* an Leonardo was working o the *Mona Lisa* when bot were commissioned to paint murals at the Palazzo Vecchio in Florence. Looking forwar to showing up his rival, Michelangelo began a 288-sq.-ft. sketch. But Pope Julius II ordered th sculptor to Rome, and th matchup never took place

LUCAS CRANACH THE ELDER/MUSEO POLDI PEZZOLI—SCALA

IN SILENCIO ET SPE ERIT M · L FORTITVDO VESTRA

ideologue of the century
martin luther (1483-1546)

IN THE 16TH CENTURY, IF THOSE IN POWER DISAGREED WITH YOU writing, they usually burned it. If you kept issuing the same, the burned you. Martin Luther, brave and cantankerous soul, kept writ ing, turning out thousands of pages of crusading sermons, fulminat ing pamphlets—even many hymns—during his 62 years. He wrote s much that he is credited with helping shape the modern German lan guage. Some of these writings were the doubtful, occasionally anti Semitic musings of a depressed ex-monk. ("However irreproachabl I lived as a monk, I felt myself in the presence of God to be a sinne with a most unquiet conscience," he recalled late in life.) But hi doubts led him to question much established wisdom. His 95 These were a powerful criticism of papal excess. They not only set off score of religious movements known collectively as Protestantism bu eventually also led to a reformed Roman Catholic Church. Luther i a pivotal figure for a more subtle reason too. In embracing a view tha "faith alone" could bring salvation—not faith plus good works, an certainly not "indulgences" purchased from the church for partial ab solution—Luther propelled the ordinary individual to the heart of re ligion. And his fortuitous grasp of the power of the printing press al lowed not just for dissemination of his ideas but also for the abilit for everyone to judge them, opportunities for each soul to thin about its status before earthly powers and before God.

Scary Prince

The romance of Don Carlos has become opera and drama: the idealistic heir to Spain is betrothed to a French princess until his grim father, the king, decides to wed her himself. Reality was uglier: the prince was mad and homicidal. Philip II had him locked up in a tower where Carlos slept naked on blocks of ice and eventually died of neglect or suicide.

Scarier Prince

For the good of the country, a ruler, wrote Niccolò Machiavelli, below, in *The Prince,* should "know how to enter evil," his success depending on "cruelties badly used or well used." *The Prince* was dedicated to the Medici duke Lorenzo II, but its ruthless tenets were practiced best (or worst) by a Medici princess: Lorenzo's daughter Catherine, Queen Mother of France.

Signs and Portents

Most Feared Text	Best Plumbing
The Bible translated into the vernacular fans religious chaos	In England, Sir John Harington invents the first flush toilet

stage-managed her own personality cult. She dressed to kill, glittering with jewels in wondrous costumes to bedazzle her subjects. She went on royal progresses—the equivalent of photo-ops—to show off and get to know her people. She had the common touch, able to rouse a crowd or charm a citizen. She had flattering portraits painted and copies widely distributed. She encouraged balladeers to pen propagandistic songs. Her marvelous mythmaking machinery cultivated a mystic bond with the English people. "We all loved her," wrote her godson Sir John Harington, "for she said she loved us."

Notoriously parsimonious—except for her own fashions—Elizabeth hated war for its costly wastefulness, yet embroiled England ineffectually in the long Continental struggles of the Counter-Reformation. When the Catholic threat of Spain reached its apogee in 1588, her penny pinching nearly cost England its independence before luck and the skill of her sailors defeated the Spanish armada. Yet at the moment of imminent invasion, she dressed in a silver breastplate to address her troops and imbue them with her dauntless courage. "I know I have the body of a weak and feeble woman," Elizabeth said, "but I have the heart and stomach of a King, and a King of England too." Her countrymen gloried in her victory, transforming the battle into an act of national consciousness that gave birth to nearly four centuries of patriotic imperialism. She spawned England's empire, chartering seven companies—including the East India—to plunder and colonize in the name of trade.

She was a larger-than-life royal with a genius for rule, who came to embody England as had few before her. The new spirit emanating from so brilliant a sovereign inspired a flowering of enduring literature, music, drama, poetry. Determinedly molding herself into the image of a mighty prince, she made of England a true and mighty nation. —By Johanna McGeary

astronomer of the century

(1473-1543) copernicus

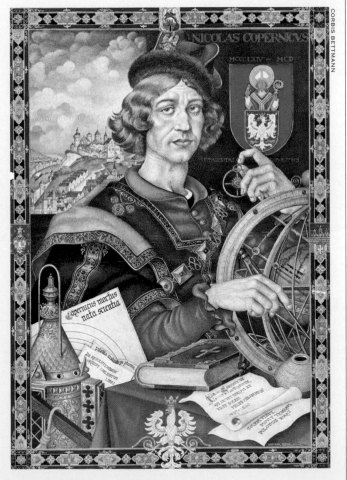

FAME WOULD PROVIDE NICLAS KOPERNIK'S NAME WITH THE WEIGHT of Latin, as if the sonorous tenor of antique sages were needed to embellish the genius of a boy born in Torun, Poland. Orphaned at 10, he was raised by his uncle, the Prince-Bishop of Ermland, and pointed toward service in the Catholic Church. But the bishop also sent his gifted nephew to his old school in Italy in 1497. And in Bologna a mathematics professor inspired Niclas to question medieval astronomical dogma. Tradition held that the universe was geocentric, with a stationary Earth placed at the center of several concentric, rotating spheres, each of which bore either a single planet, the sun, or all the stars. Returning to Poland, Kopernik pondered the strange motions of Mars, Jupiter and Saturn, which sometimes appear to halt and reverse their travels through the sky. His startling conclusion: the so-called retrograde motion could be best explained by a heliocentric universe. "Finally," he wrote in the math-filled argument published shortly before his death, "we shall place the sun himself at the center of the universe. All this is suggested by the systematic procession of events and the harmony of the whole universe, if only we face the facts, as they say, 'with both eyes open.'" In this revision of the cosmos, the stars and planets, including the Earth, revolved around the sun. And our planet rotated daily on its axis. Archimedes said that given the right place to stand, he could move the world. Copernicus did it with numbers.

isaac
newton
(1642-1727)

His scientific search for a grand design in the
universe overturned ancient assumptions

Standing in an unstable universe where distances contract and clocks slow down, and time and space are plastic, Albert Einstein cast a wistful backward glance at Isaac Newton. "Fortunate Newton, happy childhood of science!" he wrote. "Nature to him was an open book, whose letters he could read without effort."

A child's first tasks are to walk and talk and understand his little universe. Newton, the 17th century's formidable prodigy, simply enlarged the project. The first of his family of Lincolnshire yeomen to

be able to write his name, Newton grew into a touchy, passionately focused introvert who could go without sleep for days and live on bread and wine, and, at an astonishingly precocious age, absorbed everything important that was known to science up to that time (the works of Aristotle and, after that, the new men who superseded him: Copernicus, Kepler, Descartes and Galileo, who died in 1642, the year Newton was born). Riding on the shoulders of giants—and correcting the giants where they went wrong—Newton began assembling and perfecting the Newtonian universe, a miraculously predictable and rational clockwork creation held together by his universal gravitation and regulated by his elegant laws of motion.

Amazingly, the bulk of Newton's formative thought was accomplished at 23 and 24, while he was rusticated to Lincolnshire by the Great Plague, which shut down Cambridge University several months at a time from 1665 to 1667. Newton lived to be 84. Before he was done, his comprehensive intelligence—with which he seemed to have thought and tinkered his way into the very mind of God—had set off not one but four scientific revolutions—in mathematics (he invented the calculus, as did Leibniz in Germany, independent of Newton), in optics (he invented the reflecting telescope, and his experiments with spectrums established the nature of color and the heteroge

Best Makeover
Czar Peter I (later known as the Great) toured England, Prussia and France incognito. As part of his program to Westernize Russia, he cut off the beards of his noblemen, the boyars.

Worst Makeover
As a sign of servitude to the new Qing dynasty, the Manchu conquerors decreed that all Chinese men—on pain of death—must shave their heads, save for a queue of hair.

Most Influential Essayist
John Locke's writings, including *An Essay Concerning Human Understanding,* expounded on the rights to revolution, liberty and the pursuit of happiness.

Most Pithy Philosophy
René Descartes's eureka was *Cogito, ergo sum*—"I think, therefore I am." It is the key link in his philosophy of deductive reasoning, mind-body dualism, the proof of God and the dream of medicine's leading to physical immortality.

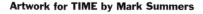

Artwork for TIME by Mark Summers

I have seen
further,
it is by
standing upon
the shoulders of
Giants."

THE GRANGER COLLECTION

Best Bicultural Masterpiece
Miguel de Cervantes' characters are indelible: the irrationally idealistic Don Quixote de La Mancha and his earthbound and earthy squire Sancho Panza. But *Don Quixote,* in English translation, has also provided us with these expressions: "sky's the limit"; "thanks for nothing"; "a finger in every pie"; "paid in his own coin"; "a wild-goose chase"; "mind your own business"; "think before you speak"; "forgive and forget"; "to smell a rat"; "turning over a new leaf"; "the haves and have-nots"; "born with a silver spoon in his mouth"; "the pot calling the kettle black"; and "you've seen nothing yet."

Signs and Portents

Secret Royal Scandal
King James I conducts affairs with the Earl of Somerset and the Duke of Buckingham

Open Royal Scandal
Sweden's Queen Christina wears pants, hunts bear, talks philosophy, refuses to marry

Open Royal Scandal Pt. II
Christina, daughter of Sweden's Lutheran hero-King, abdicates to become a Catholic

Royalty Usurped
Foreign-born Queen Nur is de facto ruler of Mogul India as alcoholic husband lies dying

Royalty Underserved
Meisho, a girl, is "Emperor" of Japan while brothers grow up. She isn't allowed to have kids

Steal of the Millennium
On Aug. 10, 1626, the Canarsee Delaware Indians agreed to sell the 22-sq.-mi. Manhattes island at the mouth of the Hudson River to Dutch settlers under Peter Minuit. The price: cloth and trinkets. At the end of the 20th century, Manhattan was estimated to be worth at least $143 billion.

ART RESOURCE NY

revolutionary of the century
galileo galilei (1564-1642)

IF ANY ONE MAN LAID THE FOUNDATION OF MODERN SCIENCE, IT was Galileo Galilei of Pisa. Gifted in mathematics and astronomy, he discovered the laws of falling bodies and, legend has it, demonstrated them by dropping objects from the top of the Leaning Tower. Among other achievements, he calculated the parabolic motion of projectiles, described the motion of objects rolling down an inclined plane, and invented a military compass and the pendulum clock. But he is best known for his astronomical feats. Hearing in 1609 that a spyglass had been invented in Holland, he built one of his own, turned it on the heavens and in short order discovered, and confirmed in his writings, that four large moons were orbiting Jupiter, that Venus had phases and that the sun had spots, all of which contradicted church dogma. The universe, he insisted, "is written in the language of mathematics ... without which it is humanly impossible to understand a single word of it; without these, one is wandering about in a dark labyrinth." For Galileo's sins, the Inquisition condemned him, compelled him to abjure his findings and placed him under permanent house arrest, where he remained till death. In his honor, the four largest Jovian satellites are called the Galilean moons, and a spacecraft named Galileo is even now successfully orbiting Jupiter.

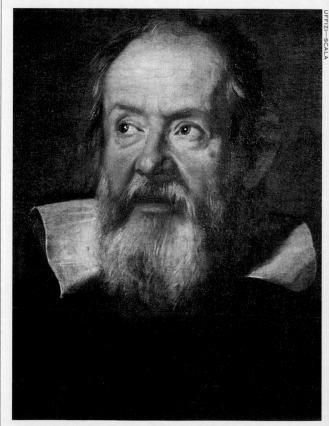

UFFIZI—SCALA

neous components of sunlight), in mechanics (his three laws of motion changed the world) and with his understanding of gravity. The last explained the phenomena of heaven and earth in a single mathematical system—or did until Einstein arrived.

Newton is the man of the century for this reason: by imagining—and proving—a rational universe, he in effect redesigned the human mind. Newton gave it not only intellectual tools undreamed of before, but with them, unprecedented self-confidence and ambition. If Shakespeare incomparably enlarged humanity's conception of itself, Newton—working later, in the turmoil of the English civil war and Restoration—set in place those cooler universals that were the premise of the 18th century's Age of Reason and the dynamic of the 19th century's age of revolutions—industrial, political and social.

In a sense, all the change that shaped the world until the onset of modernity had its origins in Newton's mind. For what he showed was this: the universe is knowable and governed by universal laws—therefore predictable, therefore perfectible by human reason and will. Go beyond science to politics and society: if all bodies, great and small, are subject to the same universal laws, the idea leads on to democracy

Most Pernicious Immigrants
Yellow fever made its way from West Africa to the Americas after its carrier, the *Aedes egypti* mosquito, carved out an ecological niche in the New World. The insect's larvae traveled in water casks aboard ship. In the previous century, syphilis had come to Europe and Asia from the Americas. That sexually transmitted disease may have affected the fertility and sanity of members of the royal families of France, England and Turkey.

Most Devout Immigrants
Unwilling to live in an England that they believed was going the way of decadent crown and looming antichrist, a hundred Puritans applied for a government patent to colonize a "New England." Their ship, the *Mayflower,* arrived in what is now Massachusetts on Nov. 11, 1620.

Most Fortuitous Epic
A firebrand in Oliver Cromwell's Glorious Revolution and a proponent of the execution of Charles I, the poet John Milton was marked for arrest and death with the restoration of the British Crown. But his blindness spared him, and in his last years he wrote *Paradise Lost.* Literary critics say it is possible to see in Satan, the poem's fallen angel and rebel against God, Milton's autobiographical sympathy for the devil.

Signs and Portents

Most Chilling Effect
Descartes gives up the study of astronomy after Galileo's encounter with the Inquisition

Most Contentious Island
Chinese rebels defy the Beijing government and set up a regime on Taiwan

Most Ominous Rebellion
French nobles and peasants stage huge antiroyal uprising, but it's just 1648, not 1789

(equality of all humans great and small) and the principle of universal justice. Newton's laws ousted older preferments of feudal hierarchy and magic (though Newton himself devoted frustrated years to the study of alchemy) and installed the authority of the inquiring human mind.

In a sense, of course, Newton's was the greatest magic of all: the thought (owing something to alchemy) that for all phenomena of nature and society, there must be not only a discoverable secret but a generalization with the force of law—a solution to every problem, scientific, social or moral.

We live in the consequences of that immense ambition; we have seen its results, both splendid and ghastly (space exploration, Marxist utopias). If religion taught faith and the mystery of the Causeless Cause (the ultimate secret, God), Newtonism located human intelligence in a cosmos of magnificently impassive reciprocities, celestial mechanics working by God's infinitely reliable and predictable cause and effect. Perhaps Newton merely codified what we intuitively knew (equal and opposite reactions, for example). As Einstein said, "The conceptions which he used to reduce the material of experience to order seemed to flow spontaneously from experience itself, from the beautiful experiments which he ranged in order like playthings."

The Newtonian heritage to us, in any case, is pervasive. W.H. Auden in 1939 wrote lines that might have been composed about, say, Kosovo last winter: "I and the world know/ what every schoolboy learns./ Those to whom evil is done/ do evil in return." What is that but Newton's third law of motion? Einstein's image of Newton as a child occurred, oddly enough, to Newton himself. Maybe that's where Einstein got it. Just before he died, Newton remarked, "I do not know what I may appear to the world; but to myself, I seem to have been only like a boy, playing on the seashore, and diverting myself in now and then finding a smoother pebble or prettier shell than ordinary, while the great ocean of truth lay all undiscovered before me." —**By Lance Morrow**

bard of the century
william shakespeare (1564-1616)

IN AN AGE THAT HAUGHTILY MADE MAN THE MEASURE OF ALL THINGS, Shakespeare betrayed the essential fragility of the species, defining humanity with stories that continue to be our parables, both existentialist and romantic. His words are still the vessels of our dreams and thoughts. "The slings and arrows of outrageous fortune." "My salad days when I was green in judgment." "Shall I compare thee to a summer's day?" "Now is the winter of our discontent." "The most unkindest cut of all." "A tale told by an idiot, full of sound and fury, signifying nothing." "Star-cross'd lovers." Only the language of the King James version of the Bible, assembled miraculously by committee, comes close. For the generations after him, Shakespeare would be both goad and god—not only the autocrat of the English language but a seer into what Coleridge called "the interior nature" of human existence. We know little of Shakespeare's interior life, and some even question his identity. But there is no need for pyramids or monuments. As John Milton wrote, "Dear son of memory, great heir of fame,/ What need'st thou such weak witness of thy name?" His monument is his name. Shakespeare is now the global code word for culture.

our evolving culture

A short history of four simple ideas and how they changed the way we dream, travel, learn and walk

1st millennium

0 500 1000

11th century

1050

12th century

1100 115

architecture

- The ego sought permanence in stone, building spires to touch the sky or domes to echo heaven

◄ **11th century**
San Marco, Venice. The Doge's chapel was modeled on a now destroyed church in the rival—and more splendid—metropolis Constantinople. But as it prospered, Venice both updated and preserved San Marco's splendor: five shallow Byzantine brick domes were covered over by metal ones. The 320-ft. campanile, foreground, raised in 912, collapsed in 1902. It was rebuilt in 1912—on its 1,000th birthday.

ships

▼ **c. 850**
The Vikings' longboats were versatile: they could either be rowed or moved by sail, maneuvered by a steering oar on the right side. They struck fear throughout Europe.

- c. 1000, Leif Ericsson sailed to Greenland and Newfoundland in a longboat

c. 1150
The mariner's compass was used by the Chinese well before 1050, the year the instrument made its appearance in European ships in Mediterranean waters.

■ **c. 1200**
The steering oar was slow replaced by the **rudder,** a maritime invention from East As that had ma its way to Europe via Arab marine

paper

▶ **A.D. 105**
Invention
According to tradition, an imperial eunuch named Cai Lun invented paper. The material, however, has been found in Chinese tombs dating to the 2nd century B.C. By the end of the 8th century, Chinese paper craftsmen had set up shop in the Middle East.

■ **11th century**
Movable type was developed in China by the year 1048 and the metal variety in Korea by 1403. However, it was impractical for the ideographs both used (as many as 400,000 characters). Rubbing off wood blocks and stone, practiced since the 7th century, was the preferred technology of a versatile book trade.

■ **1150**
Technology transfer The Arabs took paper from Iraq and Egypt to North Africa and Muslim Spain.

■ **13th cent**
Italy gets paper Finally Europe had a cheap alternat to vellum and parchment. (It took the skins of 80 lambs to create a 200-page parchme manuscript.)

shoes

sandals

- A journey of 1,000 miles begins with a single step—better have the right shoes. The sandal is basic. Then add fashion and technology

▶ **1850-1870**
Bolivia It's time for a fiesta with this painted leather-and-wood clog with a silver buckle.

▼ **c. 1000-1300**
North America
A no-frills yucca-fiber model from the Anasazi.

◄ **1999**
U.S.A. Sole-fitting Wraptor by Teva for yuppie trekking

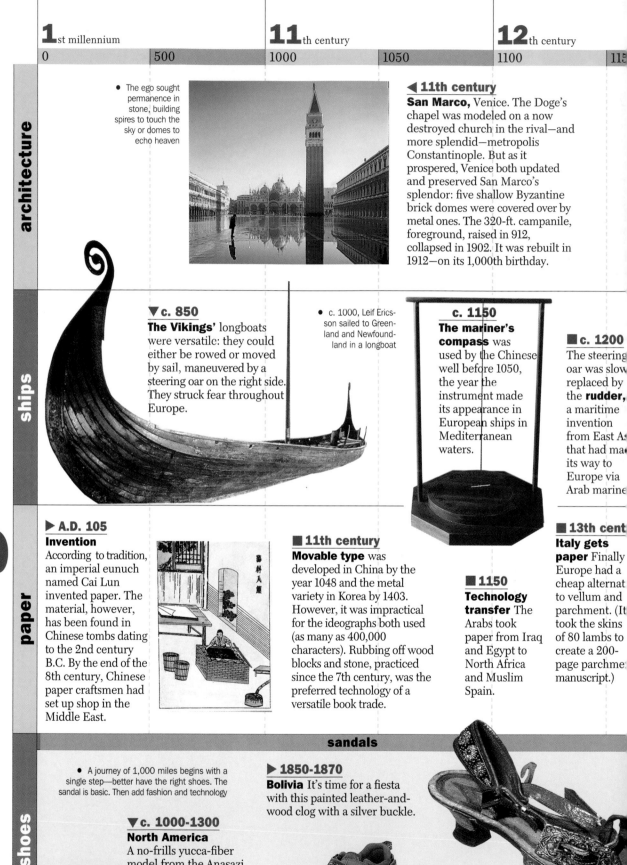

ARCHITECTURE: DMITRI KESSEL—LIFE; DAVE G. HOUSER—CORBIS; MARC GARANGER—CORBIS; ANDREA JEMOLO—CORBIS; SCALA—ART RESOURCE; CULVER PICTURES; MICHAEL S. YAMASHITA—CORBIS; JOHN DAKERS—EYE UBIQUITOUS-CORBIS
SHIPS: GRANGER COLLECTION; MARK TUSCHMAN; GRANGER COLLECTION (2); NATIONAL MARITIME MUSE

13th century
1200 1250

14th century
1300 1350

15th century
1400 1450

▼ 1113-1150
Angkor Wat, Cambodia (213 ft. tall). Part holy mountain, part city, the sprawling temple built by King Suryavarman II was intended as proof of his divinity.

▶ 1224-1424
Nôtre Dame de Chartres (112 ft.). Again and again, over 200 years, fire destroyed the cathedral as commoners, clergy and nobility struggled to raise it. But with its towers, sculpture and luminous stained glass, it became the crown of the High Gothic age as it celebrated the piety, pride and prosperity of Crusader France.

■ 1295
Marco Polo described huge ships in Chinese seaports with separate watertight bulkheads. Without the compartments, ships with pierced hulls would sink. A half-century would pass before Western naval engineers adopted the technology.

◀ 1417
Prince Henry the Navigator of Portugal organized a **naval academy** of engineers, mapmakers and ship's pilots. Borrowing from Arab vessels, they designed the first caravels. Propelled by lateen rigging, the three-masted ships were fast and tacked into the wind.

▼ 1492
In 1492, in the service of Spain, the Genoese navigator **Christopher Columbus** took the caravels *Niña* and *Pinta* along with the *Santa Maria* on his historic voyage across the Atlantic.

◀ 1300s
Block printing arrived in Europe, perhaps brought by merchants and bureaucrats of the expanding Mongol Empire. And paper was available for use.

● Once available only in Latin, the Bible was being translated into the vernacular and, because of printing, more easily distributed. As religious debate turned bloody, the Scriptures became a subversive text

◀ 1455
Johann Gutenberg invented an efficient press in Germany and used movable type to publish Bibles, transforming Europe.

platforms

...was an antique passion: old Venice obsessed with height. ...heels evolved and platforms vanished, returning only when ...men Miranda did the samba. They're still here

◀ 1600
Venice So much cork was needed for the fashion that whole forests were endangered.

◀ 18th century
India An ornate silver-covered wood *paduka* with a gold toe knob.

▶ 19th century
Turkey Altitude to keep feet from street dust.

▲ 1970s
Italy A mod combo of platform and heel.

cont. on next page
→

our evolving culture

architecture

▼ **1555**
St. Basil's, Moscow (107 ft.), marked Ivan the Terrible's victory over the Mongols.

■ **1550-1557**
Suleimaniye Mosque, Istanbul (174 ft.). Suleiman the Magnificent's reply to Justinian's Hagia Sophia.

■ **1506-1626**
St. Peter's Basilica, Rome (452 ft.), took 120 years to complete by a *Who's Who* of architects, including Bramante, Raphael, Bernini and Michelangelo. Begun by the warrior Pope Julius II, it is the fortress of Catholic faith.

▼ **1630-1653**
The Taj Mahal, Agra (200 ft.), was built by Mogul Emperor Shah Jahan as the tomb of his beloved wife Mumtaz Mahal.

ships

▼ **1588**
The invincible **Spanish Armada,** with about 130 ships, sailed to conquer England. Its defeat by the English navy, with its smaller but more maneuverable ships, would change the balance of world naval power.

■ **1775**
American rebels gave the name ***Enterprise*** to a 70-ton sloop captured from the British. It was later burned to prevent recapture.

▼ **1807**
Robert Fulton's **steamboat** *Clermont* ran from New York City to Albany in 32 hrs. A sailboat would have taken four days.

■ **1831**
The U.S. Navy had a four ship by the name ***Enterp*** a 194-ton schooner.

paper

■ **1591**
Those rotten journalists
A Chinese border official complained of irresponsible "news-bureau entrepreneurs" who give no consideration to "matters of [national] emergency."

▶ **1605**
Newspapers The first weekly appeared in Antwerp; it would be 1650 before the first daily was published, in Leipzig.

■ **1776**
Thomas Paine
His printed pamphlet *Common Sense* would inspire the Declaration of Independence; his *American Crisis* rallied Washington's troops at Valley Forge.

▼ **1811**
Industrial Revolution The steam engine began to power the press; the rotary press (invented in 1846) allowed runs of 20,000 sheets an hour.

boots

shoes

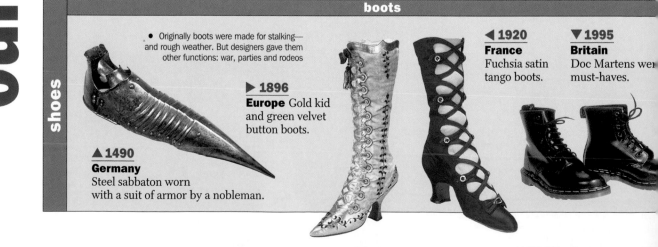

- Originally boots were made for stalking—and rough weather. But designers gave them other functions: war, parties and rodeos

▲ **1490**
Germany
Steel sabbaton worn with a suit of armor by a nobleman.

▶ **1896**
Europe Gold kid and green velvet button boots.

◀ **1920**
France
Fuchsia satin tango boots.

▼ **1995**
Britain
Doc Martens wer must-haves.

19th century
1800 | 1850

20th century
1900 | 1950

- Buildings soared as iron and steel frameworks supported not only floors but also walls. With the invention of fast elevators by 1887, the sky was the limit

◀ 1889
The Eiffel Tower, Paris (984 ft.), was built as a temporary structure to celebrate the centennial of the French Revolution. It was first called an eyesore and then, as the world's tallest structure, be-came a source of pride, defining the skyline of the City of

◀ 1930
The Chrysler Building, New York City (1,046 ft.), was quickly surpassed by the Empire State Building—but only in height. Its Art Deco beauty celebrated a Golden Age of American capitalism.

◀ 1996
Petronas Towers, Kuala Lumpur, Malaysia (1,476 ft.). Peaked like Angkor Wat, the world's tallest building attests to the ambitions of Prime Minister Mahathir Mohamad.

▼ Mid-1800s
The French and British vied to build the better **ironclad battleship.** In 1862 the Union's *Monitor* and the Confederacy's *Merrimack* clashed in the first battle of ironclads in history. The result was indecisive.

■ 1938-1958
In World War II, the **U.S.S. Enterprise** was an aircraft carrier. She sank 71 enemy ships and downed 911 planes. Severely damaged by kamikaze attack at the end of the war, she would later be sold for scrap.

■ 1877
The fifth ship by the name **Enterprise** was a 1,375-ton steam-powered sloop of war.

▼ 1961
The latest **U.S.S. Enterprise** was commissioned, the first nuclear-powered aircraft carrier ever built.

▶ 1981
The space shuttle took a new ship shape into a new sea.

▼ Final frontier?
U.S.S. *Enterprise*

▲ 1851
The New York *Times*, then the New York *Daily Times,* was founded. Adolph S. Ochs bought the paper in 1896. His descendants still run the Gray Lady,

▼ 1890s
The press barons Joseph Pulitzer and William Randolph Hearst engaged in a circulation war filled with sensational headlines and "yellow journalism." Hearst's papers helped foment the Spanish-American War.

▲ 1931
Rupert Murdoch was born in Australia. Beginning in the late 1960s, he became the founder of the first truly global media empire, with properties ranging from newspapers to a movie studio to cable and broadcast television networks.

▼ 1968
Toward e-paper Jerry Yang, co-founder of Yahoo, was born in Taiwan. Though Yahoo has ventured into print magazines, its greatest asset is the 385 million page views its sites provide every day.

suffering for style

▼ c. 1695
Portugal An early high heel for a man, with silver lace and pink silk.

▲ c. 960 to 1900s
China 1936 coverlet for bound foot; some were 3 in. long.

▲ 1980s
France Yves Saint Laurent pumped up biker envy with this rhinestone strap.

- Heel shapes arch shapes elegant foot. It's torture. But ponder the bound feet of the women of imperial China—arches broken, toes crunched, all for status and eros

▼ 1998
U.S.A. Painfully elegant silver lamé stiletto mule with chinchilla trim by Manolo Blahnik.

thomas jefferson

(1743-1826)

A political visionary's "expression of the American mind" still inspires revolution around the world

LEONARD DE SELVA—CORBIS

Worst Revolutionary Machine
The guillotine, named for Joseph-Ignace Guillotin, a proponent of humane execution, was built by piano maker Tobias Schmidt. By the Reign of Terror's end, it had had 2,585 victims, including Louis XVI and his Queen, Marie Antoinette.

Best Revolutionary Machine
James Watt's single-action steam engine, patented in 1769, revolutionized industry and spawned even more machinery to spur productivity.

THE GRANGER COLLECTION

O f all the Founding Fathers, Thomas Jefferson has fared the worst at the hands of revisionists. If he has managed to keep his place on Mount Rushmore, he has been vilified almost everywhere else in recent years as a slave-owning hypocrite and racist; a political extremist; an apologist for the vicious, botched French Revolution; and in general, somewhat less the genius remembered in our folklore than a provincial intellectual and tinkerer.

The onslaught is unfair. But even ardent Jeffersonians admit that the man was an insoluble puzzle. The contradictions in his character and his ideas could be breathtaking. That the author of the Declaration of Independence ("All men are created equal") not only owned and worked slaves at Monticello but also may have kept one of them, Sally Hemings, as a mistress—allegedly fathering children with her but never freeing her or them—was merely the most dramatic of his inconsistencies.

The brilliant American icon gets overtaken from time to time by his own apparent incoherence, his strangeness. He kept minutely detailed account books, for example—he was an obsessive record keeper who made daily notes on everything from barometric readings to the progress of 29 varieties of vegetables at Monticello—yet he somehow lost track of his debts and died bankrupt. The historian Paul Johnson has catalogued a few of the inconsistencies: Jefferson was an élitist who complained bitterly of élites; a humorless man whose favorite books were *Don Quixote* and *Tristram Shandy*; a soft-spoken intellectual sometimes given to violent, inflammatory language ("The tree of liberty must be refreshed from time to time with the blood of patriots and tyrants") that in our day gets quoted by paranoiacs holed up in the Idaho mountains. Both liberals and conservatives claim him as their own.

What does it mean to be a Jeffersonian? You must pick your Jefferson. Every other American statesman, Henry Adams wrote, could be portrayed "with a few broad strokes of the brush," but Jefferson "only touch by touch with a fine pencil, and the perfection of the likeness depended upon the shifting and uncertain flicker of semitransparent shadows."

Painting for TIME by C.F. Payne

Alas, indignant—or prurient—revisionism does not work with a fine pencil. Thomas Jefferson amounted to something infinitely more important—and more interesting—than one would know from the noise and scandal obscuring his achievement now.

He was arguably the most accomplished man (and in some ways the most fascinating one) who ever occupied the White House—naturalist, lawyer, educator, musician, architect, geographer, inventor, scientist, agriculturalist, philologist and more. His only presidential rival in versatility of intellect was Theodore Roosevelt. Though Jefferson wrote only one book, *Notes on the State of Virginia,* he was a magnificent writer and tireless correspondent. He left behind an astonishing 18,000 letters, including his memorable correspondence with John Adams. (Adams and Jefferson died on the same day, July 4, 1826, the 50th anniversary of the Declaration of Independence.)

Jefferson was a creature of the 18th century; he was *the* man of the 18th century. A dozen powerful strands of the Enlightenment converged in him: a certain sky-blue clarity, an aggressive awareness of the world, a fascination with science, a mechanical vision of the universe (much thanks to Isaac Newton) and an obsession with mathematical precision. The writer Garry Wills has suggested that Jefferson believed human life could be geared to the precision and simplicity of heaven's machinery. Many of the contradictions in his character arose from the discrepancies between such intellectual machinery and the passionate, organic disorders of life.

Jefferson's finest hour came when he was young, only 33. The Continental Congress, meeting in Philadelphia in June 1776, chose a committee of five (Benjamin Franklin, Adams, Roger Sherman, Robert Livingston and Jefferson) to draft a Declaration of Independence. Jefferson nominated Adams to compose the draft. Adams demurred, "I am obnoxious, suspected and unpopular. You are very much otherwise." Besides, "You can write 10 times better than I." The committee chose Jefferson.

Best Prophet

Capitalist guru Adam Smith, below, predicted that America, then in rebellion against Britain, and other "empty continents" would be the brave new models of a mercantilist world.

Best Village Philosopher

He claimed a grandparent from faraway Scotland, but Immanuel Kant, top, was a stay-at-home who spent almost all his life in Königsberg, east Prussia (now Kaliningrad, Russia). His reputation for sagacity was such that pilgrims of philosophy flocked to Königsberg.

Saddest Lost Cause

Inspired by the French Revolution, the slave Toussaint L'Ouverture led a Haitian revolution against French royalist colonizers. But the French republic turned imperial, restored slavery and jailed L'Ouverture, who died miserably. His ally Jean-Jacques Dessalines expelled the French but became Emperor. The U.S. sent a crown.

THE BRIDGEMAN ART GALLERY

Signs and Portents

Most Sobering Levy
A tax on gin and a rise in grain prices in Britain drive the country to another drink: tea

Worst Vanishing Act
Poland is nibbled by Prussia, Russia and Austria until 1795, when there is nothing left

Most Measured Reform
France goes metric as the revolution divides everything into 10s, even the week

savant of the century

benjamin franklin

(1706-1790)

IN ORDER TO UNDERSTAND BENJAMIN Franklin's historic significance, we must first rescue him from the schoolbook stereotype: a sage geezer flying kites in the rain and lecturing us about a penny saved being a penny earned. His experiments with electricity led him to invent the lightning rod, devise the theory of positive and negative charges, name the battery and become one of his century's foremost scientists. As for his *Poor Richard's Almanac* adages, they made him not only a best-selling author but also the first American media mogul: printer, editor, publisher, newspaper franchiser, and consolidator and controller of the first great distribution network—the postal service. His inventions included the Franklin stove and the

NATIONAL PORTRAIT GALLERY, SMITHSONIAN INSTITUTION/ART RESOURCE, NY

bifocal lens. As a statesman, he played a key role in America's four founding documents and was the only person to sign them all: the Declaration of Independence (he edited Jefferson's draft), the treaty of alliance with France (which he negotiated), the peace treaty ending the Revolution (which he negotiated) and the Constitution (he came up with the idea of a House representing the people and a Senate representing the states).

All this made him, for a while, the most famous person in the world. More important, he was the first embodiment of what became the American archetype: a middle-class shopkeeper, proud to wear a leather apron rather than put on airs, who strikes it rich as an entrepreneur but never loses his love of civic associations and community cooperation.

THE GRANGER COLLECTION (2)

The truths that Jefferson famously declared to be "self-evident" were not new. He drew his ideas from an extraordinarily wide range of reading, especially from the works of Francis Bacon, Sir Isaac Newton and John Locke, and from the Scottish moral philosophers—Francis Hutcheson, Thomas Reid, David Hume, Adam Smith.

Some have dismissed the Declaration as merely eloquent propaganda—a sort of fancy mission statement for an insurrection. The only response is to observe the power of language to alter history. Jefferson explained, "I did not consider it as any part of my charge to invent new ideas altogether ... It was intended to be an expression of the American mind."

The work of a life may transcend the biography; a civilized person, the slave-owning hypocrite—or whatever he may have been beneath the impenetrable enamels of his character—formulated, in the Declaration of Independence, the founding aspiration of America and what is still its best self, an ideal that retains its motive force precisely because it is unfulfilled and maybe unfulfillable: "We hold these truths to be self-evident, that all men are created equal, and that they are endowed by their creator with certain inalienable rights; and that among these are life, liberty, and the pursuit of happiness."

In later years, he discerned how democracy could be distorted, pointing to Republican France and Napoleon (a "wretch," Jefferson declared, of "maniac ambition"; he added "Having been, like him, entrusted with the happiness of my country, I feel the blessing of resembling him in no other point"). Jefferson stitched together popular sovereignty and liberty, all under divine sponsorship and legitimized by ancient precedent and English tradition. Writes the historian Merrill Peterson: "For the first time in history, 'the rights of man,' not of rulers, were laid at the foundation of a nation. The first great Colonial revolt perforce became the first great democratic revolution as well."

With the Declaration, Jefferson gave the Enlightenment its most eloquent and succinct political expression. He lifted the human race into a higher orbit.　　　　　　—By Lance Morrow

est Musical Prodigy

ohann Chrysostom Wolfgang madeus Mozart, above, to give im his full name, began composing music before he could rite notes (his father Leopold anscribed). By age 6, he was ouring with his father and older ster Maria Anna and was the usical wonder of the world y 10. In his short life he composed some of the most beautiful music ever written. But when e died in 1791, at 35, he was great debt and was buried in common grave.

Least Appreciated Genius

The music of Johann Sebastian Bach got little respect in his lifetime. Critics called it "turgid and confused," excessively artful and not at all comparable to Handel. After his death in 1750, the transcriptions of his work were scattered, and some 100 of the sacred cantatas were lost. A small group of devotees kept his cult alive, enough for Bach to be "discovered" in the early 1800s and championed by such Romantic composers as Felix Mendelssohn.

composer of the century

udwig van beethoven

(1770-1827)

IS ART SOARED WITH DRAMA AND PATHOS; s life met with debilitation and despair. udwig van Beethoven was born in Bonn, e son of a tempestuous father who raised eethoven to succeed Mozart and then rank himself to death. Beethoven's early ompositions were for piano; his performances throughout Europe earned him acaim as an improviser. But he was plagued ith hearing problems, and after suffering prolonged bout of depression, he relocated to a rural village outside Vienna and ught relief in composing. He found the lace he wanted—producing, over the next decade, the most glorious, enduring symphonic works ever written. The music, bridging e catastrophic finale of the old century of his birth and the febrile

promise of a new era, had the whiff of revolution, destroyed the classical symphonic molds and established a new era of Romanticism. His music echoed his character. When his hero Napoleon proclaimed himself Emperor in 1804, Beethoven, in a rage, tore in two the score of his *Third Symphony*, till then titled *Bonaparte*. It was later renamed *Eroica*. After meeting Beethoven, Goethe wrote that "altogether he is an utterly untamed personality." Yet even as his hearing worsened, sending him alternately into fits of despondency and manic frenzy, Beethoven continued to create art of astonishing uplift. The *Ninth Symphony*, his last, included the choral *"Ode to Joy,"* a melody so timeless and sweeping it was used in a triumphant reprise 170 years later to celebrate the fall of the Berlin Wall.

thomas edison

(1847-1931)

His inventions not only reshaped modernity but also promised a future bounded only by creativity

Art for What's Sake?
"Journalism is unreadable and literature is not read," Oscar Wilde, above, lamented. The literary mainstream was commanded by the likes of Charles Dickens, bottom, and his reportorial novels, while Wilde led an aesthetic movement. Like Tom Wolfe vs. John Updike today. Except Wolfe is in Wilde's clothing.

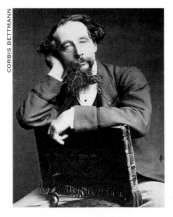

n 1926 the philosopher Alfred North Whitehead wrote, "The greatest invention of the 19th century was the invention of the method of invention." That method, Whitehead added, "has broken up the foundations of the old civilization." Thomas Alva Edison never thought of himself as a revolutionary; he was a hardworking, thoroughly practical man, a problem solver who cared little about ideas for their own sake. But he was also the most prodigious inventor of his era, indeed of all time, and he was recognized as the spirit of a new age by his contemporaries. They observed the amazing new products streaming out of his New Jersey laboratory and, sensing magic, named Edison the Wizard of Menlo Park.

There *was* a sort of magic about Edison, although it had nothing to do with illusions or misdirections. An assistant once described the Wizard at work, "displaying cunning in the way he neutralizes or intensifies electromagnets, applying strong or weak currents, and commands either negative or positive directional currents to do his bidding." But behind his arcane dexterity lay Edison's exhaustive research and his tenacious unwillingness to quit tinkering until a technical challenge had been met. "Genius," he famously remarked, "is about 2% inspiration and 98% perspiration." Or again, as he said in his autobiography, "There is no substitute for hard work."

Edison's tireless work habits took shape during his childhood in Port Huron, Mich. His formal education, according to most accounts, lasted only three months; he quit school after a teacher pronounced him "addled." His mother, herself a former teacher, educated him for a while at home, but the boy's growing fascination with chemistry soon led him into a rigorous course of independent study. To pay for the materials needed for his experiments, Edison at age 12 got a job as a candy and newspaper salesman on the Grand Trunk Railway. By the time he was 16, he had learned telegraphy and began working as an operator at various points in the Middle West; in 1868 he joined

Artwork for TIME by Amy Guip

1000 MILE
ENDURANCE RUN
BAILEY ELECTRIC
NEW EDISON
STORAGE BATTERY

Edison's Latest Invention
THE ELECTRIP EDIPHON

Phonograph

EDISON'S
ELECTRIC PEN and PRESS
❦ 5000 ❦
COPIES FROM A SINGLE WRITING.

Experiment No. 1. Feby 12 1880

Small Phonoedison

Revolutions: Cézanne's in art, Pasteur's in medicine and Marx's in politics

Most Obsessive Artist

Impressionism gave way to Cubism as Paul Cézanne rendered the world "in terms of the cylinder, the sphere, the cone." He would attack the same subject in canvas after canvas to discover its geometry. "There's a minute of life passing," he said. "Paint it in its reality and forget everything to do that!"

Best Doc and Best Bud

Louis Pasteur's medical discoveries saved countless lives. But pasteurization also saved industries and helped beermakers export safe brew everywhere.

Worst Prophecy—So Far

Karl Marx's: "Capitalist production begets, with the inexorability of a law of nature, its own negation." By 2000, communism had won and lost a world.

Most Infectious Tyrant

Napoleonic egomania would inspire dictators well into the 20th century. Bonaparte embellished his own legend with portraits and enigmatic anecdotes. When he moved into the rundown Tuileries palace, an associate said, "How sad this place is, General." Napoleon's reply: "Yes, like greatness."

the Boston office of Western Union. It was here that he read Michael Faraday's *Experimental Researches in Electricity* and decided to work full-time as an inventor.

His first patent, for an electric vote recorder, taught him a lesson that would guide the rest of his career. There was no demand, at the time, for electric vote recorders, and his device earned him nothing. Edison vowed never again to invent something unless he could be sure it was commercially marketable.

Fortunately for him, America during the post–Civil War boom of the 1870s was famished for faster and more reliable ways of doing business. An improvement Edison made in the stock ticker eventually earned him $40,000, a considerable sum at the time. He used this windfall to set up and staff a shop in Newark, N.J., to manufacture these tickers. But other companies began besieging Edison for technical advice, and in 1876 he moved his operation to Menlo Park and created the world's first industrial-research facility, a humming workplace dedicated to improving or creating new products for pay. Some think that Menlo Park itself, which showed the industrialized world a new method of making progress, was Edison's most influential invention.

Other candidates for this honor soon abounded. Edison was working on a problem in telegraphy in 1877 when he noticed that a stylus drawn rapidly across the embossed symbols of the Morse code produced what he later described as "a light, musical, rhythmical sound, resembling human talk heard indistinctly." If it was possible, he reasoned, to "hear" dots and dashes, might not the human voice be reproduced in a similar manner?

charles darwin (1809-1882)

CHARLES DARWIN DIDN'T WANT TO MURDER GOD, AS HE ONCE PUT it. But he did. He didn't want to defy his fellow Cantabrigians, his gentlemanly Victorian society, his devout wife. But he did. He waited 20 years to publish his theory of natural selection, but—fittingly, after another scientist threatened to be first—he did.

Before Darwin, most people accepted some version of biblical creation. Humans were seen as the apotheosis of godly architecture. But on his voyage on H.M.S. *Beagle*, Darwin saw that species on different islands had developed differently. Humans could thus be an accident of natural selection, not a direct product of God. "The subject haunted me," Darwin would write later. In fact, worries about how much his theory would shake society exacerbated the strange illnesses he suffered. It's also worth noting that Darwin's life wasn't Darwinian: he achieved his wealth through inheritance, not competition, and some might say his sickly children suffered because they were inbred.

Darwin's theories still provoke opposition. One hundred and forty years after *The Origin of Species*, backers of creationism have made a comeback in states like Kansas, pushing evolution out of the schoolroom. Yet Darwinism remains one of the most successful scientific theories ever promulgated. There is hardly an element of humanity—not capitalism, not gender relations, certainly not biology—that can be fully understood without its help.

COURTESY OF ERNST VON HARRINGA

Women In and Out of Power
Britain's Queen Victoria, center left, epitomized an age of plenty but assumed the throne in 1837 only because her uncle William IV died childless. China's Empress Dowager Cixi, near left, was a mere concubine but acquired enormous clout by bearing the Emperor his only son. Queen Liliuokalani of Hawaii, far left, succeeded a brother but lost her kingdom to white sugar planters, who got America to annex it in 1898.

fter much trial and error, Edison gathered a small group of itnesses and recited "Mary Had a Little Lamb" into a strange-ooking contraption. The spectators were amazed to hear the achine play back Edison's high-pitched voice. The phono-raph was born.

Edison is commonly called the inventor of the light bulb. In uth, he and his co-workers accomplished far more than that. n 1879 they created an incandescent lamp with a carbonized lament that would burn for 40 hours, but a working laborato- model was only the first step. How could they make this de-ce illuminate the world? For this they would need a host of evices, including generators, motors, junction boxes, safety ses and underground conductors, many of which did not ex-t. Amazingly, only three years later Edison opened the first mmercial electric station on Pearl Street in lower Manhattan; served roughly 85 customers with 400 lamps and pioneered e inexorable process of turning night into day.

Either alone or as the supervisor of his research teams, Edi-

Signs and Portents	
Worst Victim of Globalization	**Best Labor Policy**
China's markets are forcibly opened by Britain's opium trade, creating a nation of drug addicts	Britain moves toward the week-end as we know it, with half Saturdays to rest for Sunday worship

son amassed more than 1,000 patents, including one for the movie camera. That invention alone would have ensured his lasting renown, but it was only one of the many contributions Edison made to the now ubiquitous technological environment. He created the look and sound of contemporary life. He cared not at all about the fame and wealth he earned as long as he was allowed to get on with his work. He never lost the relentless desire to learn and to make things that had animated him as a boy. He remained the most childlike of titans. Once, he was signing a guest book and came to the INTERESTED IN column. Edison wrote, "Everything." —*By Paul Gray*

conscience of the century

abraham **lincoln** (1809-1865)

BY CONVENTIONAL STANDARDS, NO AMERICAN PRESIDENT WAS more ill prepared for the job. Raised poor in Kentucky and Indiana, Lincoln finished barely a year of formal schooling. But his ambition, pragmatism and generosity of spirit catapulted him into politics at a time when the nation was riven by slavery and looming secession. He opposed the spread of slavery to the Western states (famously enunciated in his debates with Stephen Douglas); in 1860, pledging to save the Union, he was elected President. During the Civil War he showed himself to be a shrewd military tactician and a leader of surpassing moral courage. With the signing of the Emancipation Proclamation in 1863, he expanded the purpose of the war, making it nothing less than a fight for freedom and the survival of democracy. He became convinced that slavery was a sin shared by North and South, and that it had to be cleansed on the battlefield. "If God wills that it continue ... until every drop of blood drawn with the lash shall be paid by another drawn with the sword," he said, "so it still must be said, 'the judgments of the Lord are true and righteous altogether.'" America's greatest President paid for that faith with his own life.

time's
atlas
of the
millennium

Sources: *Altlas of World History;* U.N
TIME Graphic by Joe Ze
Maps for TIME by Mike Reaga

1000
the empires of islam

CALIPHS IN CAIRO, CORDOBA AND BAGHDAD REND THE UNITY OF ISLAM BUT not the prosperity. Gold from Nubia and the Caucasus is minted into dinars, the common currency from Spain to Lahore; and slaves from Asia, Europe and Africa labor in mines, cities, armies and harems from Cádiz to Samarkand. Meanwhile, Europe is still limping out of the Dark Ages.

Center of The World

⭐ **Baghdad:** Bazaar of world trade; seat of the most prestigious caliphate. Rivals: Constantinople in the Byzantine Empire; Kaifeng in Song dynasty China.

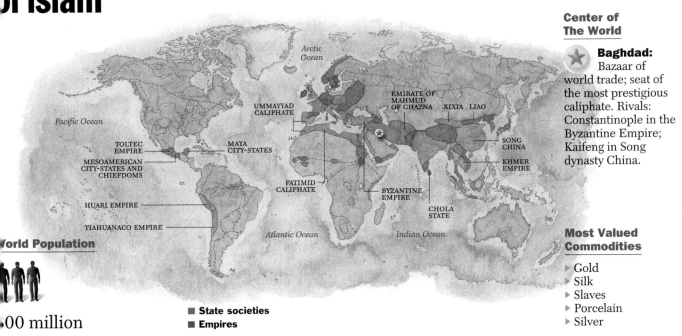

World Population

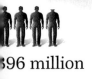

00 million

■ State societies
■ Empires

Most Valued Commodities

▶ Gold
▶ Silk
▶ Slaves
▶ Porcelain
▶ Silver

1300
heirs to the great khan

KUBLAI KHAN'S FAMILY RULES CHINA, KOREA AND MONGOLIA FROM DADU (today's Beijing), but related Mongol khanates in Central Asia and Russia are virtually independent if not hostile; and the once subservient (and Buddhist) Il-Khans of Persia have converted to Islam. Meanwhile, drawn by the decay of Byzantium, Osman and his Turks germinate the Ottoman Empire in Anatolia.

Center of The World

⭐ **Dadu:** Magnet for trade, diplomacy and the fabled riches of Asia. Rivals: Venice, merchant of the Mediterranean; Timbuktu, golden capital of Mali.

World Population

396 million

■ Mongol Empire and vassal states
■ Other empires
■ Countries

Most Valued Commodities

▶ Gold
▶ Slaves
▶ Silk
▶ Porcelain
▶ Spices

1500
europe takes to the seas

THE RICHEST EMPIRES ARE MING DYNASTY CHINA AND THE REALM OF THE Ottomans, which blocks Western Europe's old land routes to the east. Portugal and Spain seek oceanic alternatives: Lisbon rounds the Cape of Good Hope to reach India; Madrid crosses the Atlantic in hopes of landing in Marco Polo's Cathay but finds the Americas instead. Two continents are suddenly open to conquest.

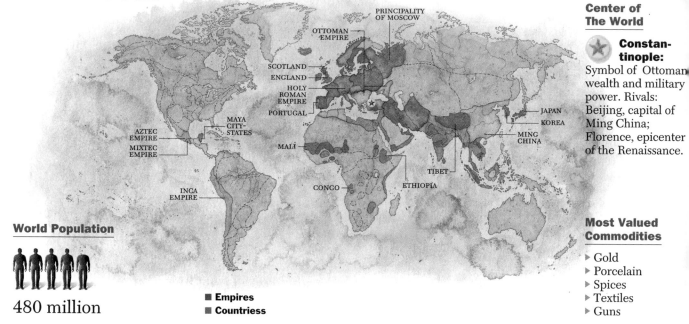

Center of The World

⭐ **Constan-tinople:** Symbol of Ottoman wealth and military power. Rivals: Beijing, capital of Ming China; Florence, epicenter of the Renaissance.

World Population

👤👤👤👤👤
480 million

■ Empires
■ Countriess

Most Valued Commodities

▶ Gold
▶ Porcelain
▶ Spices
▶ Textiles
▶ Guns

1700
traders and trade wars

LOUIS XIV'S FRANCE IS PRE-EMINENT IN A EUROPE OF RIVAL COMMERCIAL powers and about to embark on the long war of the Spanish succession (and over the fate of Spain's rich colonies). It will take place in Europe (France and Spain vs. Austria, England and the Netherlands) and in North America (French colonists vs. their British counterparts).

Center of The World

⭐ **Versailles:** Louis XIV's palace is the place to be. Rivals: London—colonies and commerce make it Europe's largest city; Mexico City, the jewel of Spanish America.

World Population

👤👤👤👤👤👤
640 million

■ French
■ Dutch
■ British
■ Portugese
■ Spanish

Most Valued Commodities

▶ Gold
▶ Slaves
▶ Textiles
▶ Tea
▶ Timber

1900

pax britannica

BRITANNIA RULES AN EMPIRE ON WHICH THE SUN NEVER SETS. AND Western powers rule almost every other part of the world. Japan emulates Europe and the U.S. and joins Britain, Russia, France and Germany in contemplating the dismemberment of the decrepit Chinese Empire. Nationalism sows the seeds of two world wars.

Center of The World

London: Heart of world's largest empire. Rivals: Berlin, the Kaiser's haughty home base; San Francisco, cosmopolis built by gold, fed by trade and trains.

Most Valued Commodities

▸ Gold
▸ Coal
▸ Timber
▸ Steel
▸ Armaments

World Population

.65 billion

■ **British Empire**

2000

pax electronica

MORE THAN 200 COUNTRIES MAKE UP THE WORLD—AND IT'S STILL FRAYING. But the Internet is now the medium for imperium, as electronic democracy links even tyrannies with an increasingly World Wide Web. As chips grow cheaper, the new have-nots are the technologically underserved. What spark can pull the global plug?

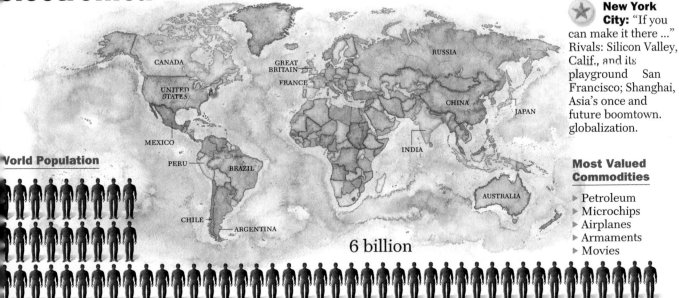

Center of The World

New York City: "If you can make it there ..." Rivals: Silicon Valley, Calif., and its playground San Francisco; Shanghai, Asia's once and future boomtown. globalization.

Most Valued Commodities

▸ Petroleum
▸ Microchips
▸ Airplanes
▸ Armaments
▸ Movies

World Population

6 billion

Our "Notebook" section:

commentary on politics, sports, animal rights;

sometimes all at once.

The world's most interesting magazine.

the web we weave

We've had the Internet in many forms
over the centuries, creating a collective
mind that thinks faster and faster

By ROBERT WRIGHT

n the middle of the 19th century, Ralph Waldo Emerson registered a lyric complaint about the oppressive force of material goods: "Web to weave and corn to grind; Things are in the saddle and ride mankind."

Talk about your sensitive poets. If Emerson found such modest machinery as corn grinders dehumanizing, how would he handle the end of this century? Today we are more than ever slaves of technology, tethered to computers and cell phones and beepers. Meanwhile, we have to cope with unprecedented change. Things are riding us faster and faster.

And the more tethered we become, the faster things change, because the tethers are plugging people into the very social collaboration that drives the change. Science, technology, music, politics—flux in all these realms is hastened by the new electronic synergy. The Internet and allied technologies make us neurons in a vast social brain, a brain that keeps enticing us into making it bigger, stronger, faster. We have, you might say, a Web to weave.

Robert Wright is the author of The Moral Animal. *His new book,* Nonzero: The Logic of Human Destiny, *comes out this week*

What are we to make of all this in practical terms, philosophical terms, even spiritual terms? How to comprehend an age in which, suddenly, we find ourselves enmeshed in a huge information-processing system, one that seems almost to have a life of its own and to be leading us headlong into a future that we can't clearly see yet can't really avoid?

The first step is to delete the word suddenly from that last sentence. For this giant social brain has been taking shape, and hastening change, for a long, long time. Not just since Emerson's day, when the telegraph—sometimes called the "Victorian Internet"—made long-distance contact instantaneous, but since the very dawn of the human experience. For tens of thousands of years, technology has been drawing humanity toward the epic, culminating convergence we're now witnessing.

This fact is best seen from a perspective that flourished more than a century ago, as Emerson was fading from the intellectual scene. In the wake of Darwin's theory of natural selection, some anthropologists started viewing all human culture—music, technology, religion, whatever—as something that evolves rather as plants and animals evolve. "In the mental sphere the struggle for existence is not less fierce than in the physical," observed the

TRANSMITTING KNOW-HOW A 4,000-year-old North African cave painting

British anthropologist Sir James Frazer. "In the end the better ideas carry the day."

Lately, this view, "cultural evolutionism," has been revived and given a new vocabulary. "Meme"—a word chosen to stress the parallel with "gene"—is the label for packets of cultural information: technologies, songs, beliefs and so on. Just as those genes most conducive to their own replication are the ones that prevail, those memes best at getting themselves transmitted from human to human are the ones that come to form the human environment.

From the very beginning, cultural evolution was a social enterprise, mediated by what you could loosely call a social brain. One person invents, say, a flint hand ax; the idea creeps across the landscape, gets improved here and there, and finally, in a distant land, stimulates a whole new idea: axes with handles conveniently attached.

That it took hundreds of thousands of years to get from hand ax to ax with handle suggests that as of 50,000 B.C., during the Middle Paleolithic, the social brain was not humming very vibrantly. There were only 2 million or 3 million "neurons"—a.k.a., people—scattered across the whole planet, and lacking fiber optics or even postal service,

they weren't exactly in constant contact.

Still, even back then, the social brain, through positive feedback, was maturing. With each advance in subsistence technology, survival grew more secure, hastening population growth; and as population grew, the advances came more quickly. By the Mesolithic Age, around 10,000 B.C., with the neuronal population up to around 4 million, the rate of advance had moved from one major innovation per 20,000 years to a sizzling one per 200—including such gifts to posterity as combs and beer.

It was around this time that, as the economist Michael Kremer has noted, Mother Nature happened to conduct an experiment that underscored the value of large social brains. Melting polar ice caps severed Tasmania from Australia and the New World from the Old World. Thereafter, just as you would expect, the larger the landmass and hence the population, the faster subsistence technology progressed. The people of the vast Old World invented farming before the people of the smaller (and, at first, thinly populated) New World. And the Aborigines of yet smaller Australia never farmed. As for tiny Tasmania, modern explorers, on contacting the Tasmanians, found them lacking such Australian essentials as fire, bone needles and boomerangs.

Farming, which took shape in the Old World around 8,000 B.C. and in the New World a few millenniums later, is a much misunderstood meme. Anthropologists sometimes call it an "energy technology," since food does, after all, energize us; but farming may have originally mattered more as a kind of information-processing technology. By radically increasing the human population that a given acre could support, farming sped up the synergistic exchange of cultural information, lubricating innovation; it packed lots of neurons together, raising both the size and the efficiency of social brains.

The results were epoch making. In both the New World and the Old World, within a mere 5,000 years of the inception of farming, there were dazzling technological advances, including monumental temples, big dams and, above all, a whole new information technology: writing.

Early writing didn't spur invention the way writing does now. There were no technical journals to convey news of inventions, no patents to file. No, the main service of writing, like that of farming, was to permit bigger, faster social brains; to allow neurons to be packed more densely still, further boosting intellectual synergy. After all, it was via writing that

SLOW TECH Hieroglyphics and illuminated manuscripts nevertheless helped

royal bureaucracies kept large cities functioning. And writing also meant clear, precise legal codes, which kept urban life peaceful, even though people now lived cheek by jowl with lots of other people who were neither friends nor family.

For example, the code of the Mesopotamian city of Eshnunna in the early second millennium B.C., developed a century before the more famous code of Hammurabi, left no doubt what would happen if you punched a man in the face: a fine of 10 shekels of silver (a bargain compared with the levy for biting off his nose, which would cost 60). As long as people could go about their business without fear of getting their noses bitten off, the social brain could productively throb.

FASTER TECH High-speed presses and broadcasting expanded the evolving net

As distant cities became linked through commerce (much of it orchestrated by written contract), culture acquired a kind of disaster insurance. An valuable meme—the concept of the chariot or of coins—would spread so fast from city to city that it could survive any catastrophes that afflicted its birthplace. The world's data-processing system was getting better at making backup copies.

That's why so much Roman culture survived the disintegration of the Western Empire. The most prolific memes had long since spread to Byzantium if not beyond and would keep replicating themselves even as Western Europe struggled to regroup. Thus the astrolabe would eventually be reintroduced to the area via Islamic culture, which thrived during the early Middle Ages. Meanwhile, in Asia, key memes would arise—the spinning wheel, even printing—and some would migrate all the way to Europe.

The movable-type printing press, up and running in Europe by the mid-15th century, was by far the most Internet-like technology in history. Eventually, it would convey detailed news of inventions, allowing people in distant lands who would never meet to collaborate, in effect, on new technologies. "James Watt's steam engine" was actually lots of people's steam engine, including the Frenchman who had first shown that steam could move a piston.

The economic historian Joel Mokyr, stressing this sort of international synergy, has attributed Europe's Industrial Revolution to "chains of inspiration" by which one idea sparked another. But, as we've seen, chains of inspiration had been vital to the whole history of technical advance, even the glacial process by which the stone flake inspired the inventor of the stone knife. What was new was how fast the chains were being forged, even across great distances.

In the early 19th century the coming of the railroad train further sped things up. Paired with increasingly smooth local postal service, the train meant that people thousands of miles apart were separated by only days. With chains of inspiration sprouting wildly, the multina

WHAT END TO THE MEME? Cybercafés are another link in the global brain

ional technical community became an almost unified consciousness. Increasingly, good ideas were "in the air."

Witness how often the same basic innovation was made independently by different people in different places at roughly the same time. And witness—as testament to the impetus behind easing communication—how often those independent breakthroughs were in information technology itself: the telegraph (Charles Wheatstone and Samuel F.B. Morse, 1837); color photography (Charles Cros and Louis Ducos du Hauron, 1868); the phonograph (Charles Cros—again!—and Thomas Edison, 1877); the telephone (Elisha Gray and Alexander Graham Bell, 1876)—and so on, all the way up to the microchip (Jack Kilby and Robert Noyce, 1958).

And each such advance—by easing the transmission of data, whether by sound, print or image—only raised the chances of further advances. Via endless positive feedback, the technological infrastructure for a mature global brain was, in a sense, building itself. And so it had been, ever since the Middle Paleolithic: the story of humankind is faster and vaster data processing.

So where does this cosmic perspective leave us? Inspired? Depressed? As helpless in the face of technology's onslaught as ever?

For starters, if you equate nature with beauty—as Emerson and other transcendentalists tended to—then there is a kind of beauty in the unfolding of technology. It is a process of natural evolution, and may deserve the tribute that Darwin paid to organic evolution: "There is grandeur in this view of life."

Indeed, if you believe, as I do, that intelligent, culture-generating animals were a likely outcome of biological evolution, then you might even say the first great evolutionary process naturally spawned the second, which has since taken over as the great molder of the material world. In this view, the kind of global brain now taking shape has been in the cards not just since the Stone Age but since the primordial ooze; it has been, in some sense, life's destiny.

This aura of inexorability has led some people to wax poetic about cosmic purpose. The Jesuit theologian Pierre Teilhard de Chardin, writing at midcentury, long before the Internet, nonetheless discerned a "thinking envelope of the earth" that he dubbed the "noosphere." This was the divinely ordained outcome of the two evolutions, and would lead to "Point Omega," where brotherly love would reign supreme.

Now, nearly a half-century after Teilhard's death, we have cause to be less sanguine about this noosphere business. Viewing the noosphere up close and personal—from the inside—we can see that its potential for good and evil is about equal. The Internet can unite people across distance, but it is indifferent to whether they are chess players, crusading environmentalists or neo-Nazis.

And, for all the benefits that keep us plugging into the Internet, it can be alienating. (Is it just me, or is e-mail a much poorer substitute for face-to-face contact than a phone call is? And if so, why am I letting e-mail crowd out my phone calls?) There is indeed the sense sometimes that, like neurons, we subordinate ourselves to the efficiency of the larger whole—that technology wins in the end, that culture trumps biology. As Emerson put it, "There are two laws discrete, Not reconciled,— Law for man, and law for thing; The last builds town and fleet, But it runs wild, And doth the man unking."

Yet, in the end, we are free to use the technology however we want, even if it takes real effort, inspired by a touch of resentment toward our would-be technological master. We can in theory follow Emerson's advice: "Let man serve law for man; Live for friendship, live for love." Maybe all along it was the destiny of our species to be enmeshed in a web that would give us the option to exercise either amity or enmity over unprecedented distance, with unprecedented power. There are worse fates than to have a choice like that. ∎

TIME

THE WEEKLY NEWSMAGAZINE

JANUARY 1, 2000

Hello, 21st Century

Happy New Century!

ON NEW YEAR'S EVE, SIX-YEAR-OLD Christian put the lighted flashlights into the sleeves of his rust-red sweater and, a veritable 21st century automaton, ran down the hallways of TIME magazine to his mother, picture editor MaryAnne Golon. With not a small degree of pride, he loudly declared, "I'm Y2K compliant!"

And so were we. Some 90 staff members, a few with family members in tow, worked in our New York City offices this past weekend to prepare this keepsake issue. We had planned it for two months

information-technology staff set up a generator-powered "war room" in the basement of the Time & Life Building, filled with computers and equipment ready to produce the magazine in case of a catastrophic breakdown of electricity and communications. "We even rented extra furniture," says creative services manager Kin Wah Lam.

As it turned out, the most dramatic incident, indeed a historic one, was unexpected: the resignation on the morning of Dec. 31 of Russian President Boris Yeltsin. Our Moscow bureau quickly sup-

plied reporting, and managing editor Walter Isaacson asked for an assessment of Yeltsin from the White House, which the President provided virtually overnight in an essay that appears on page 94.

The world's passage into the third millennium after Christ proved to be more celebratory than alarming, as Joel Stein notes in his story accompanying the magazine's photographic commemoration of the turn of the century. That was certainly clear to those of us who worked through New Year's Eve into the early hours of New Year's Day. TIME's headquarters overlooks part of the Times Square area, and every now and then, as we monitored the world, we looked out our windows to see the crowds massing, waiting for the famous ball to drop.

At the strike of midnight, the roar from the streets echoed into the building and a snowfall of confetti fell outside as fireworks reflected off the glass walls of nearby buildings. We popped champagne and sprinkled some of our own confetti to mark the passing of the old millennium before heading back to our terminals. They worked.

Other adventures into the 21st century were fortunate. Photographer Steve Liss traveled to the Chatham Islands, which were, until the Kingdom of Tonga and the nation of Kiribati tampered with the rules, the first inhabited place on earth to greet each new day, and thus would have been the first to reach the new millennium. But when he got to the tempestuous isles, he was told, "We get to see the sun rise maybe four times a year." Nervously, Liss waited and was rewarded, along with the islanders, with a brief but stunning dawn, the first sunrise of the new century. A single daybreak, the beginning of another accumulation of days to make a year, a century, a millennium. After all the extravagant and theatrical celebrations of immense measures of time, all of us must now return to live the future day by day.

And the war room? It will be dismantled. The rented furniture is going back to the store.

Overnight crew: seated from right, systems engineer Kevin Kelly, associate art director Daniel Guadalajara, assistant managing editor Howard Chua-Eoan, traffic desk assistant Urbano Delvalle, assistant picture editor Mark Rykoff and his wife Lena, deputy art director Cynthia Hoffman; standing from right, news desk editor Eileen Harkin, systems engineer Roger Rodriguez, picture editor MaryAnne Golon, news director Marguerite Michaels, associate picture editor Robert Stevens and his wife Alexa Grace

with some trepidation, aware of the potential for the fog of technology and the insinuation of terrorism. Last weekend all of TIME's bureaus were on alert, and we posted several dozen photographers around the world to record the passing of 1999 into 2000. In Washington, correspondent Sally Donnelly took a New Year's Eve flight with the head of the FAA. Julie Grace of our Chicago bureau spent the evening with a family of Y2K worriers in Ohio. Denver bureau chief Richard Woodbury watched Norad even as Norad watched the skies. Meanwhile, other correspondents followed sun worshippers in India, opera lovers in Egypt and nervous brides in Vegas.

As police throughout the world secured emergency bunkers for themselves, the TIME magazine and Time Inc.

SLEEPOVER: William Grace-Stevens, Lydia Booz (Hoffman's daughter), Christian Golon

Howard Chua-Eoan,
Assistant Managing Editor

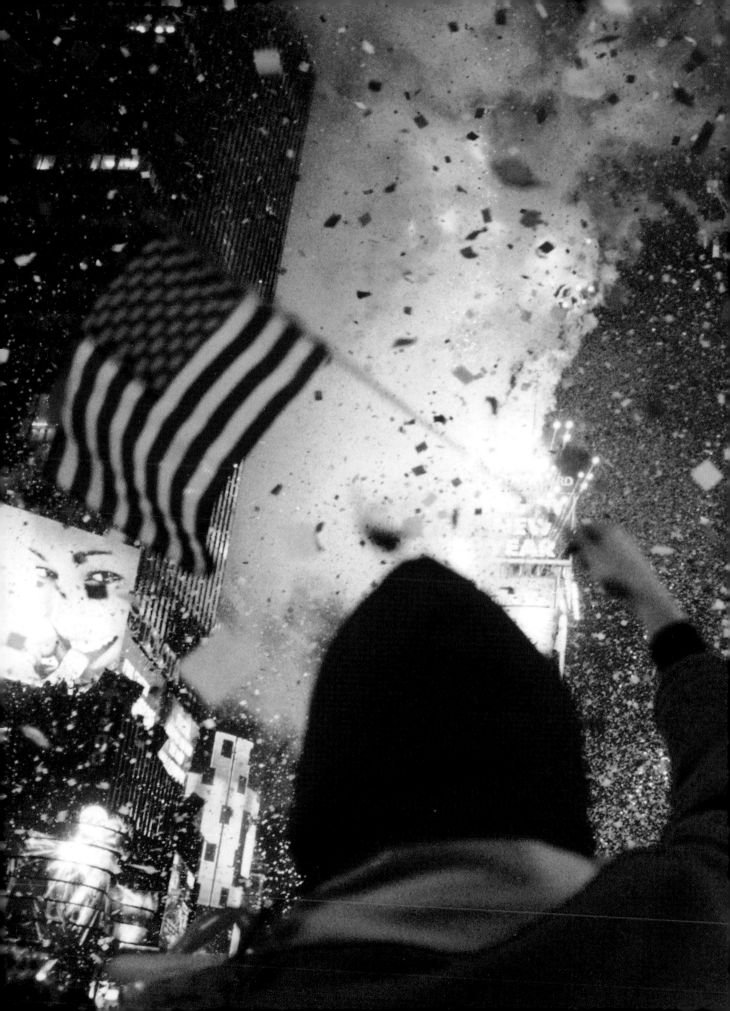

Birth of A Century

2000

Times Square, NEW YORK

Close to 2 million people, three tons of confetti, 8,000 police officers (including sharpshooters secretly perched on skyscrapers), 14 arrests, one man dressed as a white spider who was allowed to slither through the police barricades, 130,000 free souvenirs, one very expensive ball, 48 bomb threats—all of them hoaxes—and one very happy mayor. For Bronwyn Jones, 28, who traveled 33 hours from Perth, Australia, "It's the biggest party I've ever been to without a drink."

Chatham Islands, NEW ZEALAND

Russell Goomes with his granddaughter Shontelle at the year's first dawn over a populated area. The nation of Kiribati had the international dateline moved so its uninhabited "Millennium Island" would be the first to welcome 2000. But Chatham's 750 people, just 15 minutes behind, were blessed with the sight of this sunrise—a symbol, says Goomes, of "a higher power guiding us toward something better."

AROUND THE WORLD

STEVE LISS FOR TIME

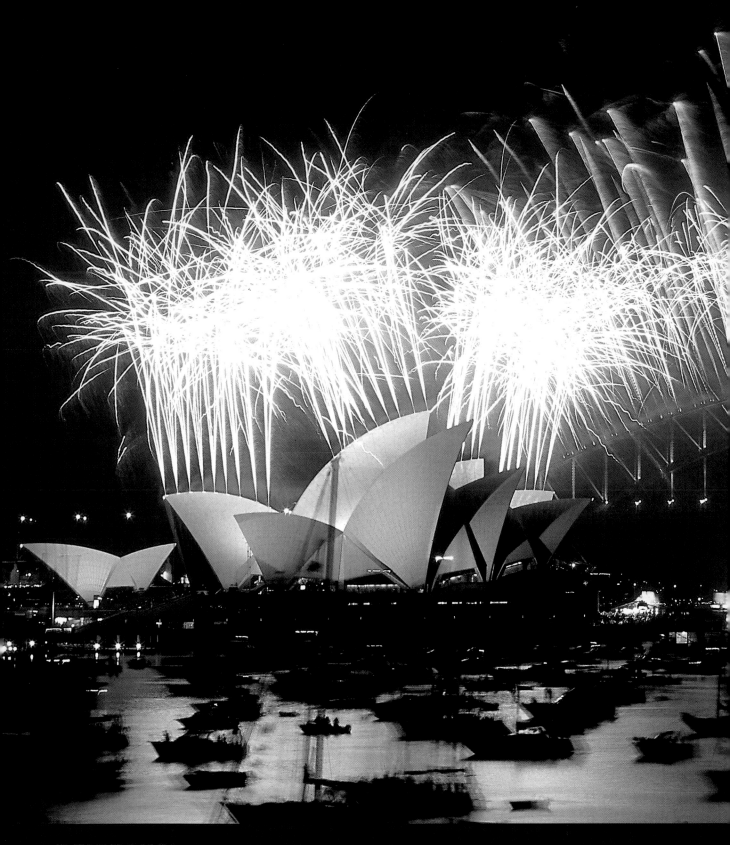

Sydney, AUSTRALIA

A million people thronged to the city's harbor by foot, yacht and even dinghy, so
staking out choice shoreline spots days in advance for a view of the pageant. As par
the show acrobats scaled the Sydney Opera House, an electric smiling face v
suspended over the harbor, three-story lanterns shaped like mythic sea bea

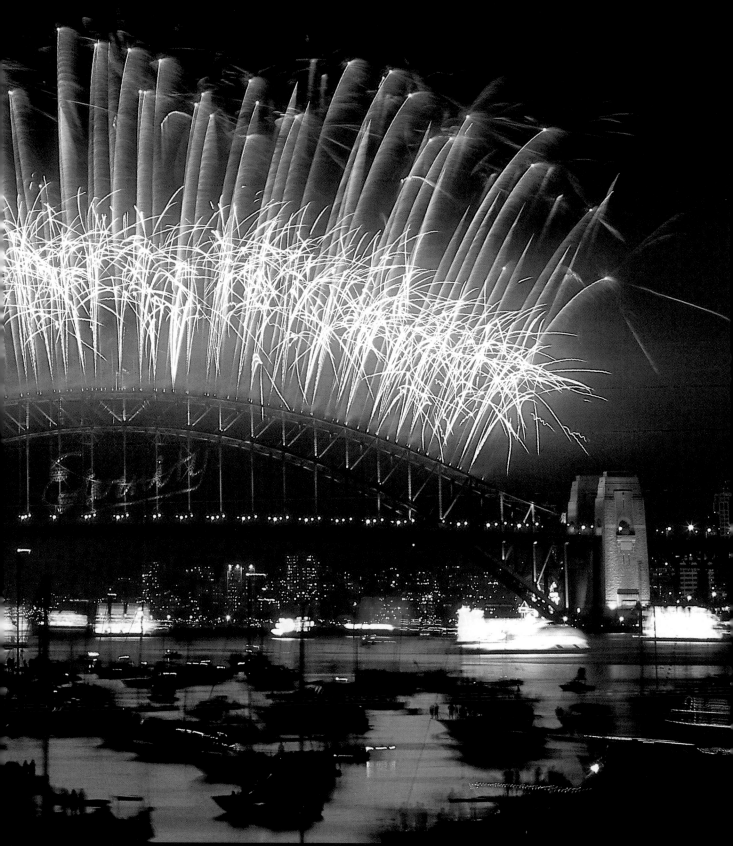

MICHAEL AMENDOLIA—NETWORK PHOTOGRAPHERS FOR TIME

nced on the waterways—all bathed by 20 tons (and more than $3.5 million worth) of fireworks. Cathedral bells ed at the finale as the word ETERNITY in neon lit the city's historic Harbour Bridge, tribute to a local graffiti st and mystic who inscribed the word on the city's sidewalks and walls. As good as the show was, Australians sider it all a warm-up for the party they'll give this September when the Olympics come to town.

AROUND THE WORLD

Taipei, TAIWAN
Celebrators gathered at a local school to pray for peace and release 10,000 sky lanterns.

Bali, INDONESIA
After a day spent in the surf on Kuta Beach, partygoers danced in a disco's bubble pool.

Ho Chi Minh City, VIETNAM
The dignified beating o 200 drums welcomed the new century.

CLOCKWISE FROM RIGHT: GREG GIRARD—CONTACT FOR TIME; RICHARD VOGEL—AP; CHARLES DHARAPAK—AP; TAO-CHUAN YEH—AFP

anghai, CHINA

country that invented fireworks celebrated in the traditional manner, with a 45-min. pyrotechnic display along Huangpu River. As ordinary Chinese watched from the streets, some of Shanghai's newly wealthy dined on ar and champagne at a $250-a-head century party in a terrace restaurant high overhead. The Chinese new —the Year of the Dragon—does not formally begin until Feb. 5, but revelers were undeterred.

2000

AROUND THE WORLD

Kanniyakumari, INDIA

At the southernmost point of
the Indian subcontinent, the
Arabian Sea, the Bay of Bengal
and the Indian Ocean swirl together.
On Jan. 1, practitioners of the
yogic ritual Surya Namaskar
gathered at this sacred spot to
honor the sun god Surya and
welcome the new millennium.

DILIP MEHTA—CONTACT FOR TIME

Hey, you in that bunker,
YOU CAN COME OUT NOW!

After a year of computer-bug fears and a month of terrorism warnings, everything was Y2OK. So the world partied as if it all shared one calendar

By JOEL STEIN

IT WAS THE PERFECT FABLE FOR OUR time: HAL recast as a billion tiny bugs, his omnipotent malevolence replaced by our own innocent oversight. Technology had become so all-encompassing and incomprehensible, the fable began, that we had unwittingly lost control of it. So the smallest thing, our human habit of hiply referring to years by the last two digits, was going to topple this electronic pack of cards, sending planes crashing to the ground, nukes leaping from their silos, electricity to a standstill and all of humanity back to a time much earlier than the 1900 our computers would believe it was. It was a cleansing fantasy, a dream of ridding ourselves of the increasingly unavoidable yoke of overcivilization and going back to a society simple enough for us to understand.

So at 4:30 a.m. on Dec. 31, in Lisbon, Ohio, fable believers Bruce and Diane Eckhart awoke and immersed themselves in technology for what they believed was the last time, turning on their two televisions, dialing up the Internet and clicking on their shortwave radio to monitor the first Y2K rollover in Kiribati. Since 1997 the Eckharts have been stockpiling food, conducting surprise drills, practicing firearm skills, converting savings into gold coins and studying rudimentary dentistry and field medicine. "So far, it's just a minor power outage in New Zealand," Diane reports, before uttering a sentence few have ever delivered. "But we've heard nothing about Guam; it's kind of disturbing."

As the day wears on, and news reports show that not even China is having problems, their daughter Danielle, 12, is the first to lose interest. "Whatever happens, happens," she says, after singing along to a Sheryl Crow tape. "We won't have to go grocery shopping for a while." And while Bruce, 45, is still talking about being wary of strangers from neighboring Youngstown coming to loot his stash, his wife Diane, 42, is already contemplating their massive store of canned food. "I'm going to save on

Lisbon, OHIO
Y2K was no game for the Eckhart family, who stockpiled six months' worth of food

Viva Las Vegas Chapel, LAS VEGAS
After their wedding, Hanna Sandstrom and Richard Barton dance to music by Elvis impersonator Ron DeCar

groceries," she says, determined to eat their 12 cans of Spam, disaster or not. "I can't decide if I'm going to buy a Jacuzzi or a new computer with the money."

In Tennessee, Karen Anderson woke up on New Year's Day less ready than the Eckharts to dig in to her canned food. The self-designated Martha Stewart of Y2K (her book *Y2K for Women: How to Protect Your Home and Family in the Coming Crisis* as well as her website, *y2kwomen.com,* give tips on reusable tampons) now fears a leap year computer bug on Feb. 29, among other potential disasters. "We don't know what's going to happen with the economy. If the markets crash or my husband loses his job, we're ready," she says. In Ontario, Bruce Beach, who began constructing a bunker of 42 buried school buses 18 years ago, watched astounded as city after city passed into modernity with nary a scratch. And MTV Online, as if to mock it all, was showing Internet film of the six kids it set up in a campy Y2K bunker under a building in Manhattan.

Almost as interested in world rollovers as the bunkered down were the U.S. and Russian military officers at Peterson Air Force Base, the now permanent Center for Year 2000 Strategic Stability. Officers from both sides of the cold peace, who were there to make sure no nukes accidentally went off, labored to keep busy, channel surfing among CNN and other news shows and showing one another Russian Internet fare. The only old-school touch was the hot-line phones, black for Moscow, white for the U.S. When the clocks changed in Moscow and no bugs were reported, the Russian team applauded and U.S. Major General Thomas Goslin Jr. congratulated Russian group leader Colonel Sergey Kaplin. He may have deserved even more congratulations. Russia spent $4 million on Y2K military preparations while the U.S. spent nearly $4 billion. In fact, Americans spent an estimated $100 billion to be ready on all fronts, from telecommunications to sewage treatment. It is still unclear whether that was money partly wasted or money that saved us from a meltdown, but

any funds that happene to be spent on ensurin the safe, swift delivery o newsmagazines is mone well spent.

The FAA confidentl sent its chief, Jane Ga vey, flying from Wash ington to Dallas durin the key hour of midnigh Greenwich Mean Time The only surprising thin about the flight was tha the FAA chief had to fl coach. Joining her wer 36 passengers, includin one brave TIME report er, Washington Senato Slade Gorton and Jane Rhodes, 63, whose life goal was to fly durin midnight of the millenn um. Rhodes booked th trip months in advance had her flight cancele twice owing to lack o passengers and eventua ly got a ticket on the fligh Garvey was taking, figu ing American couldn cancel that one. "I'm a happy as a lark," sh chirped, after drinking glass of complimenta champagne. "This is th most fun I've ever had o a flight. I just love bein part of history."

Fear itself was virtu ally nonexistent on Friday, with almost n one making a last-minute ATM run, leavin the $50 billion of extra cash the Feder Reserve had printed for the occasion to b turned into mulch later this month.

So as Apocalypse Not struck around th globe—and all terrorists were either caugh in bed watching television, or releasing planeload of hostages—people everywher celebrated. Many cultures celebrated d spite the fact that most follow complete different calendars, and despite the fa that far too many people were pointing o that the millennium doesn't really start u til next year and that our system is messed up anyway, because Jesus was bor 2,004 years ago. They celebrated becaus the most famous odometer mankind h ever created was displaying three zeroes a row. It's exciting enough when it happe to your own car; when it happens to th world, it makes you downright giddy.

After a dispute sillier than states con peting to hold the first election primary, th Republic of Kiribati beat out Tonga an

New Zealand's Chatham Islands for the media's anointment of birthplace of the third millennium. To jump in front of the Chatham Islands by 15 minutes, Tonga sneakily used daylight savings time, while Kiribati had the international dateline moved in 1995 so its snazzily named if unfortunately uninhabited Millennium Island would be first. Kiribati's Micronesian dancers, shipped in from Tawara, whupped it up before the world's cameras for six minutes and then prepped for the next TV spot. Not to be outdone, the Chatham Islands—the first actually inhabited land to see the new millennium—jumped on boasting rights for the first haircut, first horse race, first beer brewing and first fishing competition. The 21st century looks to be even more competitive than the last.

And the day of odd weddings began early with a dispute over the first wedding. Was it the marriage of Chatham hardware-store managers Monique Croon, 33, and Dean Braid, 27, whose televised wedding was accompanied by fireworks? Or was it that of Cheryl Berthelsen and Matthew Beach, both 28 and from Virginia, who won a $15,000 auction at *weddingchannel.com* to be married in the South Pacific on private Turtle Island, which employs daylight saving time? Later, 700 couples were married in a ceremony in Philadelphia; 2,000 in a Bangkok ceremony; 110 along the Delaware River; 20 couples in the Maryland courthouse where Monica Lewinsky testified against Linda Tripp two weeks ago; and 20 in Las Vegas' Chapel Viva Las Vegas, which featured hula girls, showgirls, a Merlin and, of course, an Elvis impersonator. For the rest of their lives, all these people will have to answer questions about their wedding album with, "No, I don't know who that person is either."

Along with people who like to wed in groups, the Millennial New Year was an excuse for attention-needy adrenaline seekers. A large group went to the South Pole to drink champagne as scientists performed their annual repositioning of the U.S. flag (glacial movement shifts the flag). After midnight, four Emory students planned to finish their ascent up Argentina's 22,834-ft. high Mount Aconcagua amid 150 m.p.h. winds and subzero temperatures. At dawn on the ever popular Chatham Islands, six people parachuted to see the first sun-

rise from above the clouds. At Jerusalem's Golden Gate, which some predict will be the site of Jesus' second coming, police arrested entertainer Dudu Topaz, who dressed up as Jesus as a stunt for his TV show. Near Montpellier, France, cave explorer Michel Siffre, who has been underground for a month and no longer has any sense of time, thought Friday was Dec. 27. And in Chicago, *The Jerry Springer Show* offered "Y2Lovers," a daring episode in which people were confronted by both of their lovers.

LOTS OF BABIES WERE BORN TO PARents who were just lucky or had planned really carefully last April. A Silicon Valley hospital gave its first baby a share of Yahoo! stock and five shares of Silicon Graphics. Twins were born on either side of midnight in Berlin, Virginia, Indianapolis, Oklahoma and Seattle. Regardless of what any of them accomplish in life, this is how they will always be described.

But it was the parties that got most of the attention, since the 72% of Americans who stayed home this year needed something to watch. Australia set off some fireworks, as did Japan, where Prime Minister Keizo Obuchi tried to backpedal from weeks of warnings to stockpile food and water. He had even declared a three-day emergency holiday. A country that has been burned as badly by its faith in tech-

nology over the past decade as Japan deserves to be careful. But for China, which really doesn't have many computers and uses a different calendar anyway, to declare a holiday in fear of the Y2K bug seemed just about as silly as the manly N.F.L.'s forcing teams to fly to opposing fields a day early on Friday to avoid being in the air in the new year.

London, while offering a fireworks display of disturbing duration, had some mishaps. The much hyped fire on the Thames, which was to travel at the speed of the earth's rotation, didn't quite happen, and the giant Ferris wheel being built for the occasion was not ready. This was not because of a Y2K bug, but because they are British. The Millennium Dome, however, was ready and so big that if held upside down under Niagara Falls, it would take 12 minutes to fill. This is entirely unhelpful as to figuring out how big it is.

Paris' 11 Ferris wheels were working fine, and though its fireworks display was shorter than London's, it clearly was more impressive. This comparison is far less uninteresting than the 10 minutes of debate on ABC between Barbara Walters and Cokie Roberts over which is a better city, Paris or Rome. ABC had 25 hours of time to fill. Walters changed outfits twice, enough time for anchor Peter Jennings to report an e-mail from a viewer saying she liked Walters' first outfit better. ABC had 25 hours of time to fill.

MARK RICHARDS FOR TIME

E-City Studios, SANTA MONICA
Bored with real-life partying? This high-tech midnight-to-dawn rave was broadcast live on the Internet

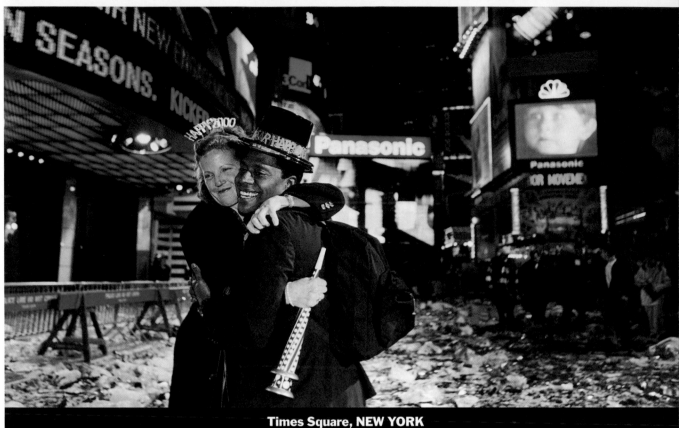

Times Square, NEW YORK
Two million revelers at the crossroads of the world were bombarded with three tons of confetti. Some stuck around when it was all over

Meanwhile, in that ironic way communist governments have of ignoring the people's will, Cuba declared that there should be no celebrations since the millennium really starts next year. Instead, they celebrated the 41st anniversary of their revolution and permitted only foreigners to attend a show at the Tropicana.

In America we couldn't quite get the mood right, with the mayor of Chicago inviting two people from every country in the world to dinner and presiding over the city's official 2,000-minute-long party. It included a new dance called the Milly, which, fortunately, few TV news organizations covered. In Washington the President had a large group of people over for dinner, including Don McLean of *American Pie* fame. They all then watched a movie made by Steven Spielberg that ended with an old man's hand touching a baby's hand against a backdrop of an American flag. In Los Angeles one of the Dust Brothers, a record-producing duo, was married at his house; Beck served as the wedding band. In New York, Internet millionaire Josh Harris spent $700,000 on a month-long party that culminated at midnight with his trying to coordinate six fornicating couples into simultaneous orgasm at midnight. Everyone has a dream.

Regardless of what you may think of New York's Mayor Rudolph Giuliani, you must admit he was the right man at the right time. Two million people stood perfectly in place as the ball dropped, five helicopters circled above, and 100 confetti-dispersal engineers, trained all week by Treb Heining, the man who invented animal balloons, dropped 45-lb. boxes worth of paper on the crowd.

EVEN THOUGH THE TIMES SQUARE celebration went better than expected, the parties worked best in the locations that were able to provide a backdrop of history: Greece's Acropolis, Egypt's Pyramids, the Vatican, London, Versailles and Moscow's Red Square, which partied just hours after Boris Yeltsin handed a briefcase of nuclear codes to Vladimir Putin. Instead of the futurism that all these zeroes seem to command, the event was best celebrated by looking back, partially because futurism always comes off as incredibly stupid. So Seattle, Wash., a symbol for technology as well as troublemakers in sea-turtle costumes, canceled its main party, and no one really missed it.

But more than wondering what th event meant, the more pressing question How do you pop up out of your bunke Should you wear an embarrassed grimac smiling through the 300-lb.-millet-bag jok lobbed by your Y2complacent neighbor Should you be angry, suing all the Engine Littles who tricked you into believing the sl was falling? Or should you climb back i side, waiting for the systems shutdowns February because of the leap-year bug?

No, you should emerge from your Y2 bunker as your father did from his bom shelter after the Cuban missile crisis and your forefather did from his cave when th first eclipse passed. Like them, you shou celebrate. You should celebrate longer ar harder than your neighbors who dance and drank while you tested your flashligh You should celebrate that it's no mirac that the world didn't end because of a fe zeroes. That it's no miracle we can still co trol the myriad intricate systems we ha built. That it's no miracle that our global i terconnectedness makes us stronger, n weaker. After all, is it a miracle that the su which we understand far less than our con puter systems, rose yet again?

Yes, it is.

—**Reported by the Staff of TI**

2000

AROUND THE WORLD

Las Vegas, NEVADA

Vegas parties like it's 1999 all the time—maybe even into 2000. But for these mad hatters from Jackson, Wyo., Y2K marked a first trip to the Strip.

WILLIAM MERCER MCLEOD FOR TIME

Miami, FLORIDA

Jemima Vernette Blaise, 6 lbs. 11 oz., Jackson Memorial Hospital's first baby of the millennium, squeals as a nurse tells mom, "She has your dimples."

ROBERT NICKELSBERG FOR TIME

2000

VATICAN CITY

Ever more frail, John Paul II attended a service six hours before blessing the crowd in St. Peter's Square. "I wish you a year filled with serenity and happiness," he said. "May you always be certain of God's love for us."

London, ENGLAND

From the deck of the new ferry to the Millennium Dome, Queen Elizabeth lit the 26-ton national beacon. Later she gamely linked arms with Prime Minister Tony Blair to sing *Auld Lang Syne.*

Robben Island, SOUTH AFRICA

Nelson Mandela lit a solitary candle from cell where he spent two decades a as a political prisoner. His millennial admonition? "The freedom flame can never be put down by anybody."

The River Thames

Not since World War II had so many rockets exploded over London—this time with enchanting results. As Big Ben chimed, fireworks raced up the Thames, illuminating 3 million revelers.

Moscow, RUSSIA

Despite dire predictions, only Boris Yeltsin was not Y2K ready. Missiles did not launch, lights stayed on, vodka and champagne flowed freely.

NIKOLAI IGNATIEV—NETWORK—SABA FOR TIME

Cairo, EGYPT

The city rang in its seventh millennium to the beat of a techno-opera and fireworks, while laser beams enshrined the 4,500-year-old Pyramids.

ENRIC MARTI—AP

Paris, FRANCE

Just days after once-in-a-century storms, a once-in-a-millennium display transformed the Eiffel Tower into a geyser of lights. Parts of France had to greet the new millennium as they did the last one—without electricity.

THIERRY ORBAN—CORBIS SYGMA FOR TIME

Rio de Janeiro, BRAZIL

Take one humid and hot summer night in the land of carnival. Add millennium celebrations and a dash of mysticism. Leave to sizzle. Result: Rio de Janeiro's sandy waterfront heaved with an estimated 3.5 million partygoers. That's more than the population of neighboring Uruguay. Most came to honor the African water goddess Iemanjá by tossing flowers, jewelry, perfume or champagne into the sea. Stand in the surf, they say, and she'll cleanse your soul.

CARLON HUMBERTO TDC—CONTACT FOR TIME

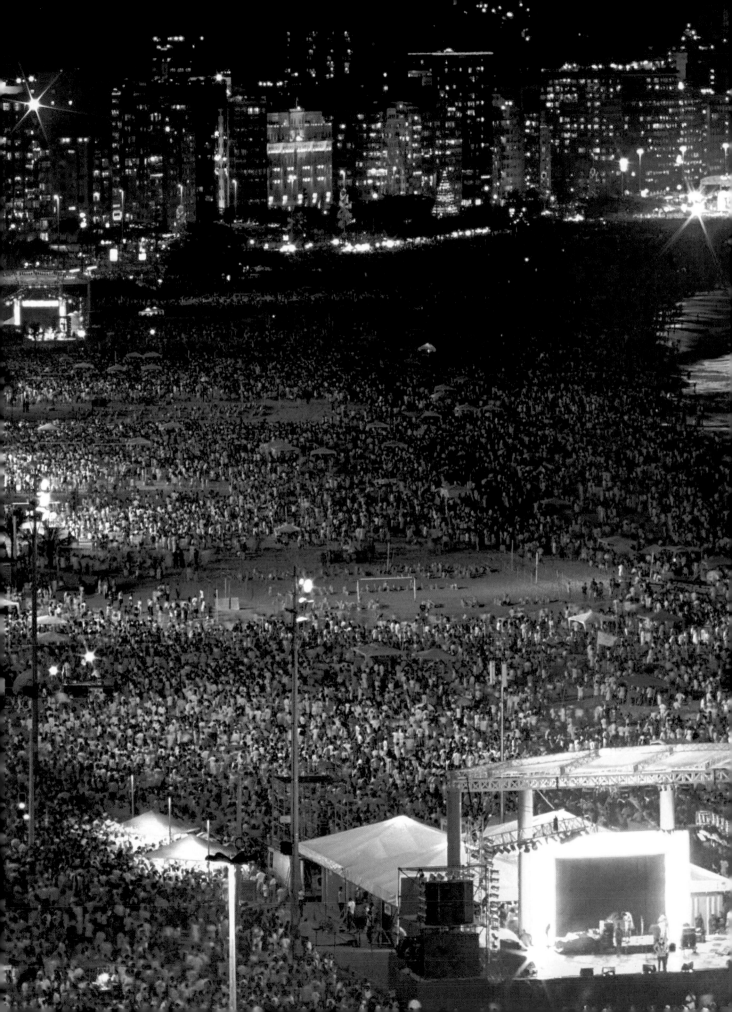

2000

AROUND THE WORLD

Washington, U.S.A.

The public spectacle of fireworks shooting up the Washington Monument inspired oohs and aahs. And the President threw a lavish black-tie bash for 300 special guests, including Muhammad Ali, with a menu that evoked its own oohs—Beluga caviar, lobster, foie gras and oyster velouté. Before the midnight fireworks, Clinton addressed the nation. The 21st century, he said, "will require us to share—with our fellow Americans and, increasingly, with our fellow citizens of the world—the economic benefits of globalization."

AP; CHRIS USHER FOR TIME

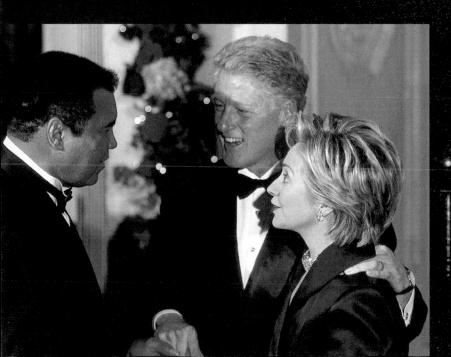

San Francisco, U.S.A.

**While Times Square was being
cleared across the continent, a lonely,
luminous Western dawn fell on San
Francisco Bay. In the deep millennial
glow, the Golden Gate's 1.2 miles of
reinforced steel and concrete were
transformed into a magisterial,
beckoning bridge to the 21st century.**

TOM ZIMBEROFF FOR TIME

Roger Rosenblatt

A letter to th

Dear America,

ARE YOU WEARING PAJAMAS? I DO NOT MEAN TO BEGIN this letter by getting personal. I was just wondering if you people leave the house anymore—something that seems to be increasingly unnecessary these days, a hundred years ago. Not that leaving the house is always a good idea. Outside lies the wide and brittle world of wars, gunplay, scandal, disease, superstition, categorical hatreds, willful ignorance, envy, pettiness and cant. In your perfected age, all such things undoubtedly have been eradicated. (How I wish I could hear your laughter.)

Are you six-feet-six? Are you fly-fishing on Mars? Are you talking on a cell phone? We are, usually.

We are talking on a cell phone as we walk among the blazing office towers and the gridlocked SUVs, along a frozen sidewalk on the Avenue of the Americas in New York City, from which we call a colleague in an airplane who, while speaking to us, is faxing an application for a Platinum card and e-mailing a color photo of his beaming children, taken with a digital camera and put on a CD, to a screen in his home in Connecticut, where the kids are playing Pokémon (don't ask) or dancing to *Livin' la Vida Loca* (don't ask), before he trades a hundred shares of Microsoft, transfers some cash, buys a Palm Pilot for his wife (who's doing Pilates at the health club this afternoon), auctions off the cabin in Vermont, then orders one set of tickets to a black-tie dinner for breast cancer and another to the latest off-off-off-Broadway play, about a man talking on a cell phone as he walks among the blazing office towers and gridlocked SUVs, along a frozen sidewalk on the Avenue of the Americas.

I am not, of course, accounting for the Mexican boy in South Central Los Angeles who lies on his bed staring up at paint chips on his ceiling; or for the pale girl gazing out a high-floor window in one of those blazing office towers at a pale boy in the tower opposite, gazing back; or for the bearded hermit crouching near the statue of a general on horseback in a city park and talking on a cell phone that does not exist.

As lovers leaving lovers say, By the time you read this, I'll be gone. Or possibly I won't. Given the way life is being prolonged these days, I—with my pig's liver, titanium hips and knees, arti-

ficial heart, transplanted kidney and reconstructed DNA—coul[d] write this letter in my century and pick it up in yours. ("Dea[r] Me"—the perfect address for a solipsistic time.) No thanks. It i[s] enough to be able to send these words across the abyss of year[s] to tell something of who we are. We are members of a narrativ[e] species, you and I—two eras connected by a story that change[s] just enough to keep it interesting.

I write you in the dead of winter from a summer village by th[e] Atlantic Ocean. The last of the houseflies beats its body against th[e] window, through which I watch the tremors of a berry bush an[d]

e year 2100

a summer house to be near partygoing writers, editors and agents, whose principal ambition in life is to be able to rent a $350,000 summer house. One person is paid $10 million a year for hitting a baseball. Another person is paid $7 million a year for talking to other people on television. Another is paid $35,000 for teaching math in high school. The hit movie of the past few years was about a sinking ship. The most memorable quotation of the past few years was "I did not have sexual relations with that woman." The most exciting product was a pill called Viagra (I won't tell you how exciting). The most overused word of the times: synergy (*see* "mischief").

As long as I am on the subject of language, do the following have any meaning for you: "like"; "you know"; "what's up with that?"; "like, you know, what's up with that?"? You have no idea what I am talking about? Good. How about "yada yada yada"; "fuhgeddaboutit"; "pumped"; "zine"; "you're history"? (*We're* history.)

We are generally content, generally at peace, generally optimistic, and with good reason. As a people, we are simply a lot more interesting and various. Our latest immigrants come from everywhere, with more Latino immigration than European, and new Americans popping up from places like Sri Lanka, Pakistan, Korea, the South Pacific and Ghana. If I had been writing to you a hundred years ago, in 1900, my age group (55 to 64) would have represented 5% of the population. Today it accounts for 9%. In 1900 only 4% of the population was 65 and old-

he shorn stoic trees. Afternoon lowers on evening; the sky is the color of unpolished silver. A Cole Porter song, *In the Still of the Night,* goes through my head. I do not know why.

Some facts, to begin with: The gross domestic product is up about 4%. Inflation is at 2.6%. Unemployment is at 4.1%. Our budget surplus stands at $124 billion; the deficit in our balance of international payments is about $300 billion. A three-bedroom apartment in the most fashionable neighborhoods of Manhattan rents for about $12,000 a month. The median price for a house nationwide is $133,000. People pay as much as $350,000 to rent

er. Now that number is 13%. Geographically, we are more spread out. America's 10 most populous cities in 1900 were the industrial centers of San Francisco, Chicago, St. Louis and points east. Today Americans range over the breadth of the continent in cities such as Phoenix, Houston and San Antonio, where they have settled in the path of the sun.

We are generally rich; more people have homes of their own. We are generally healthy, thanks largely to remarkable advances in medicine. People who died of certain diseases even 30 years ago are routinely saved today. A colonoscopy will detect and lead

to the removal of a cancer that shows no external symptoms. Lifesaving operations on hearts and brains occur every day. Not only has medicine advanced; it has allowed people to act on their more selfless impulses. In September a middle-school teacher in Fayetteville, N.C., learned that one of her students suffered from kidney disease and needed a transplant. So the 42-year-old woman offered the 14-year-old boy one of her kidneys. Two miracles are at work in the story. The teacher wanted to sacrifice herself, and medicine would enable her to do it.

In short, we are generally O.K. in spite of notable low spots and areas of significant concern. Our movies are mostly silly. Our books? Mostly small. The quality of our cultural criticism is generally so low that one cannot tell how good or bad any artist is, but in literature, at least, it is highly unlikely that any writer touted as a heavyweight in our era will make it to the ring in yours. Movies that once were judged by normal artistic criteria are now valued by the amount of money they make over a weekend. For your horrified amusement, see if you can dig up a print of something called *Scream* or *The Blair Witch Project*.

Our theater? Mostly lights and tricks. Music? Mostly sappy-sentimental, and rap—a rhythmic fusion of grunts and hisses, minus the notes. Like Wagner, it's not as bad as it sounds, but one misses doo-wop, pop and jazz, especially jazz. Teddy Wilson, Billie Holiday, George Gershwin, Miles, Ella, Satchmo, Bix. I hope they have survived. It is, of course, possible that you long for Dr. Dre and Limp Bizkit the way I long for Cole Porter, but are you crazy?

Humor? It rarely translates from age to age. Have you heard the one about the dyslexic atheist who did not believe in Dog? Are you out there? I can hear you breathing.

Money drives the culture. Television has recently hit on the old successful formula of big-money quiz shows. The new ones give away millions to people who know which Presidents' faces appear on different dollar bills. (The most candid of these shows is called *Greed*.) The likable and funny fellow who is host of *Win Ben Stein's Money* may turn out to be the symbolic spokesperson of the age. He challenges contestants to match his wealth of information and simultaneously implies that education for its own sake is preposterous. If you're so smart—Stein asks merely by existing—why aren't you rich?

Signs of the times: When your bank says no, Champion say yes; You have a friend at Chase Manhattan; You get much more at the Money Store; Diamonds are forever; American Express—Don't leave home without it; Thank you, PaineWebber.

The nation has become a kind of giant store; everything is for sale. Catalogs rise like dough in our mailboxes, offering "the best double-buffer shoe polisher"; "the only floating practice green," which transforms "any pool into a challenging golf shot"; a "baby elephant sprinkler topiary" that sprays water from its moss-covered trunk. Fame is for sale. New hair, necks and noses are for sale. Debt is for sale. Every inch of space is used for advertising. A good pass in a pro basketball game is identified as an "AT&T Great Connection." Politics is for sale; candidates buy public opinion to try to get elected. Love is for sale, or at least a variation of it. Last year a man in Minnesota advertised for a bride, hired friends to interview candidates, and wound up with what the market would bear, as did she. The wedding took place in the Mall of America.

The idea, as ever, is to make people feel that they have to have purposeless merchandise they do not want. In a restaurant, a waiter will giddily announce, "We have mahi-mahi!" A sensible person would say, "So what?" America says, "I'll take it!"

We enlarge and expand. We have recently found out that the entire universe is expanding more than we had initially believed. We build, invent and discover at a pace that is dizzying for us, perhaps turtle footed for you. This year the automobile industry produced a vehicle powered by liquid hydrogen; Detroit plans to have fuel-cell cars on the roads in 2004. (I assume yours run on carrots.) The computer industry comes up with a "killer app" every 18 months. With silicon chips reaching their limit, the industry announces "molecular computing"—shrinking computer circuits to the size of molecules. Soon we will have flexible transistors and bendable screens, easy to fold, like a newspaper.

Once the human genome is decoded, genetic sequences can be patented, licensed and (of course) sold. On a higher plane, in the past three years alone, astronomers have discovered 17 nearby stars that appear to be orbited by planets the size of Jupiter. We're experiencing a bit of trouble with outer space lately, having just lost two costly gizmos we launched toward Mars. Have you found them?

Half the country is fat, half low-fat. Butter and eggs, once

out, are in; I suppose you have tossed them out again. Coffee, once considered poison, turns out to be harmless. Red meat is not as lethal as once thought. Take a shot of Scotch, of red wine. Take a shot: vaccines are on the way soon that will prevent pneumonia, rheumatic fever, meningitis and the flu. There's a new prospect called regenerative medicine—using the body's own stem cells and growth factors to repair tissue. We make ourselves anew. And how are you?

While we expand, we also contract. America Inc. has become a term for describing the unending mergers of vast companies— multibillion-dollar mergers, real money today. Oil companies, car companies, food companies, banks; everything comes together. Media companies become telephone companies. Telephone companies become software companies. Book-publishing companies are swallowed whole by companies that make music, movies and magazines. Nothing is wrong with these adhesions in principle, but some "products," like books, suffer. Not long ago, the large book publishers would take on a number of excellent but unprofitable manuscripts as a kind of intellectual duty, pro bono work for the national mind. These days, if a book is not predicted to sell at least 5,000 copies, fuhgeddaboutit (there you go). *The Great Gatsby* (fewer than 24,000 copies sold in its first 15 years) would not be published by a major house today.

Religions merge: this past year the Methodists with the Episcopalians. Folks are merging too. U.S. immigration officials recently predicted that by 2050 (50 years ago for you), nearly half the country's population will be nonwhite. There are more interracial marriages every year. I like to picture you as a nice, rich shade of beige.

Did I mention that this is a presidential election year—an invitation to nutcases ordinarily? This time everyone seems to have accepted the invitation, evidently having taken seriously the truism that anybody can grow up to be President. In addition to normally qualified candidates, those who have presented themselves as potential leaders of the free world include an apologist for Adolf Hitler; a professional wrestler who changed his name from the Body to the Mind; and a real estate magnate at once so ridiculous and self-confident that he is oddly mesmerizing. Indeed, watching the entire crop of Reform Party candidates vie for position is like watching dogs copulate in a public

square: it's not pleasant, but you can't take your eyes off them.

For all our Big Business expansions, government too remains big, and most people engage in the harmless hypocrisy of condemning its interferences and relying on its services. Fundamentally, we remain a liberal nation in spite of the gloatings or laments that liberalism is dead. If this year's Democratic platform resembles that of the Republicans, it will not be because the Democrats have capitulated but because the G.O.P. has absorbed the liberal agenda.

Nonetheless, as one of our few genuine statesmen, Daniel Patrick Moynihan, has said, "Liberalism has to learn to deal with the aftermath of its successes." In recent years, liberals have cornered themselves into appearing to approve of everything opposed to God and family. The country has been polluted with an idea called political correctness, which is simply a fundamentalism of the left. We are beginning to reach a point of equilibrium between laissez-faire capitalism and the welfare state, and to learn to discriminate between useful sympathy for the needy and wasteful excuses for careless behavior. But we still have plenty of braying pietists. Has the name William Bennett floated up to you?

I wish I could accurately report on our status in the world. We've got the weapons and the dollars. What Henry Luce saw as the American Century in the middle of the 1900s is nothing compared with the Americanization of the globe these days. Whether this owes more to cheap hamburgers or to free thought is hard to know. We are as we were and probably will be forever—eager to control the world and eager to stay out of it.

There are almost 190 independent countries, of which some 30 remain monarchies, most of them constitutional. There are many more democracies than before, and one senses a yearning on the part of former enemies, even those of bitter long standing, to bury the hatchets and the Uzis and get on with it. Northern Ireland recently appeared to be healing itself. The Middle East seems to be coming to its senses; the other day, the leader of Syria made a peaceful move toward Israel, which made a peaceful move in return, and the world did not come to an end. For all we know, both these areas may be associated only with productive cooperation in your time. If you are still smoking cigars, I hope they're Cuban.

But just so you know that human nature has not entirely altered as of this writing: what America once feared as the Soviet Union, we now fear as the Russian non-union—seething duchies with warheads underground. China, with its split personality, continues to make us nervous; we court its markets while trying to improve its government. In the Balkans, Christians spent the better part of the past nine years massacring Muslims. In Sudan, Muslims continue to massacre Christians. Over the past 100 years, we have advanced from Sarajevo to Sarajevo. If Sarajevo is again involved in a war as you read this, we may be on to something.

Our more mysterious problems are, as usual, internal. Mergers aside, we are in an increasing mode of separation from one another. The American class system (always vehemently denied) has never been more stratified. People who make the same money live in the same neighborhoods; they socialize with the same people; their kids go to the same schools; their habits, speech patterns, clothes are the same. The so-called middle class consists of a dozen sub-classes earning anywhere from $20,000 a year to $200,000. Distribution is skewed. The top 20% of American families make as much as the remaining 80%. The top 5% of that 20% makes nearly as much as the remaining 15%. In that 5%, the top one-fifth (or 1% of the total population) makes as much as the remaining 4%.

The emerging technologies that purport to bind people together have also created a new information class imposed on the others. Not everyone has a computer, so there is that class of outsiders. Even among the insiders, people seek virtual localities where they find their own kind—chess players chat with chess players, militia members with militia members. Since communication is the soul of democracy, the Internet should have become the great equalizer, but most people are in touch with their own, home alone.

At the same time, individual privacy is both systemically invaded and willingly forfeited. Businesses spend fortunes spying on the competition. A few weeks ago, a Russian spy was caught listening to a bug planted in the State Department, having possibly made a comfortable shift from cold war espionage to industrial espionage. CD-ROMs are sold with essential information on millions of citizens. Banks divulge how much

money one has; credit companies, how much one owes. Yet privacy is also eagerly, happily surrendered—on radio and TV talk-revelation-boxing shows. Everyone owns a camcorder, so everyone is on TV. One has never been more in the open, or more apart.

I wonder if we really want to have as much to do with one another as we have always claimed to want. Connectedness—that was supposed to be the desperate cry of a world frightened by modernity. "Only connect," pleaded E.M. Forster at the outset of the century. Inventions were concocted to bring us closer to one another, the machinery of communication especially. Observe a riot of fans at a soccer game and see how close we are. Historically, there has never been as much communication as in our 20th century, or as much mass murder. Communication, mistaken for a virtue in itself, has substituted for sympathetic, beneficial social existence. If living with one another merely means living in touch with one another, no wonder so many people feel closer to their computer screens than to other people.

A young boy in Harlem was sitting at a computer in a library, clearly loving the experience. When asked why, he said of the computer, "It doesn't know I'm black." We are no closer to one another than we wish to be.

Between men and women there seems to be a widening separation based partly on the new varied social status of women and on men's difficulties in making adjustments. Movie plots have men turning into women, women men. One of our weirder celebrities, a basketball star named Dennis Rodman, put on a bridal gown a few years ago and married himself. Saner but sadder consequences are evidenced in an absence of romance in courtship and the treatment of sex as sport.

Between adults and children there has always been a chasm (sentimental pretenses notwithstanding), which has of late become murderous. Child-interest groups regularly cite the vast numbers of the abused, neglected and homeless. White middle-class families blithely assume that the statistics apply to poor urban people of color. The fact is that sexual abuse in states like Iowa and Nebraska is the national average. Because of work patterns, parents of every economic status are spending much less time with their kids. Children also compete

for one's money, time and resources. In a recent exhibition of children's art in New York City, a painting showed a man raising his hands in surrender and surrounded by clocks. It carried the caption THIS IS MY FATHER.

Between people and nature there may actually be less of a division than there was, say, 50 years ago. The corruption of the atmosphere, the erosion of the rain forests, the plundering of the waters are all common topics of concern. Dozens of first-rate organizations are at work on conservation, and political candidates have adopted the issue, both because it's safe and because they mean it. The trouble is that this effort may be too little, too late. You tell me.

Between people and themselves, separations have always existed. Some of that today is due to the "Is this all there is"—ness of flush modern life; some, to the number of work hours— a mere three hours less a week than in 1970. And the pressures of competition make those hours feel like more. Maybe we are deliberately working harder so as to have less contact, less time for self-inspection. (These are self-interested but not introspective times.) I won't pretend to know what all this means, but if you have preserved Charlie Chaplin's *Modern Times*, we look more like the hectic machine than we look like the hapless Chaplin.

A woman just rowed solo across the Atlantic. Parachutists frequently leap off cliffs and out of planes. Balloonists are beginning to require air-traffic controllers. We are trying to escape from *something*.

What draws us close are accidents—catastrophes to which we attempt to assign blame or affix explanations but which we know intuitively to be inexplicable. In the past year, a teacher and 12 schoolchildren were shot down by schoolchildren in Colorado; 12 people died building a bonfire in Texas; six fire fighters died fighting a blaze in a warehouse in Massachusetts; six Marines and a Navy man fell to their death in a helicopter exercise off the coast of San Diego. Our insistently enlightened minds leap to "solve" such things, but their effect on our spirits has more to do with our helplessness. Helplessness brings us close to one another in silent acts of mourning, to weep for the life we share—with you as well.

These concerns may all sound like child's play to you, but somehow I doubt it. A hundred years isn't all that long, and your world must look a good deal like ours, if not in its devices and architecture, then in the small signs and gestures. A woman in Rhode Island wants to paint a flower. A man in Wyoming wants to catch a trout. He, somewhere, wants fame and love. She, somewhere, wants children or revenge. Everybody wants. What do you want? What should we want?

I wonder how far you have progressed. I wonder if you have learned to deal with the concept of God without turning faith into a weapon. I wonder if you have learned to control the anarchy of popular authority. I wonder if you have figured out how to make the best use of the past. Have you learned that traditions and institutions are not all bad? After a century of Freud, Marx and Einstein, we are pretty shatterproof these days, in terms of not being shocked by being all shook up. But in the words of one of our favorite songwriters, Carole King, "Doesn't anybody stay in one place anymore?" Maybe you have finally figured out how to live where we have always tried to live—safely between chaos and boredom.

Have you rediscovered a gentle, generous sense of humor? Have you recovered an appreciation of irony? Have you reacquired the ability to praise? So much of what passes for intellectual activity in our time is the carping of the jealous or the embittered. One of our poets, W.H. Auden, wrote an elegy to another, W.B. Yeats, in which he sought to "teach the free man how to praise." I hope you've learned.

People are generally more praiseworthy than we have been made out. That is a little secret of our age, perhaps of yours as well. Not all the people, all the time, but there is a tenderness, a loveliness that outlives our cruelty and stupidity. One can see it in an audience lost in a passage of Mahler's, or in a sudden, gaudy display of sunlight on a field. All the fear and self-absorption are wiped away, and in our blameless, dumb-struck faces lies the better story of the race. This too is who we are. This is who you are, whoever you are.

I see you looking back at us. You see us looking out at you. Because we can imagine one another, we constitute each other's dreams. Outside, the air is cold and deep. The moon hangs in a fingernail of light. The clouds conspire and retreat to reveal your stars and ours. Come. Walk with me in the chill still of the night. ∎

Pico Iyer/Easter Island

Who Are You in the New Millennium?

Watching a new age dawn in the company of Easter Island's "living faces"

NOTHING BUT THE SOUND OF WAVES FOAMING AGAINST black volcanic rock. A man sits alone at a desk reading verses of the Bible aloud to himself. Three white crosses stand desolate atop a bare green hill. All across the empty, silent island—a kind of Polynesian Scotland—*moai*, or worn, hollow-eyed statues carved from volcanic stone, are staring back at the new day as if it were the old.

Did a clock in Times Square just click over? Did some great historic moment just explode in the Millennium Dome? If so, someone neglected to inform the "living faces" that preside unchallenged over the loneliest island community in the world (in the same time zone, though hardly the same century, as New York City). On New Year's Eve, grass-skirted dancers perform under fireworks in front of the ancestral figures; but come New Year's Day, all is just eerie midsummer stillness again, the only sound the wind whistling in your ears. It may be that something tumultuous happened to your laptop, or that ATM down the road; but on an island 1,300 miles from the nearest inhabited landmass (Pitcairn, pop. 65), all such disturbances pass like a distant storm at sea. "The race is not to the swift," wrote D.H. Lawrence in the past millennium, "but to those that can stand still/ and let the waves go over them."

WOLFGANG KAEHLER—CORBIS

Rapa Nui (as the locals call their island, their language and their race) is not, happily, one of the typical places on the earth; there is no desperate shortage of food or drinking water or telephones. Yet it throws a curious light on our millennial dreams. There is no place of higher education to serve the 3,000 or so residents, and mass transportation is said to consist of a bus that runs occasionally on Sundays in the summer. A 21st century luxury on this remote Chilean possession is wood. And the few foreigners who gather here to see in the new millennium do so largely in the spirit of people choosing to spend the holidays with their grandparents. All over the island, in the ceremonial sites, you see lonely, breathing figures staring out into the silence.

In place of high-speed modems or PalmPilots—which look, in this scheme of things, a little like the toys the kids got under the tree last week—Easter Island offers what humanity has always relied on: petroglyphs and taboos and ways of peopling the dark. You walk here through a landscape of atavistic myth, in what can seem a Blair Witch island. Winds from Antarctica roar over broken stone heads and toppled statues in the bare earth. In the local church, the Virgin Mary is a staring-eyed *moai*, and the baptismal font sits atop a carved head. "Y2K," in the blustery quiet, sounds a lot like "Why today?"

In response to that stubborn sense of mystery, visitors have characteristically tried to fill the emptiness with explanations, speculating about immigrants from outer space or heroic oarsmen from South America; foreigners see Basque influences here; and locals speak of the statues walking inland from the coast. The monoliths, thought to be between 600 and 1,300 years old, reflect back mostly the faces of those who look at them. John Dos Passos, in 1971, saw the island's parabolic cycle—the construction of extraordinarily impressive monuments, followed by their destruction—as a warning to "college radicals"; others see an allegory of limited resources (as human bodies multiplied on the island, and resources did not, people were reduced to eating one another, and after infections and slavery raids further reduced numbers, the population, in the late 19th century, sank to 110). In Paul Theroux's formulation, "Easter Island is smaller than Martha's Vineyard, and probably has fewer stony faces."

Nowadays, the local airstrip serves as an emergency-landing area for the space shuttle. And as the new millennium approaches, vans start to appear, carrying cameras from Chile (more than 2,300 miles away) to transmit the New Year's ceremonies around the world (from an island that did not know direct television four years ago). In the few cafés around town, large men with tattoos and topknots can be seen arguing passionately that the tribal leaders now bow only before the altar of money and talking heads.

Behind them, though, bare-chested neighbors with flowing red hair are galloping down the main street on chestnut horses. A girl is kissing a customer in her delight at having completed, successfully, a credit-card transaction (her first). And around a tiny graveyard of white and black and red-brown crosses, crookedly set against the sea, the *moai* stand, restored to their dark platforms, in front of cresting waves.

You look at the statues in the early light, and they seem to ask how much a "New Year" means a new you. What ever is deepest in us, they seem to suggest, is what doesn't change, or lend itself to explanation; in love or in worship we leave the calendar in another room. As a new millennium begins in some parts of the world, the "living faces" with their hidden eyes cannot be heard shouting, "Out with the old, and in with the new!"or "Should auld acquaintance be forgot!" Rather, they seem to murmur, "Happy New Year. Happy Old." ∎

Buy low.

Sell high.

Read fast.

The world's most interesting magazine.